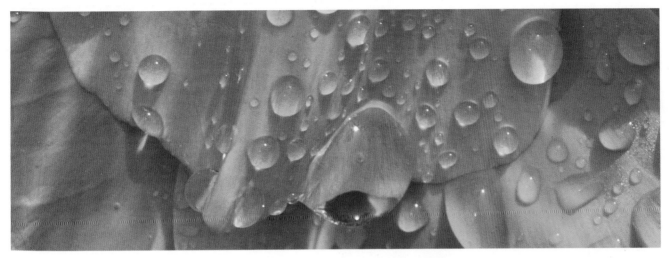

Beyond the Basics II

More Innovative

Techniques for

Outdoor/Nature

Photography

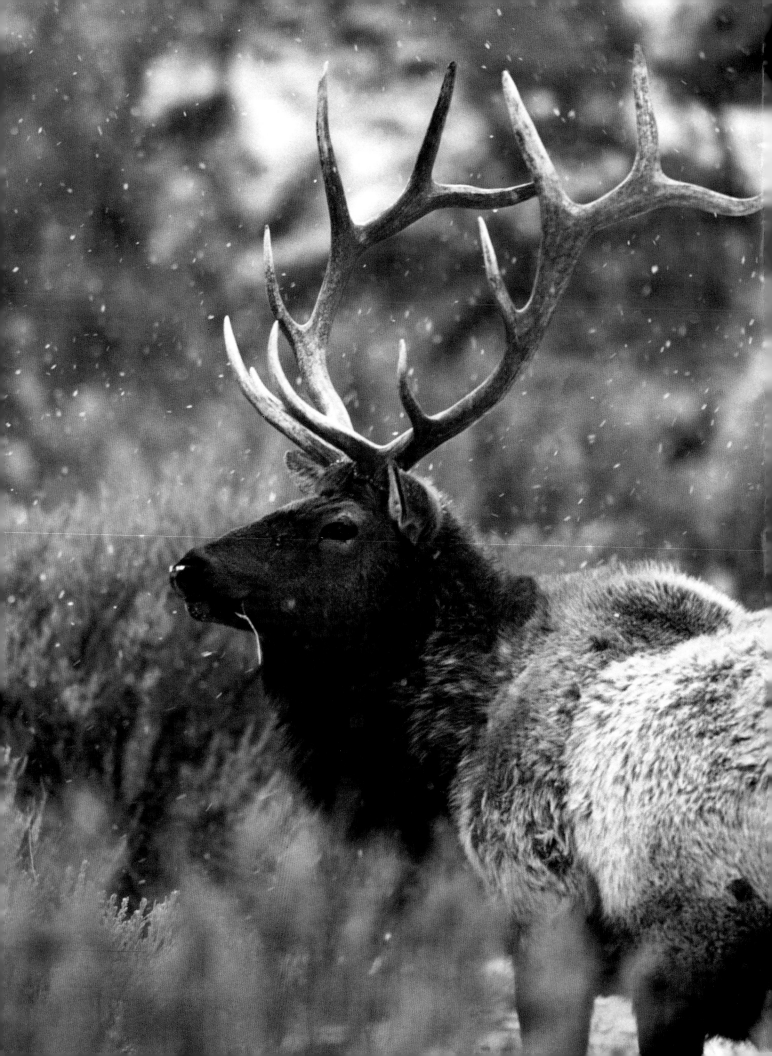

BEYOND THE BASICS II

MORE INNOVATIVE

TECHNIQUES FOR

OUTDOOR/NATURE

PHOTOGRAPHY

Photography By

George D. Lepp

Written By

George D. Lepp and

Kathryn Vincent

Book Design By

Pandora Nash-Karner

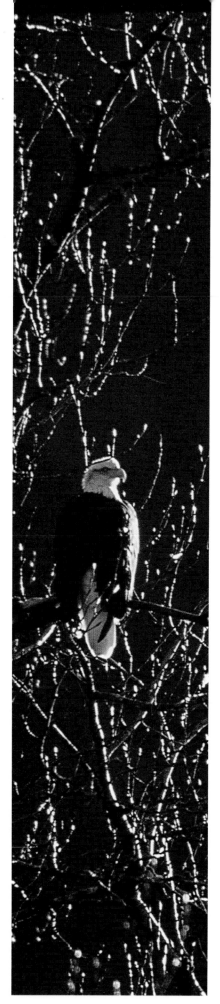

*W*hat remains of the natural scene can be
seen as symbolic of the original bounty of the
earth. The natural beauty and wonder we
now observe are a diminishing resource;
substances vital to our physical and emotional
survival are being critically depleted.

Ansel Adams editorial, 1984

Cover
A female polar bear and first-year cub huddle in the lemon grass near Hudson Bay. They await the Bay's annual freeze, which will give them access to important food sources. Canon EF 300mm f/2.8L with EF 2X tele-extender (600mm).

Page i
Raindrops on a California golden poppy. Canon EF 180mm macro lens on Kodak E100SW film.

Page ii
An elk grazes during a winter snowfall in Yellowstone National Park. Photographed with a Canon EF 300mm f/2.8 lens with EF 2X tele-extender (600mm) f/5.6) on Fujichrome 100 film.

Page iv
Near Squamish, British Columbia, Canada, a bald eagle waits for the warmth of the morning sun before swooping down for a breakfast of salmon. A Canon EF 600mm f/4L with 1.4X tele-extender (840mm) at f/5.6) was used with Fujichrome 100 film.

Page v
A wave washes over a sand dollar on a remote beach along the Pacific coast of Baja California, Mexico. A Canon EF 35-350mm lens with 25mm extension tube was used at 1/15 second on Kodak E100SW film.

Page vi
A small mammal's tracks leave a pattern in a sand dune along the coast of central California. A Canon EF 100mm macro lens and Fujichrome Velvia film were used.

Page vii
A tide-washed sand flat hosts a single scallop shell. An aperture of f/32 maximized the depth of field offered by a Canon 20-35mm f/2.8L wide-angle zoom set at 20mm on Velvia film.

Book design and production by Pandora & Company, Los Osos, California.
Designer/Art Director, Pandora Nash-Karner; Production Director, Cynthia Milhem; Production Assistant, Meghan Tolley. Produced on a Power Macintosh 7300/200 using QuarkXPress 3.3.2, Photoshop 4.0, text imported from IBM to Mac using Microsoft Word through PC Access. Low resolution photographic images placed for position and sizing for open pre-press interface. Typestyles: Akzidenz Grotesk, Goudy, Ballantines and Century Schoolbook.

Pre-press, printing and bindery were completed in the U.S.A. at American Book. All 35mm slides were scanned on a DS Screen 7060 and were color corrected using Photoshop and proofed on a Kodak Approval PS. Hi-rez files were linked with the QuarkXPress document and placed in positions with Preps software. The in-position files were imaged to Kodak Thermal plates on a Creo 3244 Trendsett. Plates were then printed on Heidelberg offset presses.

Beyond the Basics II
More Innovative Techniques for Nature Photography

ISBN 0-9637313-1-9
Library of Congress Catalog Card Number: 96-095518
Published by: Lepp and Associates
 P.O. Box 6240
 Los Osos, CA 93412
 805•528•7385
WEBsite: www.leppphoto.com

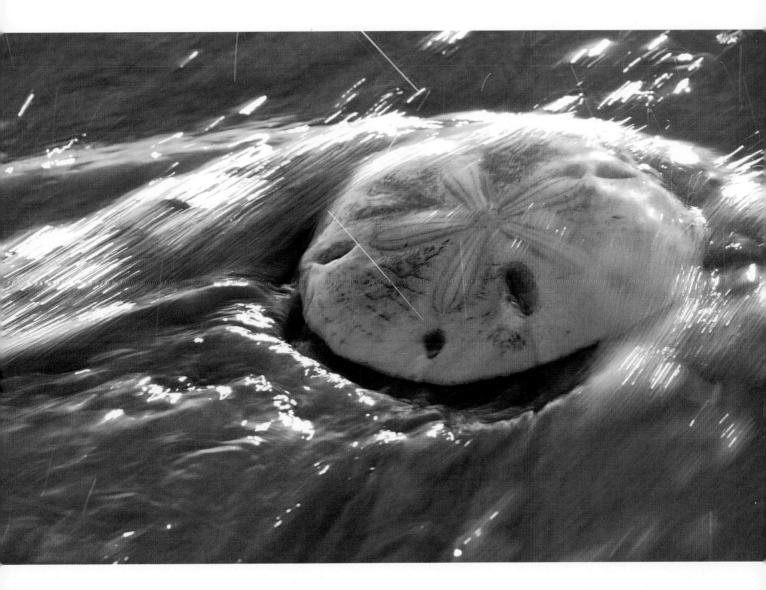

To Arlie,

WITH EVERY WAVE COME NEW TREASURES

\mathcal{T}ABLE OF CONTENTS

\mathcal{P}REFACE

I am pleased to welcome you to *Beyond the Basics II: More Innovative Techniques for Nature Photography.* This volume offers my perspectives on ten additional nature photography topics, and it is intended to supplement, rather than replace or update, *Beyond the Basics I.* In the four years that have passed since the completion of the first volume, I've learned a lot more about nature photography, natural subjects, and the photographer's role in nature. I hope that the techniques I present here will be useful to you in your own photographic pursuits, and that the ethical and political issues discussed will help to inform your own photographic standards and environmental philosophies.

This volume is organized in similar fashion to its predecessor. Topics are introduced with a portfolio of images which represent the techniques or issues discussed in the following text. Captions will contain technical information about exposure, film, camera, and lens only when relevant to the information being presented. Some readers may be frustrated by this lack of specific information, but there are two reasons for omitting it. First, I don't always notice, record, or remember the camera settings in the heat of the shoot, and second, I think it's more important for you to operate based on the principles of photography than to be distracted by the settings I used in a moment long past.

In 1995, *Beyond the Basics I* received the Photography Information Council's "Best How-To Book" award. The success of that book was due in great measure to the work of an outstanding writing, design, and production team. With *Beyond the Basics II,* the same team is back; and because we've all had a lot more practice since then, we think we've done even better work this time. We hope that you agree.

My friend Kathryn Vincent (Kathryn Roberts in the first book) has helped with my writing projects for some fifteen years. A free-lance writer and editor, Kathy holds a day job with the University of California at Riverside which brings

continuing contact with environmental and social issues in the United States and Latin America. Since 1995, she has published two edited volumes and several articles about the United States–Mexican relationship.

The gifted Pandora Nash Karner's design of the first book was highly praised. She has freshened and updated the look for this volume, and she continues to provide creative support for many Lepp projects.

Arlie Lepp is publications and business manager for Lepp and Associates and an expert coordinator of all the aspects of production, marketing, and distribution of our journals and books. She has been particularly instrumental in bringing this volume to completion and into your hands. I continue to rely upon her and her fine staff—Anita Field (who keeps the images straight and responds to all the deadlines) and Audrey Gagnon—to keep me functioning.

This book represents the efforts of many people. Thanks to Sarah Weinschenk, Andrea Kaus, Jay Diest, and Bobby Ray Vincent for their comments on various aspects of the text. The friends and colleagues who enrich my life and support my photography also are contributors to this work. Especially, thanks to Jack Kelly Clark, Bill and Lanier Sleuter, Darrell Gulin (to my delight, he shows up everywhere I go), Rich Hansen, Hal Clason, Dewitt Jones, Dave Northcott, Carl Englander, Russ and Jane Kinne, Mark Lukes, Rick Zuegel, Dave Metz, Chuck Westfall, and all the Canon representatives throughout the country who've helped in our seminars, Greg della Stua, Peggy Rea and Central Coast Printing, Tony Dawson, Todd and Bruce Harding, Lorenzo Gasperini, Steve and Michael Hess, Marti Saltzman, John Nash, Kevin Roznowski, Mike Gurley, Joe Runde, and Marc Boris.

Outdoor Photographer magazine continues to be the premier publication for nature photography. Thanks to the Werners and my editor, Rob Sheppard, for the continuing opportunity to reach the hundreds of thousands of avid readers who open *Outdoor Photographer's* pages every month.

The North American Nature Photographers Association (NANPA), established in 1993, continues to grow and serve as a forum for discussion of many of the important philosophical and ethical issues that are central to the evolving field of nature photography. Thanks to NANPA for giving me the opportunity for collegial interaction with my fellow nature photographers, writers, and publishers of nature-oriented media. I hope that readers of *Beyond the Basics II* will support and participate in this important organization.

As always, I am grateful to my family for their constant and enriching involvement in my photographic endeavors. Tory, you are a joy and a source of great pride to me, and I am constantly amazed by your inventive and creative skills. Arlie, I will always be glad we chose each other as partners in life and love. I look forward to all we will experience together as we fulfill our mutual 99-year contract.

George D. Lepp
Los Osos, California
March, 1997

EMERGING ISSUES IN NATURE PHOTOGRAPHY

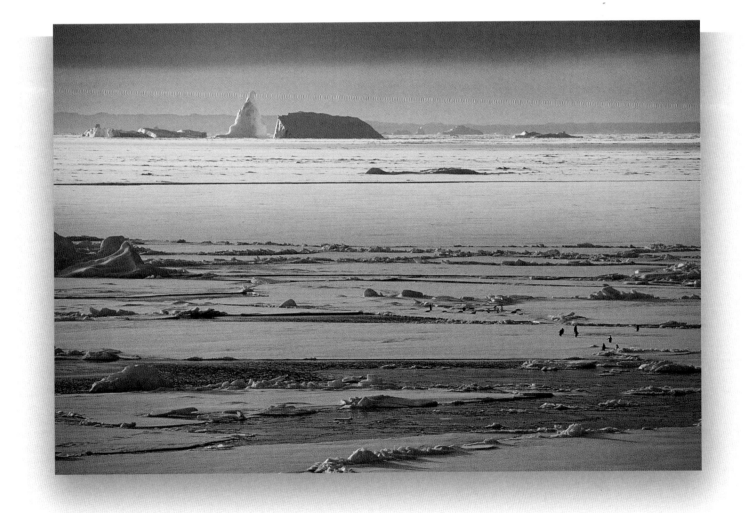

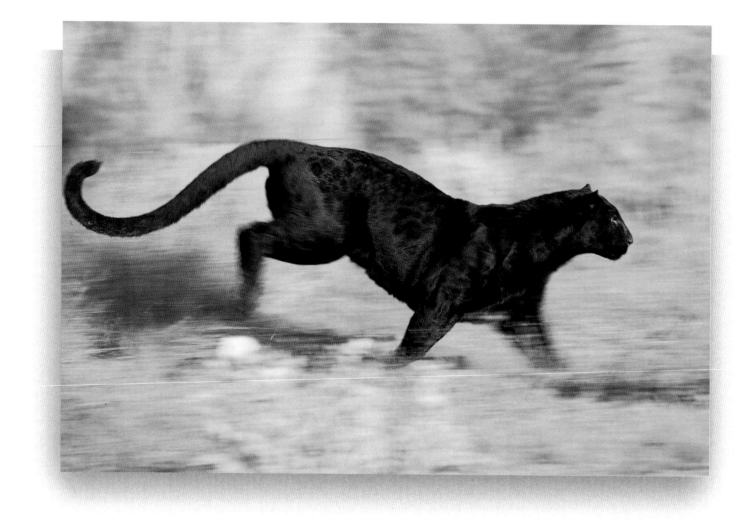

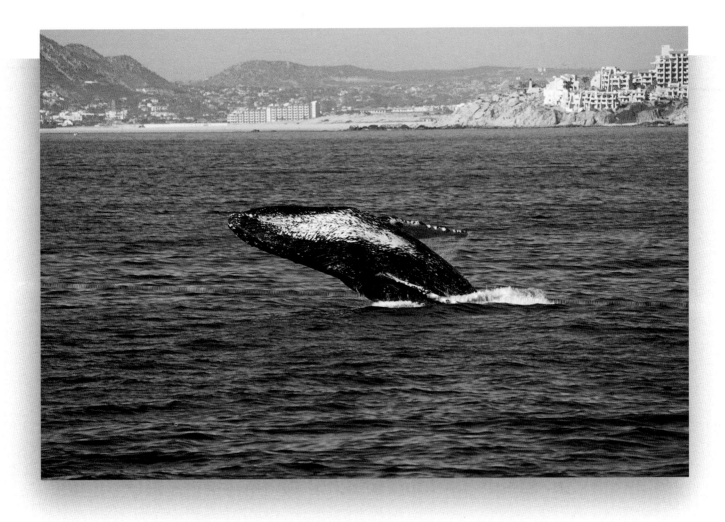

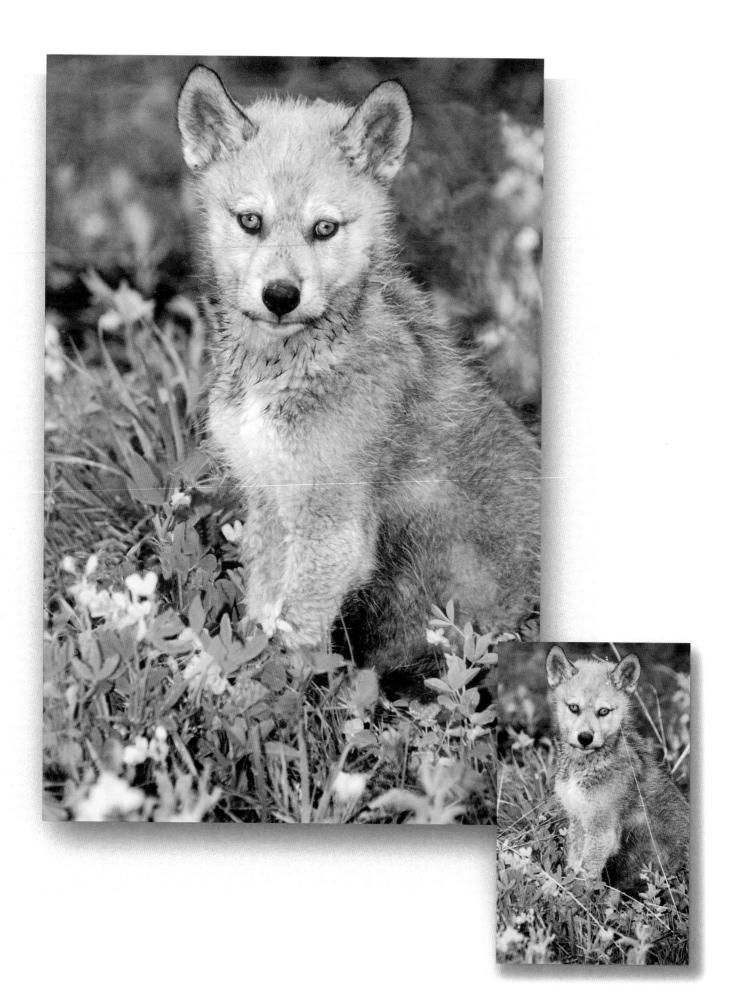

Unspoiled Vistas. Antarctic Peninsula. This is the end of the line for those traveling south on the Antarctic Peninsula, because the ocean is covered with thick ice from here to the pole. The peaks in the background are icebergs, locked in place. Among the inhabitants of this isolated natural region are adelie penguins, shown in the foreground, and, of course, intrepid human explorers in comfortable, warm boats.

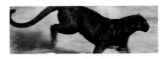

Black Leopard in Full Stride. California. How do you capture an exotic black leopard in the hills above Los Angeles? This controlled subject appeared in the movie *Jungle Book* and is trained to run predictably from one point to another. The photographer can choose the optimum position for the desired effect and capture an image that would be unlikely and unsafe to attempt in the wild.

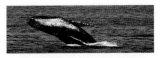

Humpback Cavorting off Cabo. Cabo San Lucas, Mexico. This image of a breaching whale backdropped by a popular resort suggests the encroachment of civilization on critical habitats. The whales of all coastal waters increasingly encounter sportfishing, commercial and recreational boaters, pollution, and diminishing food sources that jeopardize their future place in the world.

Baby Blue-Eyed Wolf. Colorado. This portrait of a wolf pup was taken at the Prairie Wind Rehabilitation Center near Denver. Wolf pups are very lively creatures, and they won't sit still while you groom the set. The inset shows my original portrayal, which is slightly marred by dried grasses. In the enlargement, I've used the computer to alter the image by removing the distracting foliage. Has the integrity of the photograph been diminished by the enhancement?

Emerging Issues in Nature Photography

Nature Photography Today

Nature is a very hot topic for the millions of people in North America who are actively engaged in, and photographing, natural environments and subjects. It concerns millions more who are involved in the management of parks and reserves, the publication of books and magazines about outdoor subjects and activities, and the study of plants, animals and other terrestrial subjects. Competition for access to natural areas and resources is keen among species, including humans, and the stress is increasing as human populations swell. Small wonder that some of today's most perplexing political, scientific, and social conundrums involve nature.

Increasingly we rely upon images for information about our world. Every aspect of society is built upon visual input, from billboards to television, magazines to the Internet. For many, images are the single best source of information about nature. At one extreme of influence, members of national legislative bodies make critical resource management decisions based on information presented in photographs. At the other extreme, the amateur photographer provides, to his local camera club, a current perspective on Yosemite National Park.

As a result, some of the most interesting philosophical and ethical issues of our time, particularly those at the intersection of technology and art, revolve around nature photography. Every photographer, from the beginner who shows his prints to the neighbor, to the professional who may reach millions with one image, has a place in this intellectual dialog.

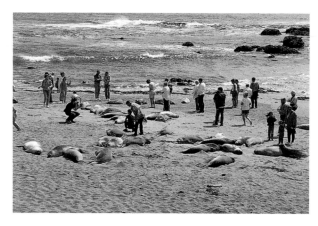

When wildlife is easily accessed, like it is at this new haul-out beach for elephant seals along California's coast, problems soon occur. The seals have been harrassed, people have been injured, and the animals have been hurt on a highway nearby. Still, the beach provides an opportunity for many people to observe closely and learn about a species that is usually inaccessible.

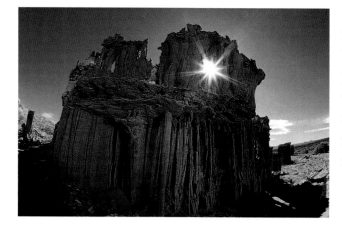

A sunburst gleams through a sand tufa formation on the shore of Mono Lake, California. The delicate formations were created by underground springs when the area was covered by the lake. Photographers need to be very careful when working around fragile formations, but their photographs will help to foster appreciation and preservation efforts. A fisheye lens was used for this image along with a large reflector to fill the shadows.

Who Are We?

One way to identify the family of nature photographers is to divide it into three branches.

First, there are all those people who carry "point-and-shoots" with them as they interact with nature as cyclists, hikers, boaters, or bird watchers. They use the camera simply to document the places where they engage in the activities that are important to them. Their photographic tools range from disposable cardboard cameras to today's quite sophisticated, lightweight, and compact snapshot cameras.

Hobbyists, the second branch, take their cameras with them not only to document their activities, but also to capture their enjoyment and interaction with nature. With photography, they endeavor to reproduce the general sense of a hike or camping trip. More sophisticated equipment and technique is required to satisfy their photographic aspirations. They, for example, may spend some time on macro photography of wildflowers along the way.

A third branch of the family lives and breathes nature photography. It is a passionate and driving force in their lives. Outdoor activities are a means to accomplish photography; excursions are designed around the pursuit of photo-graphic subjects. Mastering difficult photo-graphic techniques and concepts is their continuing education; they constantly seek to improve the quality of their photography. Professional photographers are joined by increasingly large numbers of accomplished amateur photographers in this category.

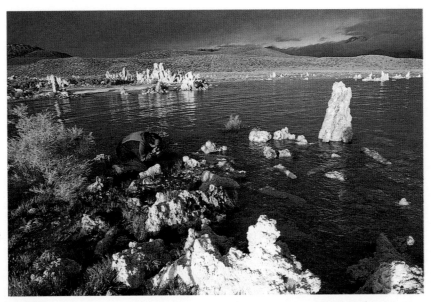

Because all the members of the family are engaged in nature and in photography, they have common interests in understanding and advancing the quality of their environments and the opportunity to do so through their photography.

Current Issues in Nature Photography

Those who consistently engage in the debate about current issues related to nature photography have developed many schools of thought about a wide variety of complex issues. Understanding the issues may lead you to an opinion, but resolutions to many questions thus far elude consensus. In the following discussion of several key issues, no definitive answers can be given. Instead, the many ways such problems can be approached are presented so that you can better understand the ongoing debates that influence your future relationship with natural environments and natural subjects.

Mono Lake is the subject for this serious nature photographer. Such dramatic destinations draw all types of photographers, from the casual point-and-shooter to the dedicated, skilled amateur of professional. All want to capture the beauty of the location for others to share.

The large king penguin colonies on South Georgia Island, a stop on the way to Antarctica, draw more and more visitors each year. As long as the guests follow common-sense rules and the directions of their guides, the human presence is of little issue. But with increasing numbers of visitors, the cumulative impact of occasional careless behavior must be considered.

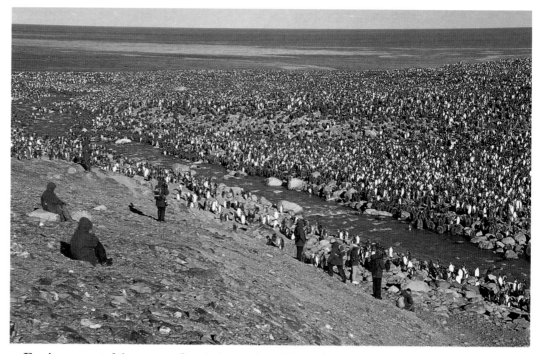

THE WRANGELL DILEMMA

From a local guide, I learned of an unusually large annual bald eagle gathering on the Stikine River Delta near Wrangell, Alaska. The birds were feeding in the tidal pools on concentrations of a small smelt. Our research confirmed that little readily available data or documentation existed about the phenomenon, even though in many years local census-takers have counted thousands of eagles in the area. In a world where everything has been discovered, we witnessed previously unphotographed, dramatic behavior in a spectacular setting. The dilemma? The area is incredibly sensitive, and there is no easy access that would not disturb the wildlife, which, in addition to eagles, included stellar sea lions and migrating birds. Furthermore, the local people, previously employed in logging operations, were looking for new economic development opportunities and eager for the opening of the area to ecotourism. As a photographer and a writer, do I present this wonderful phenomenon to the world and risk its destruction, or maintain the secret, even though someone else will surely unveil it?

Environmental impacts. Our information-rich society creates a continual flow of visitors to beautiful and sometimes fragile destinations that in the past would have been on few itineraries. We all want to enjoy the same areas, see the same natural wonders, and take them home on film. The responsibility for increasingly restricted access to natural spaces can in some ways be laid, quite literally, at our very own feet.

Photographers en masse, no matter how individually careful they are, have cumulative effects upon their subjects. As individuals, we don't know who has come before or who will follow us to a particular site or subject. Our actions, combined with theirs, make the true impact. Even if all of us are very careful with our handling of flora and fauna, there will be some direct effect. As new paths are established, plants are destroyed, and the stress of human encroachment often results in the relocation of animals from their preferred habitats.

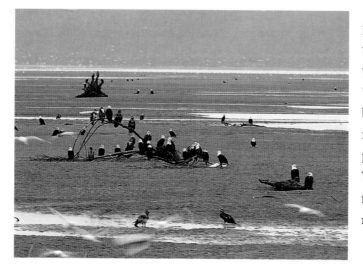

Wrangell, Alaska, briefly hosts thousands of eagles while their food source, a spawning smelt, is available. Any human presence on these tidal flats quickly disperses the eagles.

As successful photographers publish their "natural" images, they exacerbate "unnatural" influences by encouraging even more visitors to promising locations. Whether those who follow are simple nature lovers or more

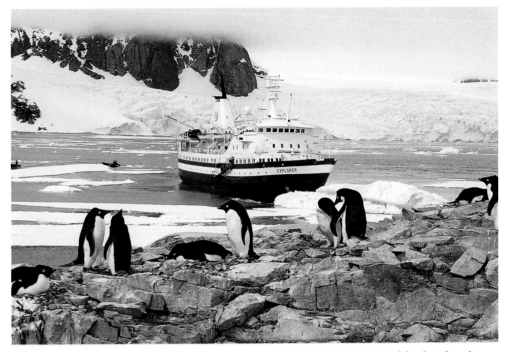

professional photographers, a pristine and beautiful area can quickly devolve from the destination the very first photographer discovered.

Once the secret is out, an increasingly popular environmental management strategy is to open the site to ecotourism, that is, limited development which facilitates low-impact and controlled use of a natural area. The catch here is that only by generating sufficient interest in a unique area can protective measures and resources be drawn to it. Understand this: It will never be the same.

Who owns nature? The so-called natural places left in the world are held by any number of entities: native communities, governments, international conservation organizations, individual private land-holders, resorts, local land trusts, and consortia such as hunting clubs. Of these, the only custodians that readily provide public access are governments who do, after all, hold land in the name of the governed. Even so, public lands with "natural value" are increasingly restricted in order to protect them from the damage caused by intense human use. While the cutting edge of conservation research recognizes humans as a part of nature, the proper and fair management of human interactions in protected areas is a complex and unresolved issue. Furthermore, the pressure to sell public lands or partially develop them in order to raise funds is offset by the growing pressure of people who want access to parks and reserves. We in the United States who are particularly aware of and interested in natural areas must make our opinions about their management known by electing public officials who assign high priority to protection of natural areas. Unique programs that reward private land-holders for maintaining and allowing access to areas of great natural beauty on their properties should be supported by nature photographers.

THE TEXAS SOLUTION
How can owners of natural treasures be encouraged to preserve and protect them and share them with nature photographers? The Valley Land Fund, a regional conservation organization, has established an innovative program that encourages private owners to open their holdings to nature photographers as part of a state-wide photography contest. The best photographs net substantial cash prizes which are shared by the photographers and the owners of the winning locations. This sets up a continuing liaison and encourages both preservation and promotion of natural areas on private land.

Signs help us, herd us, and warn us away. The question of access to public lands is an important issue for nature photographers. Some areas need to be restricted in order to protect a critically endangered species. But too often a government-posted "no trespassing" sign is just a way to deal with dwindling budgets and increasing public demand for an area.

When someone is injured because of a too-close approach, it's often the animal that loses its life for simply protecting itself, its food source, or its young. Users of natural areas should be aware of the possible consequences of their actions. This grizzly was photographed in Denali National Park with a Canon 600mm f/4L lens and 1.4 tele-extender (840mm) from the safety of a vehicle.

Photographers have another role as well—to document the visible aspects of change in the natural environment, from direct abuses and poor management to the more insidious effects of air and water pollution, soil depletion, infestation or invasion of exotic species, or encroaching development.

Remember that even one careless cameraperson—professional, hobbiest or point-and-shooter—can make a negative impression that affects future access for all people with cameras. But those carrying expensive, professional-level gear are particularly influential because of the general perception that they will make money from their images. The caretakers of parks and refuges sometimes resent their use for profit, and can be quick to take measures to protect their charges from the potential dangers of photography and photographers. Based on a prior bad experience with a camera-toting visitor, responsible and knowledgeable rangers and managers sometimes go to extreme lengths to limit others' contact with "their" land and its inhabitants. As budgetary decisions reduce the number and diversity of employees in public protected areas, the remaining caretakers are left with the most critical role of maintaining basic security. Where in the past such personnel were trained expressly in biology and natural history, the emphasis has shifted to enforcement and personal safety.

Animals are people too! You won't find much controversy among nature photographers about whether or not animal subjects deserve special consideration. Everyone believes in proper treatment. But the definition of proper treatment ranges from outright condemnation of any captivity, to allowing only contact with no impact, to simply maintaining basic animal health—wild or captive. As with the other knotty issues raised here, there is no consensus to be found. The debate centers on the attempt to establish basic standards in the following photographic activities:

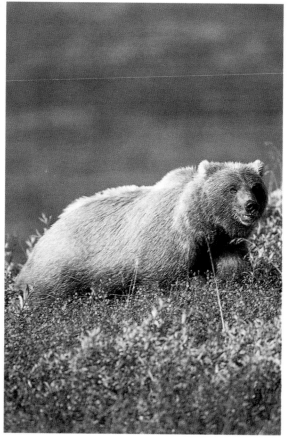

• Approaching wild subjects. How close is too close, what constitutes stress, and what short- and long-term effects are caused by accumulated stress?

- Photographing restrained or controlled animals. Is this ethical photography? Is a controlled animal a valid representative of its species? If so, what are acceptable conditions of confinement and treatment, and what ethical considerations govern publication of resulting images?

- Photographical correctness. Are animals properly portrayed or represented through our photography? Can we ethically emphasize certain behavioral traits and stereotypes?

- Exotic animals. Do photographs of exotic animals create greater demand for access to such creatures and so encourage unwise or excessive breeding for profit? What happens to such animals when they outgrow their cuteness or controllability?

Truth in photography. The adage, "pictures don't lie," has never been true! The photographer's choice of subject, lens, angle, and light have conveyed only the photographer's truth. Indeed, this editorializing is not restricted to camera users. Illustrators and artists have always had the opportunity to render natural subjects in representative or imaginary settings and attitudes. We used their often

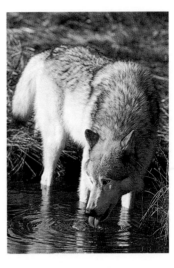

blatantly fanciful drawings to identify and appreciate nature until color photography became the norm. Because it provided a more detailed rendition and captured a "real" moment, photography was considered to be more truthful. Digital manipulation changed that. Now universally available techniques and tools that alter photographs in virtually undetectable ways have cast doubt on the "truthfulness" of every image.

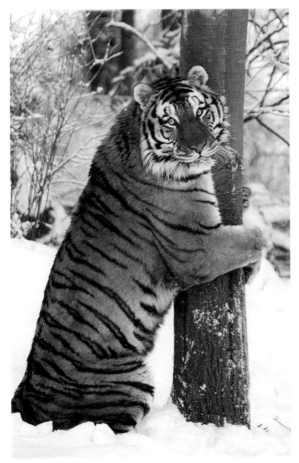

So if you finally get your ultimate nature photograph, will anyone believe it? We've lost our ability to accept that really fine photography can be achieved without after-the-fact computer assistance. While we regret this lost innocence, we need to embrace the advancements that digitalization of images offers. New tools can, in fact, free us from the restrictions of camera and lens and may improve the

WHO'S AFRAID OF THE BIG BAD WOLF?
For years, wolves were artistically and photographically presented only as vicious and aggressive predators and a serious danger to man. The persona of the big bad wolf of fairy tale fame was perpetuated in modern representations of "wolfness." Only recently has the work of biologists and photographers been used to dispel the myth and emphasize the biological truths. Wolves are a necessary predator in the scheme of healthy wild animal populations, and they have no substantiated history of aggression toward humans. How nature photographers portray their animal subjects is a critical ethical question which should be resolved on the basis of accurate biological knowledge.

Pure-bred Siberian tigers are rare in the wild and uncommon in captivity. Publishers often use photographs of captive animals to illustrate articles on a particular species that can't be safely photographed in the wild. Increasingly, the caption for such a photo illustration will acknowledge that the subject is captive.

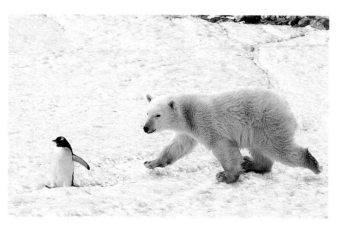

accuracy of our photography by eliminating the technical limitations that obstructed truth.

For example, when it is impossible to expose properly and focus both the foreground and background of a scene so as to duplicate accurately its existence in nature, we now might take two images and merge the clearest aspects of each into one finished computer-generated photograph that is, in fact, a truer depiction of reality. Computer digitalization also might be entirely acceptable when its use is obvious and intended to produce a humorous, creative, or illustrative result. The problem is when computers are used to create or modify images so as to mislead or misinform the viewer. Most often this occurs less from malice than from ignorance, such as when penguins are placed with polar bears in the same image. In reality, they live poles apart. But the cumulative effect of small errors can be devastating, because it breeds distrust of the photographic medium.

Nature Photography Tomorrow

No matter how intensively you engage in nature photography, you have many opportunities to participate in its evolution. Whether it is your art, craft, sport, or livelihood, the new technologies can enhance your enjoyment of nature photography. Photography can be a form of activism, the means by which you express your involvement in the protection and advancement of natural areas and subjects. In the course of your photographic activities—selecting equipment, researching subjects, accessing areas, interacting with natural subjects and their caretakers, and sharing your work—you are affecting the future of the natural world.

As photographers and lovers of nature, we face the daunting challenges of limited public resources, of diminishing wildlands, and of the prolific reproductive potential of our own species. But scientific discovery, environmental sensitivity, and new technology can help us to participate in, influence, and bear witness to our changing world. Be active and aware in your photographic pursuit of nature: Few endeavors hold so much promise for good.

Polar bears stalking penguins? They don't even inhabit the same hemisphere! Truth in imaging is up to the photographer and the artist. Wildlife artists have long been able to put an animal in any background, but the best results have been accurate portrayals. Now photographers, with their new after-image tools, must face the same questions when they create illustrations from their photographs. This is a composite of two images, one taken in Antarctica and the other in Manitoba, Canada.

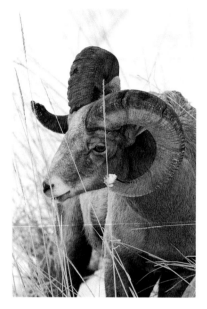

How close is too close? Each animal and situation is different. Rules that say ten feet or a hundred yards in every case are unrealistic. This bighorn ram grazed the grasses to within a few feet of the photographer because it was habituated to humans in a national park where it is protected from hunting and harassment. The park rules state that people must keep a 75-foot distance from all large mammals. Was the photographer wrong to quietly maintain his position as the animal approached?

AQUARIUMS

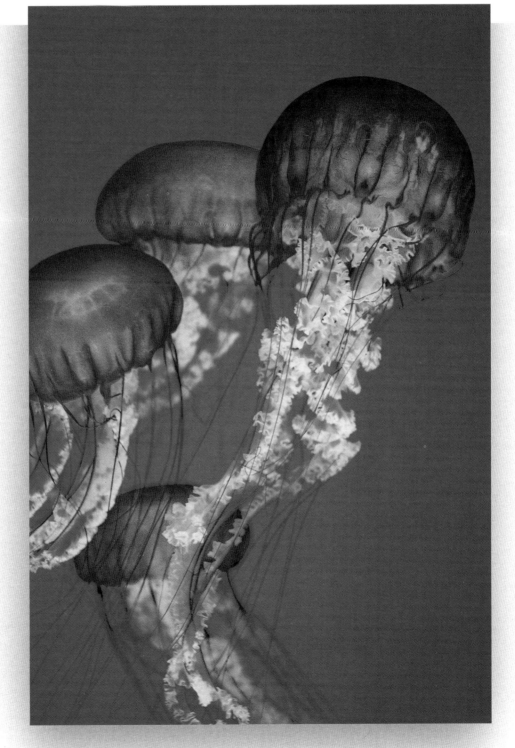

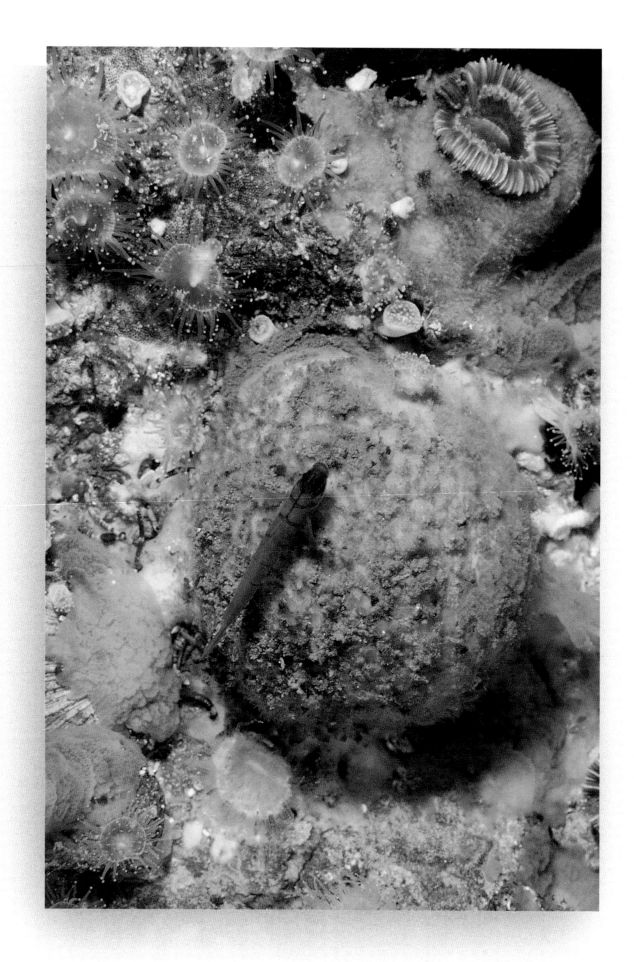

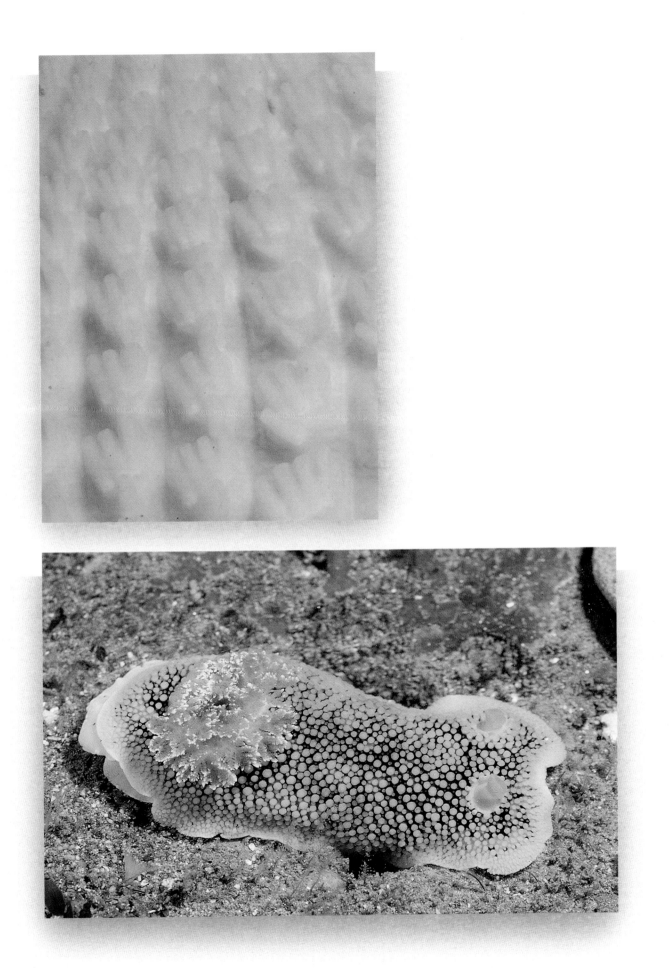

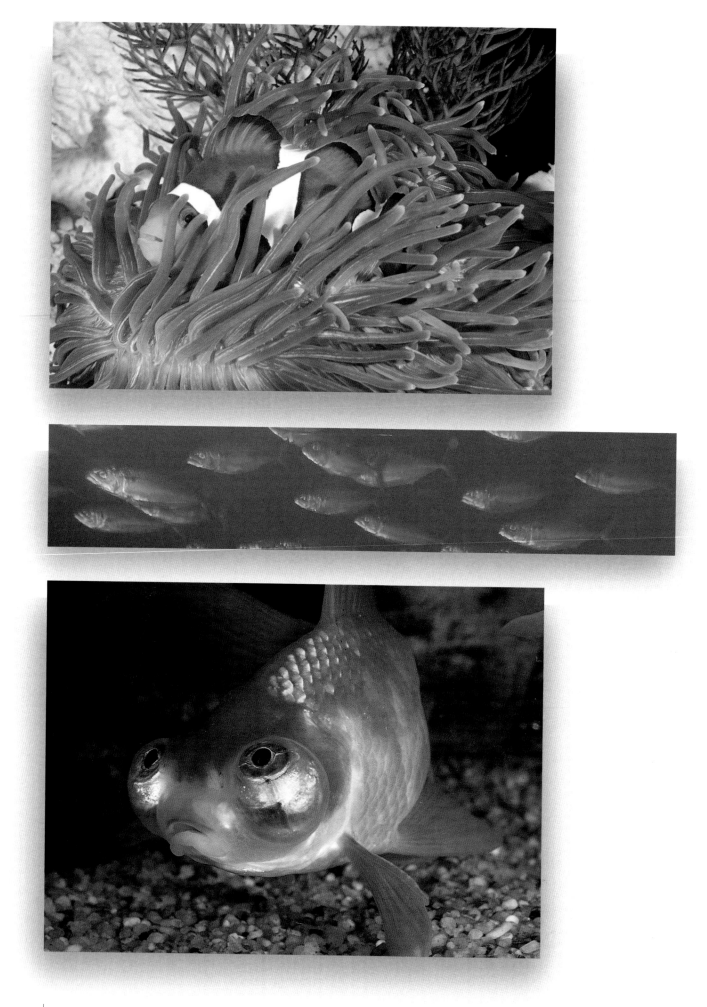

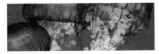

Sea Nettles. Monterey Bay Aquarium, California. These stunning jellyfish are displayed in a large tank fitted with lighting and background colors that emphasize the animals' beauty. Only the ambient light can be used to photograph them, because flash photography would alter the color and mood. The animals move very slowly through the dimly lit tank, and this presents a host of photographic problems. A slow shutter speed will give a well-lit, blurred subject, and a fast film won't hold the color and clarity of the scene. I determined that 1/30 second at f/2.8 was the exposure necessary to stop the motion, then used and processed Kodak's E100SW Ektachrome film as if it were 500 ISO to yield this vivid and sharp result.

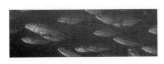

Pacific Mackerel. The deep tanks at public aquariums quickly absorb the color spectrum of your light source. Here the fish are dimly lit and carry a blue cast because they are more than ten feet from the wall of the tank. The reflective surface of the scales and the monochromatic blue gives the image a deep ocean ambience. A 50mm macro lens with two flashes on a Lepp Macro Bracket II™ were used on Fujichrome 100 ISO slide film.

Pacific Coast Habitat. A medium-sized tank at the Monterey Bay Aquarium offers an image of a complete underwater habitat. To light the larger area requires at least two flash units, and preferably a third to the side or above the camera. The increased light brings out the brilliant colors in the coral, anemones, and fish. A 28-105mm zoom set at 28mm, and two flash units on a Lepp Macro Bracket II™ were used with Fujichrome Velvia film.

Speckled Sea Lemon Nudibranch. The only way to photograph the fine details of these tiny, beautiful mollusks is to place them in a tank next to the tide pool from which they are collected. Even finding the specimens in the slippery tidal area is a challenge, with waves sneaking in behind and the clock ticking toward the returning tide. Two electronic flashes and a 50mm macro lens were used to bring out the color and forms.

Bubble-eyed Goldfish. The home aquarium offers almost complete control when photographing small subjects. They can't wander far, the lighting is easier with a small tank, and everything needed is close at hand. A 50mm macro lens along with two electronic flash units were used on Fujichrome Velvia film.

Clown Fish Peering from Anemone. Sarasota, Florida. Cruising from tank to tank and carrying a camera and the Lepp Macro Bracket II™ I found this colorful fish in a small aquarium. With TTL flash exposure and two light sources, it was easy to catch the scene on film.

Bat Star Feet. Central California Coast. A shallow tank setup next to this bat star's tidepool home allowed me to take macro photographs of its tube feet. The result is a design photograph that documents the intricate patterns of a starfish's means of locomotion.

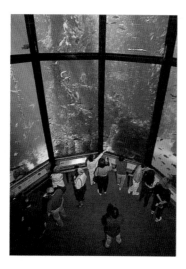

\mathcal{A}QUARIUMS

Many people think of underwater photography as the domain of intrepid explorers like Jacques Cousteau. The deeper the water, we think, the more profound the mysteries of the aquatic world—all the more fascinating because of their inaccessibility to the land-bound. But some underwater enigmas are readily uncovered without entering the underwater world. The residents of vast unseen underwater environments are brought to eye level within huge public aquariums.

Bringing such subjects into close range allows us to observe their private moments and photograph their natural behavior without danger to them or to us. This is possible because new exhibition technologies, readily available at zoos and large aquariums around the country, provide opportunities for photography that have never been available before. The big, beautiful aquariums offer modern facilities and healthy specimens. They are first-rate sites for continuing research on aquatic animals. Some of the better-known public aquariums are California's Monterey Bay Aquarium, the San Francisco Steinhart, Sea World of San Diego and Orlando, Chicago's Shedd Aquarium, the Seattle Aquarium, and Boston's New England Aquarium.

If you would rather work outdoors, explore the rich and diverse tidepools of saltwater coasts. They harbor an incredible variety of fishes and invertebrates, with shapes and colors to challenge any photographer's creative senses. You won't need a huge tank to hold your tidepool subjects; miniature photographic stages can be created with small aquariums placed near tidepools to temporarily showcase petite aquatic creatures.

Small aquariums maintained in private homes and pet shops also can provide productive opportunities for "underwater" photography of extremely small fishes, mollusks, and frogs. All aquarium photography presents challenges for

At public aquariums we can explore the sea floor without getting wet. This dramatic kelp forest is at the Monterey Bay Aquarium in California.

Once you find a good subject, it makes sense to photograph it from many perspectives. This lion fish was thoroughly photographed; close study yielded several very different compositions. A 100mm macro lens was used with three flashes–two attached to the camera and one to the side on a Lite-Link.™

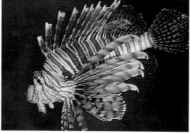
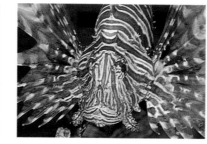

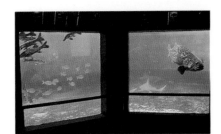

shooting through glass and getting adequate light through the water, but the resulting images will offer unique perspectives on the residents of the undersea territories.

Large Aquariums

The huge tanks at the large public aquariums hold examples of complete underwater ecosystems, such as coastal kelp beds or deep-water environments. This offers an opportunity to photograph large schools of pelagic fish, marine mammals, and denizens of the deep such as sharks, rays, and barracuda. Some feature aquatic mammals such as beavers and otters, and diving birds such as penguins and ducks.

The major problems encountered in photographing residents of large aquariums are dealing with reflections and distortions within the thick Plexiglas window and getting enough light out into the water.

Shooting through Plexiglas. Plexiglas, for all its benefits, offers many challenges to photographers. You can't shoot through scratched or dirty glass, so look for clean, unmarred areas. Any attempt to photograph at an angle through thick Plexiglas will result in major distortion and unsharp images.

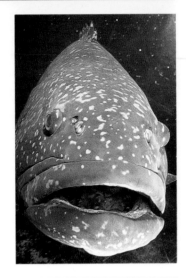

This huge (500 pounds) jewfish was on display at a small public aquarium in Florida. A wide-angle lens placed against the tank glass got the whole fish in the frame.

In order to eliminate unwanted reflections from both the light source and extraneous lights behind you, the camera lens surface must be positioned parallel to the Plexiglas. Don't let them touch each other unless you have a rubber-ringed lens hood on the front of your lens. Otherwise, you may be responsible for further defacing the surface of the Plexiglas.

To protect the residents from finger-tapping viewers, the managers of a few aquariums have installed double layers of Plexiglas, separated by an air space. If you encounter this design, enjoy watching the animals within, but forget photography. The reflections from the second layer of Plexiglas are almost impossible to eliminate.

Lighting the subject. Most large aquariums do not have sufficient ambient light penetrating from the surface to allow adequately lit photography. Electronic flash is necessary in these circumstances in order to stop the animal's movement and get sharp results. As light penetrates water, there is a tremendous loss of color. Within a few feet, nearly all red and yellow band-widths of light are absorbed. The result is a predominance of blue in most underwater photographs, even when using electronic flash.

Photograph only subjects that are fairly close to you; don't expect light from your flash to travel very far into the tank. Even though a simple on-camera flash, with the camera positioned against the glass, could work adequately, the best system for photographing into large tanks is two flashes positioned on a bracket system at least six inches away from either side of the camera. An even better

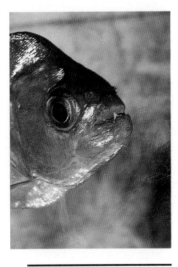

Close-ups taken with small apertures near the tank wall are likely to record scratches and prints on the Plexiglas. Fingerprints on this piranha tank showed up in the image. To solve this problem, clean or avoid dirty areas, and stay as close as possible to the plex.

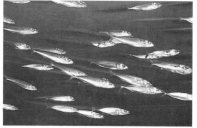

Some tanks have great background color, but the long exposure necessary to record the color shows only streaks of the moving subjects (top photo). The solution is to use the slow shutter speed for the background, and fire the flashes at the end of the exposure to record the fish sharply (lower photo).
A 50mm lens and two flashes caught these mackerel.

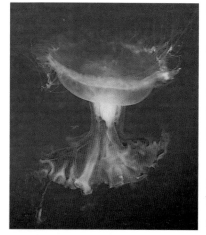

This egg yolk jelly fish was photographed using a simple technique. The marginal ambient light in the tank was enough when Kodak Ektachrome E100SW film was pushed to 400 ISO.
A 50mm macro lens was set at f/4 with a shutter speed of 1/30 second to stop the motion of the subject.

arrangement is to add an assistant to hold a third light, attached to a cordless standard slave or Lite-Link,™ to help illuminate the subject in the tank from yet another direction. The flashes must be portable hotshoe types of medium-to-powerful range. Exposure into the tank is most reliably determined by using the automatic TTL flash-metering capabilities of your camera. Because you will be photographing among many other people, your setup needs to be compact enough that it will not interfere with others' enjoyment of the facility.

In some cases the aquarium will be designed with interior lights to create a particular atmosphere. Using electronic flash in these circumstances will destroy the ambience, so use film with a faster ISO or plan to push-process a slower ISO film. If allowed by the facility, use a tripod and take care not to obstruct traffic areas with it. (To get enough room, it may be necessary to ask permission to

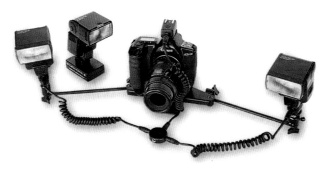

This is the ultimate large aquarium camera and flash setup: two TTL flashes out to the sides and a third TTL flash that can be placed without cords using a Lite-Link. Lenses from 100mm macro to 17-35mm wide-angle zooms are employed, depending on the subject and the tank.

photograph after hours. A fee may be required.) A final challenge will be to maintain a shutter speed sufficient to stop the movement of the dimly lit subjects.

Aquariums for Tidepool Specimens

Tidepool subjects can be photographed in place or in a simulated environment which the photographer creates with an aquarium. In either case, certain protective measures must be taken, because the residents of shallow waters are among the world's most fragile creatures.

Inter-tidal zones are simultaneously robust and fragile. They withstand incredible pressures and poundings from wave action, yet the focused weight of a human being can destroy some areas. A bed of beautiful, flower-like anemones actually requires the continuous movement of water to bring them food, but many can be killed in the path of a person walking through their domain. Plan your movement around tidepools to step on non-living strata whenever possible.

Animals that live in inter-tidal areas occupy very particular niches in their environment. They have developed and become established in that place which provides the quality, temperature, and abundance of water they require for survival. Removal will likely lead to the animal's demise unless great care is taken to maintain the conditions of its specific habitat and to return it to the precise location from which it was taken.

Before you remove a subject from a tidepool, prepare the place where you plan to accomplish your photography. As discussed below, equip an aquarium with substrata and ocean water taken from near the original site. The actual removal of the animal is very important. If it retreats from you into a hole, wait until it comes out rather than digging in after it. A sea star can be removed safely by snatching it up quickly, before it has a chance to adhere itself to a rock. But even if it resists, a gentle, patient pressure usually will induce it to release itself. Forcing a reluctant sea star to leave its place can result in damage to the tube feet that run along its arms. Crabs and other creatures that hide under rocks and in crannies may be difficult to collect. Blind attempts to dislodge them may hurt them, or you.

Protect your equipment. The powerful elements of sun, sand, and water demand extra care for your cameras, lenses, and photographic equipment. Be aware of rising tides and wave action, and put your equipment safely out of range. When working, be sure that your equipment is securely placed where it won't roll or fall into the water, and don't turn your back on the ocean. Constant vigilance will protect you and your gear from rogue waves as well as gradually rising tides.

The transference of moisture from your hands and clothing can cause permanent damage to your lenses and electronic flashes. Carry a towel, and keep it dry. Salt increases the corrosive effect of moisture on your gear; clean it frequently. Beaches add blowing sand and grit which can cause havoc with the mechanics of the equipment. Sealable, heavy-duty plastic bags are good containers for equipment not in use.

At the end of each photographic session, thoroughly clean all equipment. Use a slightly damp clean cloth on the exterior surfaces if you've been in salty or dusty conditions. Wipe or blow all camera and lens surfaces free of moisture and debris; get underneath dials and into seams. Clean the interior of the camera with a stream of air; be especially careful not to damage the fragile shutter blades.

Preparing the tank. A small aquarium is perfect to house tidepool subjects and their natural surroundings for photographic sessions. The aquarium's specifications will depend upon the subjects you intend to photograph; it should not be much larger than needed to accommodate your subject and some natural substrata and background. The point is to limit the animal's range and to minimize the amount of water between the camera and the subject, while keeping the subject far enough

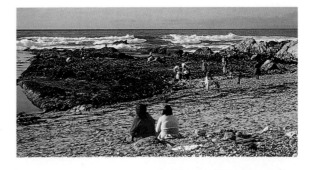

Tidepools, such as this one along the California coast, are microcosms of sea life that make excellent subjects. Many times, however, it is possible to accomplish close-up photography of tide-pool subjects only by temporarily placing them in a small tank set up nearby.

Remove subjects from tidepools carefully. Pulling a sea star from the rocks can damage its tube feet. Always return the subject to the same place where it was collected; involuntary relocation can be fatal to tidepool residents.

The small tank is placed next to the tidepool and prepared with natural substrata taken from the subject's location. The tank allows the photographer to achieve an image that appears to be taken from the bottom of the tidepool.

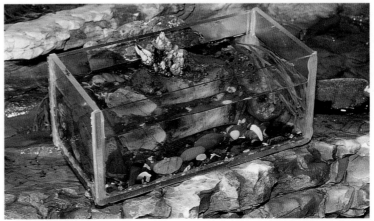

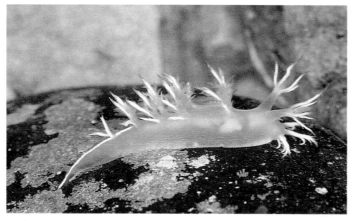

This white dendronotid nudi-branch, only an inch in length, was collected along with some rocks from a tidepool and placed in a small tank. With two TTL flashes and the ambient light, a macro studio portrait was possible.

To secure images of a small smelt that inhabits the Stikine River in Alaska, the river bottom was replicated in an aquarium that temporarily hosted the fish. The photographer waited for a moment when the fish came close to the front of the tank where they could be photographed. A 50mm macro lens and two TTL flashes on a bracket got the shot. The black cloth held behind the photographer eliminated any reflections in the glass.

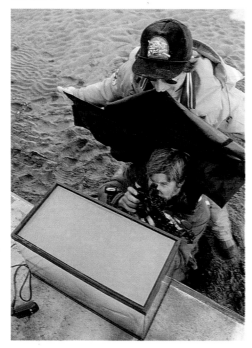

away from the glass to keep surface flaws out of the picture. For example, an aquarium suitable for nudi-branchs and small shrimp is approximately 2″ wide, 8″ long, and 8″ high. Precise positioning of the subject in a larger tank can be accomplished by using a movable glass partition which will disappear in the water. The tank can be constructed primarily of Plexiglas, but glass is best for the front panel. Plexiglas glues together quickly with proper solvents, while the glass is set in place with silicon caulking. Be sure to allow the silicon to cure before using the tank, since its fumes can be harmful to your subjects.

Prepare the tank for photography with a substrata and background material that match the subject's natural setting. Some of the material used to provide background can be placed behind and outside of the aquarium. Choose background materials that are not only appropriate and supportive of the subject, but that also are neutral in terms of exposure. A white background may cause flare back into the camera lens, while a dark background may cause overexposure of a small subject.

Add clean saltwater taken from near the subject's position. If there is an excessive amount of fine debris in the water, the flash will cause light scatter, so you may need to allow some time for the particles in the water to settle before you begin to photograph. When all is ready, clean the front of the tank carefully and make sure it's dry. Be alert to the potential for overheating the water in the small tank while you're waiting for other conditions to become optimum. The direct sun on the tank will be detrimental to the subject and will cause small bubbles to form on the subject and its surroundings.

Photographic techniques. The 50-105mm macro lenses are preferable for small aquarium subjects. Consider placing the tank on a ledge or other support that will allow you to position the camera at apparent ground level to the animal. This enables interesting angles of approach and viewpoints, and access to both full-frame animals and ultra close-ups of details.

Either a single light removed from the camera or a two-flash system positioned away from the lens at an approximate 45-degree angle to the

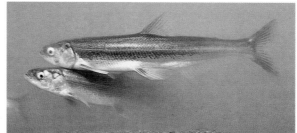

subject can be used to solve problems of reflection, light absorption, need for depth of field, color rendition, and camera

movement. The single flash maintains its TTL capability and can be maintained at the desired distance through the use of TTL cords available from the camera manufacturer. A single flash works reasonably well if you can tolerate the contrast caused by the concentration of light coming from a single direction. Some light will fill on the opposite side due to diffusion and reflections from nearby objects.

When the camera and flashes are held away from the tank, the flashes will be recorded in the glass. Hold the lens against the surface of the glass. A rubber lens hood will eliminate reflections and keep the lens from scratching the tank's surface.

A two-flash lighting system has the advantage of controlling contrast and increasing the amount of light available, providing more depth of field and a faster flash duration for hand-holding. The disadvantages of the two-flash system are their size, weight, complexity, and cost.

Subjects that are too small to inform the TTL flash sensor will be disregarded in automatic exposure calculations; instead, the camera will expose for the background, which may be of a different value. The result may be a grossly over- or under-exposed subject. Be aware of this common problem and be sure that subjects are large enough in the frame to be detected by the TTL flash sensors.

With the very fast flash duration accompanying large flashes close to a small subject, there can be a problem with the film not properly recording the full amount of light. The resulting underexposure is called reciprocity failure. A simple solution is to bracket flash exposures toward the overexposure side when working close to subjects with flashes in a macro setting.

Return your specimens. Be absolutely sure to return your tidepool subjects to the exact location from which you took them.

Home Aquariums

Aquariums located in homes and pet shops offer a comfortable and controllable environment for close-up underwater photography, from 1/10 to 4 times life size. Popular subjects include very colorful small fish, amphibians, invertebrates, and plants.

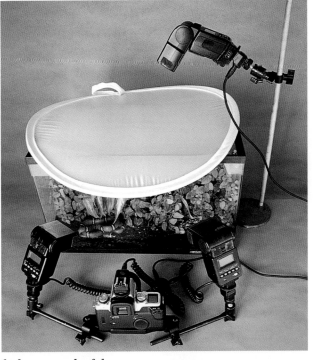

Lighting for photographing subjects in a small home terrarium is similar to that of aquariums and larger tanks. An advantage to home terrarium and aquariums is that a light can be placed over the tank to simulate natural light penetrating from above. A diffusion disc was used in the example above to soften the upper flash.

Lighting. Subjects photographed in aquariums are nearly always lit with flash because of the high intensity of light needed for additional depth of field and the quick flash duration required to stop the movement of the subject. Continuous, incandescent light sources should not be used because they are not of sufficient power to enable fast shutter speeds or the necessary depth of field, and they may heat the water in small aquariums to the point where it causes injury to fragile plants and animals. Use two, or even three light sources to control the contrast in

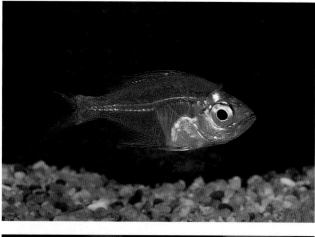

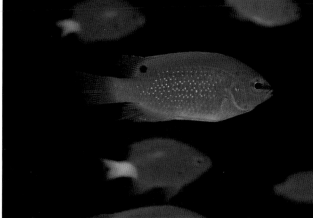

The small fish in your home aquarium can be interesting subjects, like these examples of a freshwater glass fish (top) and blue damselfish (bottom) in a marine (saltwater) aquarium.

These examples of an endangered desert pupfish were on display in an aquarium at Anza-Borrego Desert Park. Using a simple two-flash bracket with the flashes out to the sides yielded an image that would have been impossible to capture in the field.

the image and maintain the subject's natural look. Use a bracket system to light the subject from the sides of the camera. When possible add a slaved flash unit to light from above, to highlight the background, or to give backlight to the subject.

Techniques. Many of the methods and considerations applicable to the small field aquarium apply to home tanks. This is your opportunity to experiment with fine macro lenses or lens accessories that allow close focus with your existing optics. Watch for suspended particles of plant matter or other debris, because these will scatter light back towards the lens if a flash is located adjacent to the camera. The bubbles that adhere to surfaces in the aquarium are caused by static electricity and the warming of the water. Use a net to nudge them loose. Maintaining cool temperatures discourages bubble formation.

Gone Fishing

Photographing aquarium subjects is the best way to catch great fish without getting wet or baiting a hook! You can position yourself to photograph subjects that are otherwise very difficult to capture, and you can bring back photographs that rival underwater images in their vivid portrayal of aquatic subjects in natural settings.

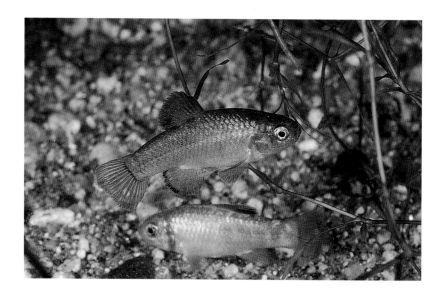

TELE-EXTENDERS FOR MACRO AND TELEPHOTO PHOTOGRAPHY

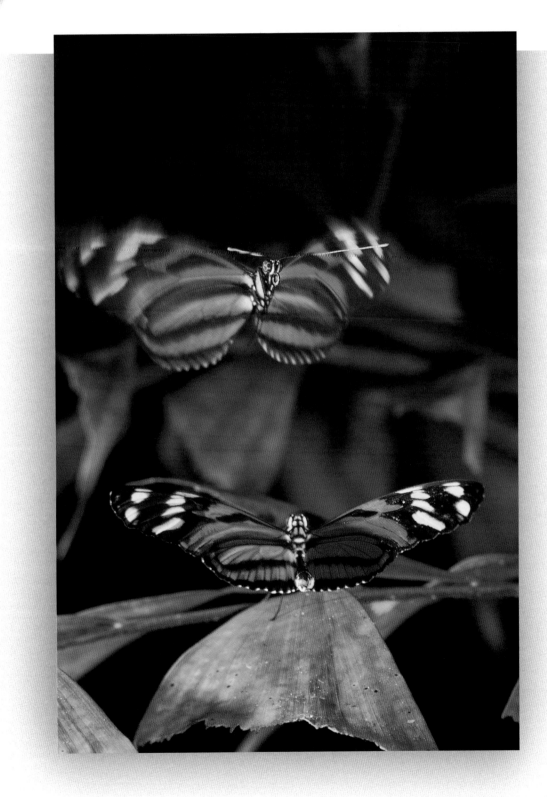

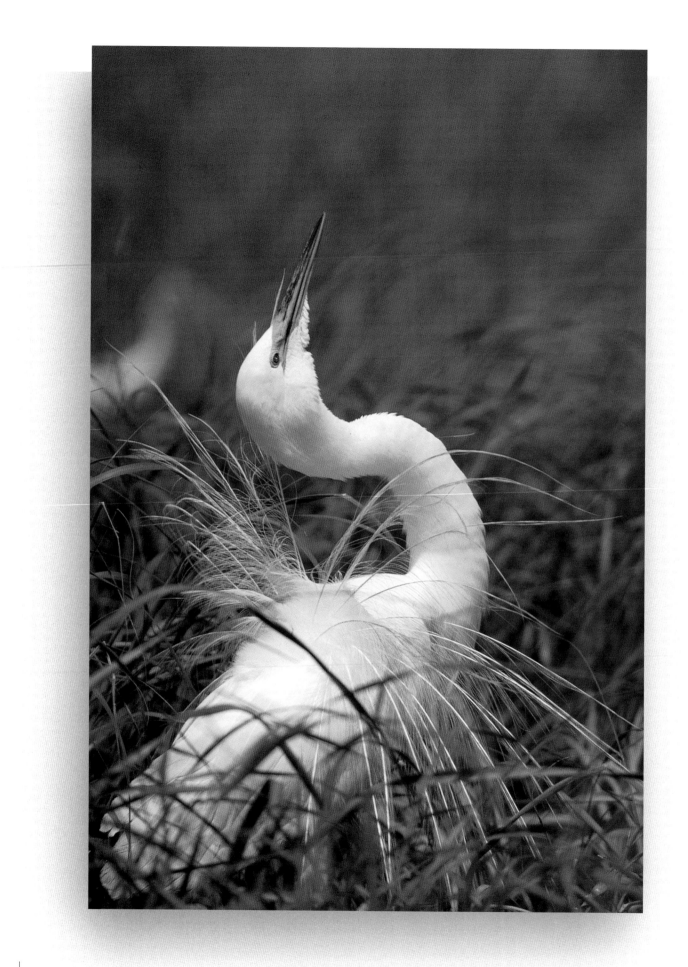

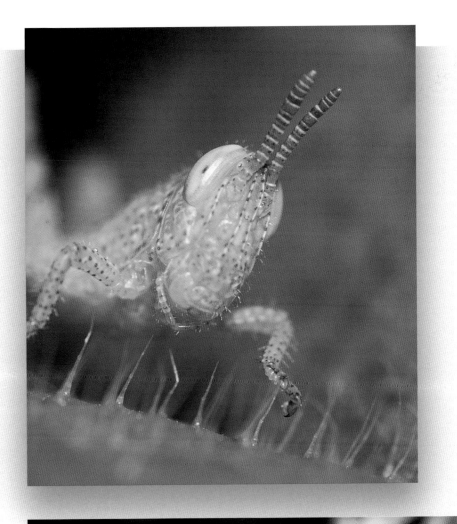

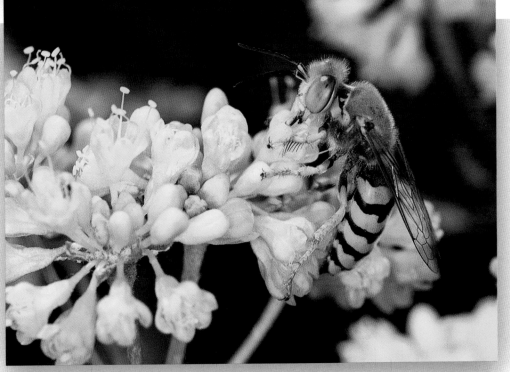

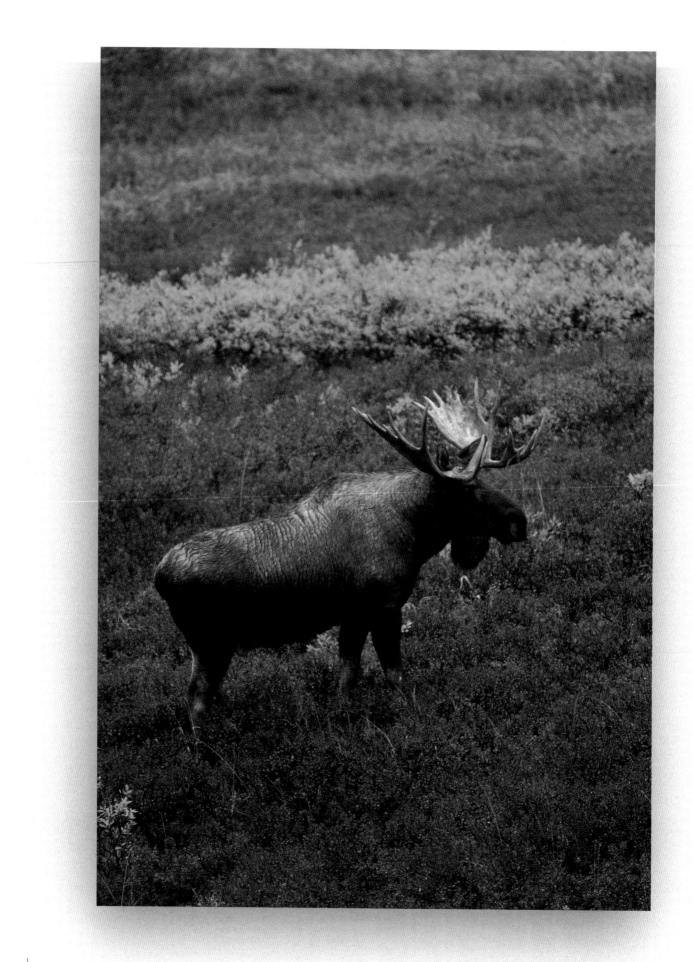

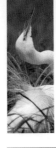

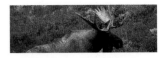

Courtship of Heliconia Butterflies. Butterfly World, Florida. A 90mm tilt-shift lens with a 2X tele-extender provided 180mm while helping the photographer to stay back out of the action. One on-camera flash and a second held by an assistant from behind and to the side of the camera lit the subjects and the background.

Egret in Courtship Display. Southwestern Louisiana. A 600mm f/4 telephoto lens was not sufficient to frame properly this egret, located some distance away from a fixed blind. Adding a 1.4X tele-extender increased the focal length to 840mm, plenty of magnification to achieve tight framing.

Wasp on Sulphur Flower (Buckwheat). Mono Lake, California. A 1.4X tele-extender attached to a 200mm macro lens gives the added working distance and 1.4X magnification desirable for working around wasps and other flighty subjects.

Grasshopper Nymph. Central California. A 100mm macro lens is enough to photograph an adult grasshopper, but this little nymph needed greater magnification. This photograph was achieved by using a 12mm extension tube to mate a Canon EF 2X tele-extender with a Canon EF 100mm macro lens. The resulting more than 2X magnification was achieved with the same working distance of the original 100mm lens.

Moose with Fall Head Gear. Denali National Park, Alaska. Common sense dictates that you don't approach large mammals in rutting season. From the safety of Denali Road, a 600mm lens with a 1.4X tele-extender brought this magnificent specimen close enough for meaningful photography.

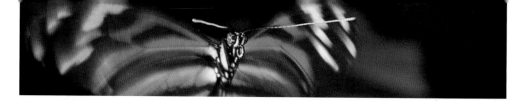

TELE-EXTENDERS FOR MACRO AND TELEPHOTO PHOTOGRAPHY

Tele-extenders are excellent tools for increasing image size without getting closer to the subject. They are particularly useful with telephoto lenses for outdoor subjects, and they can provide significantly greater image magnification in macro. Thus, tele-extenders can help you to fill the frame with your subject, whether it is a moose from 100 yards or a butterfly just a foot away. Some manufacturers call these image modifiers "tele-converters;" but because they extend the focal length of the lens, the more descriptive term, "tele-extenders," will be used throughout this book.

The first tele-extender was developed by Peter Barlow in the 1830s for use by astronomers. It was a simple negative lens added behind the prime telescope lens to amplify the image. The Barlow lens subsequently was adapted for use by photographers, but these early tele-extenders used only two or three lens elements and produced poor-quality images. The development of true telephoto lenses in the early 1900s diverted attention from the Barlow lenses, which disappeared from the market until the late 1950s, when the Barlow concept was re-introduced by several Japanese lens manufacturers to extend telephoto lens capabilities inexpensively. Their simple three-element design still did not render high-quality images, but subsequent advances in lens design have been applied to tele-extenders as well. With improved optical glass and computer-aided designs, 1.4X, 1.5X and 2X tele-extenders now are available in units specifically designed to complement a particular lens or group of lenses and in universal types that will fit nearly all focal lengths. What was once an inexpensive way to increase focal length has become an indispensable and efficient tool to bring outdoor photographers closer to their telephoto or macro subjects.

Types of Tele-extenders

There are three general types of tele-extenders. **Dedicated units** are optically designed for maximum efficiency with an individual or set of telephoto lenses. Examples are the Canon EF extenders, Minolta Maxxum's APO series, and Nikon's TC-14A, TC-14B, TC-201, and TC-301. Nikon has an even more specialized set of dedicated extenders that will work only with its AIS motorized autofocus telephotos. In many cases dedicated tele-extenders can be adapted for use with other lenses with excellent results.

Universal units, such as the Tamron and Kenko, are intended for use on a wide range of telephoto lenses. They may not produce as sharp an image as the dedicated extenders for working with long telephotos, but they hold their own when employed in a macro mode. Both the dedicated and universal extenders are available in 1.4X and 2X powers. The 2X is generally the most useful extender for macro photography because it gives a more worthwhile difference in magnification than the 1.4X units.

The universal tele-extenders come in several configurations that will affect the quality of the final image. A 2X converter that has four or five elements will be less expensive, but image quality will suffer compared to those having seven elements. The 1.4X and 1.5X converters have five optical elements and are similar to each other in construction and quality.

A third type, **the macro 2X tele-extender**, not only doubles the focal length but has a built-in helicoid extension tube to further increase the close-focus capability of the attached prime lens. The macro tele-extender is designed to convert a normal 50mm lens into a macro lens that can attain a life-size image (1X or 1:1) without any other accessories. The macro tele-extender will

Several examples of tele-extenders from various manufacturers are pictured. Dedicated units are matched to a specific series of lenses; universal units, made by accessory companies such as Kenko and Tamron, work with a variety of lenses; and macro tele-extenders work both as extension tubes and magnifiers.

The Canon EF 1.4X–Canon EF 2X tele-extenders shown here with the Canon EF 300mm f/2.8L telephoto lens—are examples of dedicated units. Dedicated units offer the best sharpness available for long telephotos.

The Tamron AF 1.4X tele-extender works with any camera/lens combination. Here a Nikon 105mm macro lens with an attached 1.4X tele-extender offers a magnification of 1.4X and still maintains its autofocus capabilities.

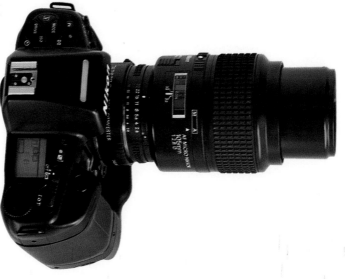

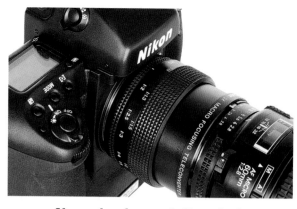

work with other lenses set for macro as well as telephoto photography. The Vivitar Macro-Focusing Teleconverter and Kenko's Macro Teleplus MC7 are examples of this 2X type. Both have seven elements in their construction to give excellent sharpness in macro photography.

If you already own dedicated tele-extenders intended for telephoto lenses, they can easily be adapted for macro use with excellent results. Usually all it takes to add a dedicated tele-extender to a non-dedicated lens is an extension tube between the extender and the lens. If your primary purpose is macro photography and you don't own any of the dedicated extenders, the universal units are good choices because they are considerably less expensive and will fit directly to your lenses. For several reasons, they give exceptionally good results for macro photography. While tele-extenders magnify optical flaws, the short-focal-length lens being extended will have fewer flaws than the long telephotos. Electronic flash will allow the lens to be used at its optimum aperture, a luxury not usually possible when

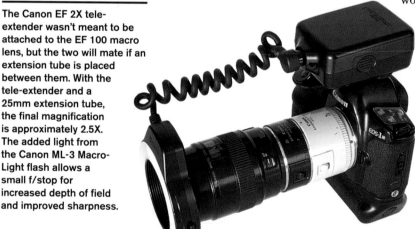

working with telephotos. The faster shutter speeds (flash duration) associated with electronic flash also tend to minimize image degradation from camera or subject movement. Most of the new universal tele-extenders are autofocus. This feature may not be important for macro photography, but it can greatly increase the lenses' usefulness when used for conventional photography with autofocus telephotos.

The 1.4X is most often used in long telephoto applications because it causes less image degradation and light reduction. The 2X extender is more useful for macro photography, especially where electronic flash is readily used. The high output of electronic flash easily compensates for the light lost due to the extender.

Using Tele-extenders for Macro

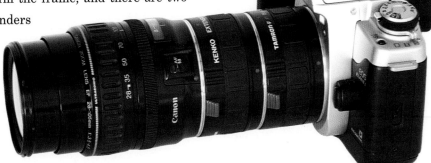

Macro is about making small subjects fill the frame, and there are two challenges to this objective that tele-extenders can help to overcome: making the subject bigger and giving the subject its space, either to keep from frightening it away, or to allow plenty of light to reach it. One way to achieve the enlargement is by getting closer to the subject, but a relatively inexpensive tele-extender (approximately $100) will achieve from 1.4X to 2X enlargement from the same distance. When more working distance is needed due to a flighty subject or to allow room for either ambient light or the photographer's flash to illuminate the subject, a tele-extender can achieve the original magnification from a greater distance. When attached to zoom lenses, a tele-extender can create a highly flexible zoom macro lens with variable magnification throughout the zoom range.

Macro can be achieved on a limited budget by combining an extension tube (36mm), a 2X tele-extender, and a mid-range zoom (28-105mm). This combination achieved a magnification of 1.4X without breaking the bank. Adding a short-duration electronic flash for lighting will increase sharpness and stop movement.

Lenses for Macro/Tele-extender Photography

Macro lenses afford a considerable amount of magnification without any additional accessories, but there are always times when more magnification or working distance is needed. The fact that 50mm and 100mm macro lenses already have the best resolution of any 35mm camera optics means that the addition of a 1.4X or 2X tele-extender will not significantly degrade the image. 2X tele-extenders can regularly be used with a 100mm macro lens to increase the maximum magnification from 1X to 2X. Dedicated, universal, and macro extenders all can be used with more than adequate results. Even Nikon has recommended the use of the 2X TC-301 tele-extender to attain 1X with the older non-AF Micro Nikkor 200mm. Because of the higher magnification and the resulting light loss when using macro lenses with tele-extenders, it is imperative that electronic flash be used.

Most single-focal-length lenses do not focus close enough to be used for macro photography, but with accessories they can be enabled to fill the frame with a macro image. The addition of two-element close-up lenses (diopters), extension tubes, or bellows will bring the lens into macro range. A 1.4X or 2X tele-extender is the finishing touch to obtain true macro imaging. For single-focal-length medium-to-telephoto lenses that already focus reasonably close, adding a tele-extender may give just enough image enlargement and perspective to carry off the photograph. For example, a 200mm lens that focuses to six feet may not produce a frame-filling image of a small flower, and the background may not be thrown as far out of focus as desired. Adding a 2X tele-extender and staying at the minimal

focus distance of six feet will double the flower's size in the image. The resulting 400mm lens will emphasize the subject's isolation and reduce the apparent depth of field to yield the in-focus flower in sharp contrast to the out-of-focus background.

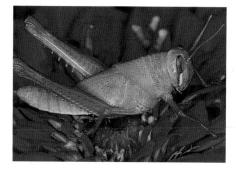
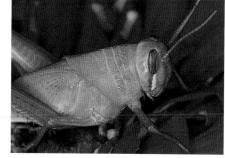

This series of grasshopper images starts at 1X. The 1.5X Kenko tele-extender brings the magnification to 1.5X (center), and a 2X tele-extender achieves 2X (right). The tele-extenders make these magnifications possible without reducing the working distance between the subject and the front of the lens. Electronic flash was used for all three images.

Zooms normally are not recommended for use with tele-extenders because their inherent optical deficiencies are magnified by the extender. Autofocus zooms don't perform reliably when coupled with extenders; they don't work well with any lens darker than f/5.6 with the extender added, and in some the necessary communications between the lens and the camera are not passed through the extender. However, for macro/close-up applications, when autofocus usually is not necessary and the lens is stopped down because of ample light from electronic flash, the performance of the camera/tele-extender/zoom lens combination can be excellent. In macro mode, most zoom lenses will provide .25X. The addition of a 2X tele-extender brings the image to .5X from the same distance. As a bonus, the resulting zoom-macro lens works with variable magnification throughout the zoom range, providing a broad array of compositional choices. An example of this useful combination would be a 70-210mm zoom with a 2X universal tele-extender between the camera and the lens. At the resulting longer focal lengths of up to 420mm, camera and subject movement will be significantly amplified; tripod, mirror lock-up, short flash duration, and other movement-reduction techniques should be employed.

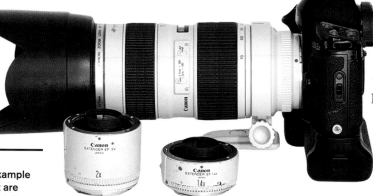

The Canon EF 70-200mm f/2.8L is an example of the new lenses that are designed to work with tele-extenders. The zoom range is extended to 98-280mm at f/4 with the 1.4X tele-extender, and to 140-400mm at f/5.6 with the 2X tele-extender attached.

Note that recent developments in zoom lenses that are actually designed to work with tele-extenders are changing some of these rules. The Canon EOS EF 70-200mm f/2.8L lens is one of the new zooms that adds considerable versatility when coupled to the EF 1.4X and EF 2X Canon tele-extenders.

Tilt/Shift Lenses and Tele-extenders

Tilt/shifts are single-focal-length lenses that afford extra efficiency in use of depth of field. By tilting the front elements of the lens, the normal slice of depth of field is tilted to extend along the plane of the subject, applying the available area of sharp focus to the subject more efficiently. The Canon EOS 90mm tilt/shift lens focuses to a close .30X magnification without any accessories. The addition of a 2X tele-extender (effectively a 180mm macro

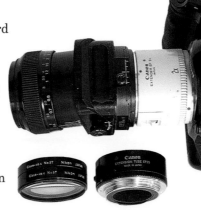

The Canon 90mm tilt/shift lens works exceptionally well with tele-extenders. The Canon EF extenders fit without intermediate tubes, and the result is either a 126mm or 180mm lens with tilt capabilities. The surface of this dahlia (below) is completely in focus because the tilt lens maximizes the efficient use of depth of field.

lens that focuses all the way to infinity) can achieve .6X magnification at close focus. With the addition of an EF 25mm extension tube and two-element close-up diopter, an incredible, bug-recording magnification of 2X can be achieved. This macro lens uses depth of field more efficiently than any other lens made.

Considerations for Quality Macro Images

Tele-extenders, unlike extension tubes and bellows, achieve their higher magnification by the use of additional optics. Each new piece of glass you place between the subject and the film has potential for degrading the image. The tele-extender may very well be the weakest link in the optical chain. Begin with the best lens you can buy, and always choose the highest-quality accessories possible.

Electronic flash is essential for most macro photography, especially when extra magnification is achieved with tele-extenders. It allows the use of smaller apertures, which maximizes sharpness from the center to the edges of the frame, and increases depth of field, a critical need in macro photography. Because the pulse of light from the flash is the primary light that records on the film, its duration overrides the camera's shutter speed in determining the length of exposure. The flash duration can be as brief as 1/30,000 second, a speed sufficient to eliminate subject and camera movement as degrading factors in the image.

A macro photograph of the surface of a sea star reveals details we usually don't notice. Flash is needed to compensate for the loss of light caused by magnification and the extender.

The flash or flashes used for macro photography give the photographer creative control of the illumination, and thus much of the appearance, of the subject. Evenly distributed light renders the subject in two dimensions, while light from one side or another can give shape and texture to even the smallest of subjects.

Not all macro photographs require electronic flash. Some soft effects can be obtained by using tripods and good photographic technique.

Using Tele-Extenders for Telephoto

We are never satisfied with the focal length of our lenses; we always want more telephoto magnification so that we can get that shot of a hummingbird at 300 yards. Of course, the cost of quality telephoto lenses increases exponentially with

increased focal length, and even more so with increased lens speed. And the weight of the longer and faster lenses nearly prohibits their use in the field for nature subjects unless the photographer has an exceptionally strong back. To varying degrees, utilizing quality tele-extenders can gain increased focal lengths with less cost, bulk, and weight. An added benefit is that tele-extenders maintain the same close-focusing distance as the prime lens to which they are attached, and some are able to maintain the lens/camera autofocus connections.

Prime telephoto lenses are even more versatile with the addition of tele-extenders. The 600mm f/4 becomes an 840mm f/5.6 with autofocus capability. Adding the 2X brings the focal length to 1200mm, but autofocus is lost.

Standard disadvantages apply: The addition of every lens element fore-shadows image degra-dation, and the loss of lens speed in f/stops is relative to the power of the tele-extender. The loss of image clarity varies with the prime lens being used and the type and power of the tele-extender attached. My optical tests have shown an approximate loss of image quality of 12% with 1.4X extenders and 20% when using 2X units. This quality loss includes both resolution and image contrast. The variance of loss from each of these types of extenders depends also on whether they were specifically intended for a lens or group of lenses; dedicated extenders are optimally designed to work efficiently with partner lenses and will almost always out-perform comparable universal types.

Recent improvements in tele-extender design greatly reduce the image degrada-tion caused by the extra glass. Five-element 1.4X extenders and seven-element 2X extenders typically correct focus from the center to the edges of the image; lower quality designs will show significant loss of clarity at the edges. Multi-spectral coatings facilitate light transmission through the numerous elements of the extender, which preserves color fidelity and eliminates as much flare as possible.

Extender/Lens Combinations

When using extremely long lenses, a 1.4X extender is a better choice than a 2X extender because it loses only one stop of light, and image integrity is better-maintained. For example, a 400mm f/5.6 with a 1.4X tele-extender gives an effec-tive 560mm lens at f/8. When using fast autofocus telephoto lenses, this may be the only combination that will maintain autofocus capabilities. The Canon EF 600 f/4L, when combined with the EF 1.4X tele-extender, maintains autofocus at 840mm and an effective f/stop of 5.6. But with the 2X at an effective 1200mm,

the lens will not autofocus due to its f/8 effective aperture. Autofocus lenses will typically become unreliable in their autofocus functions beyond f/5.6. Some manufacturers' lenses are programmed to bypass the autofocus when the aperture surpasses f/5.6. The Canon EF 500mm f/4.5, for example, has its autofocus disabled with the addition of the EF 1.4X extender because the effective aperture of the combination is f/6.3.

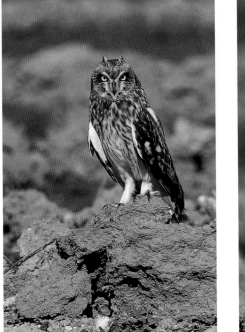 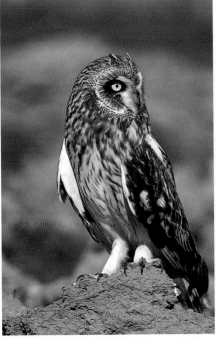 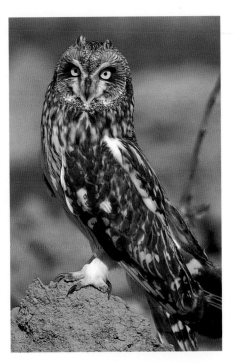

The autofocus 300mm f/2.8 lens, made by several manufacturers, is the best choice for use with the 2X tele-extender. The basic lens is usually of superb sharpness, and the fast speed can tolerate the 2-stop light loss while maintaining the manufacturer's autofocus. Each of the manufacturers offers both 1.4X and 2X tele-extenders designed specifically for this lens or lens group. The outdoor photographer, with this lens and the two extenders, has a very versatile set of optics: an extremely fast 300mm f/2.8 for low light conditions; a 420 f/4 for a medium telephoto that still is quite fast; and a 600mm f/5.6 for the long shots. All maintain the original autofocus capabilities. An added bonus for this combination is that all three lenses focus at a very close eight to ten feet, with very little additional weight and bulk. For this versatility, however, one can pay a very high price; the autofocus 300mm f/2.8s range in cost from a low of $2,500 to more than $4,000. The dedicated extenders vary in price from $100 to $400 each. Altogether, it's a hefty price for high-quality results; but if they were available, the three equivalent separate long lenses would cost far more.

For nature photographers on a budget, entering the long-lens arena is a significant step. Several combinations provide economical flexibility without unduly

This short-eared owl sat long enough to be photographed with a 600mm lens (left); with a 1.4X tele-extender added, giving 840mm (center); and with a 2X tele-extender at 1200mm (right). Conditions must be nearly perfect to obtain sharp images with a 1200mm lens because it magnifies not only the image, but also any movement on the part of the photographer or camera. From a vehicle, these images were photographed on Kodak E100SW slide film.

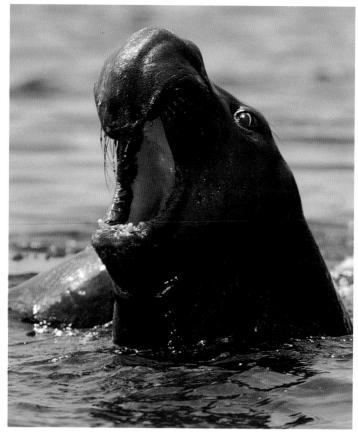

Several less-expensive 400mm telephoto lenses now approach the sharpness capabilities of the camera manufacturers' higher-priced lenses. This photograph of an elephant seal bull was accomplished with the Sigma 400mm f/5.6 APO Tele Macro with a Tamron 1.4X tele-extender (560mm at f/8).

compromising image quality. These are a 200mm f/2.8 combined with 1.4X or 2X universal extenders, effectively offering a 320mm f/4 and a 400mm f/5.6 of professional quality and extremely close focusing ability; a 300mm f/4 with 1.4 and/or 2X dedicated or universal extenders, providing a 420mm f/5.6 of professional quality and a 600mm f/8 of lesser but usable quality with properly applied long-lens techniques; and the less-expensive (Sigma APO and Tokina ATX-APO) and medium-priced (Nikon EDIF and Canon EF) 400mm f/5.6 with 1.4X dedicated or universal extenders, which effectively yield a 560mm f/8 long lens.

Mirror telephotos and zoom telephotos give less than professional results when used with even the 1.4X tele-extenders. While the mirror telephoto designs offer light weight, close focus, and reasonable sharpness for the price, their functions are significantly degraded by the addition of a tele-extender. The same is true for most zoom lenses. Image degradation and, more significantly, lack of light represent insurmountable problems when zoom lenses are combined with tele-extenders, especially the 2X. Possible exceptions are the very sharp and fast 80-200mm f/2.8 quality zoom lenses. Their autofocus may not be reliable with a tele-extender added, but in manual focus reasonable image quality can be achieved. An 80-200mm lens with a 1.4X extender gives a range of 112 to 320mm at f/4. My recommendation is to start with a prime (no extender added) 100-300mm quality zoom lens that maintains excellent autofocus even if the maximum aperture will probably be f/5.6.

Basic Telephoto Techniques

Careful telephoto technique is essential when working with long lens/tele-extender combinations; every flaw in equipment or technique will be magnified. Begin with the highest quality prime lens and extender available to you. Let the limiting factor be you, rather than the equipment.

Exercise every caution to eliminate camera movement. Long lenses and slow shutter speeds are not compatible due to the internal vibrations of the camera mirror coming to a quick halt just prior to exposure. Either lock up the mirror, if possible, or choose shutter speeds shorter or longer than the deadly 1/15 second, the speed at which sharp images are almost never obtained without mirror lockup. The addition of a cable release or a remote release will minimize any vibrations introduced by the photographer firing the camera.

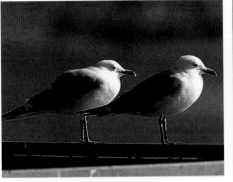 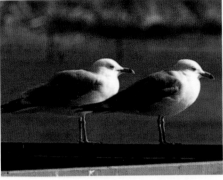 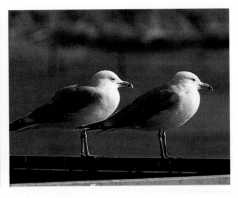

These ring-billed gulls were photographed at 840mm (600mm with a 1.4X tele-extender) at a shutter speed of 1/250 second. A heavy tripod and cable release were used to ensure excellent sharpness.

A shutter speed of 1/15 second causes vibration of the camera mirror that is nearly impossible to overcome, even with a heavy tripod and cable release. A faster shutter speed, a much slower shutter speed, or locking up the mirror will bring back the sharpness.

At a shutter speed of 1/15 second with the mirror locked up prior to exposure, the sharpness is as good as that achieved at 1/250 second—as long as the birds don't move! Avoid 1/15 second exposures when using telephotos unless you can lock up the camera mirror.

Invest in a sturdy, rigid tripod and a quality ball head to enable you to reduce camera movement and to make quick and smooth adjustments. Some recommended tripods include the Bogen 3021 and 3221, and the Gitzo 200 and 300 series. Ball heads vary in smoothness and weight-supporting ability; the very best money can buy are the Arca Swiss B-1, Kaiser Pro and Linhof Profi III. Many other ball heads may be adequate and less expensive but will not meet the standard set by these examples. The tripod and ball head may be almost as important as your camera and optic in obtaining professionally sharp results.

For extremely long lens/tele-extender combinations, it may be beneficial to invest in either the Bogen or Kirk accessory arm which supports the camera

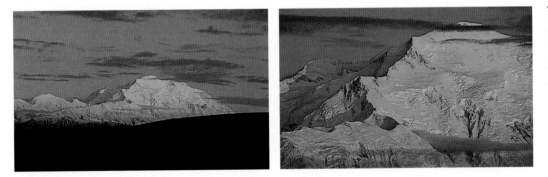

Mt. McKinley, Alaska, towards evening, taken from Camp Denali with a 600mm telephoto. For a more intimate view, a 2X tele-extender was added to achieve an optically extracting 1200mm, a magnification equivalent to a 20 power telescope.

separately from the lens with an arm extending from a tripod leg to the underside of the camera.

External and uncontrollable conditions such as air pollution, heat shimmer, and humidity can greatly affect image clarity. Reduce lens-to-subject distance when air quality is a concern, avoid photographing over warm ground surfaces where the air may be affected, and use fog and haze for effect.

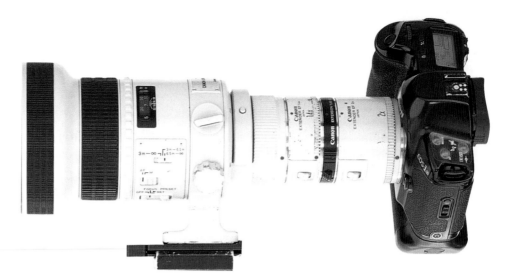

With some camera systems, two tele-extenders can be stacked for extreme magnifications. Here a Canon EF 300mm f/2.8L lens has both the 2X and 1.4X tele-extenders attached, with a 12mm extension tube between them. The resulting focal length is 840mm at f/8, and the lens still focuses to infinity.

Be Creative with Tele-extenders

Tele-extenders are incredibly versatile tools for both macro and long-lens photography and a worthwhile investment for serious photographers. They have many unconventional uses when imaginatively employed. If the combination works, regardless of the manufacturer's recommendations, it can be a viable answer to a photographic problem.

An example of the power of the two-extender combination, this image of a ladderbacked woodpecker on a blooming cardon cactus was captured in Baja California, Mexico. A sturdy tripod is a must for a sharp image like this one. Kodak E100SW film at f/8 with a shutter speed of 1/350 second.

FLYING BIRDS

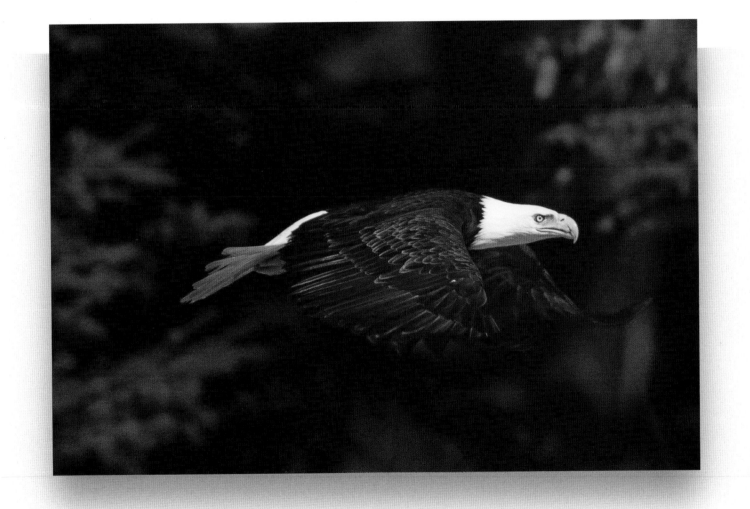

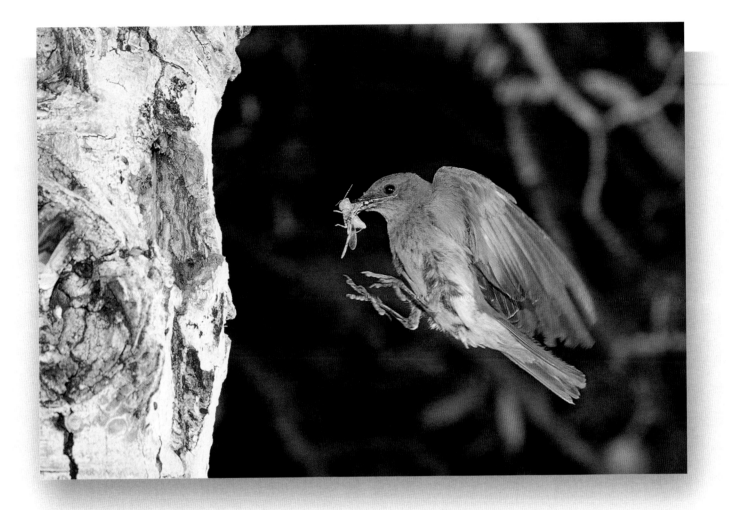

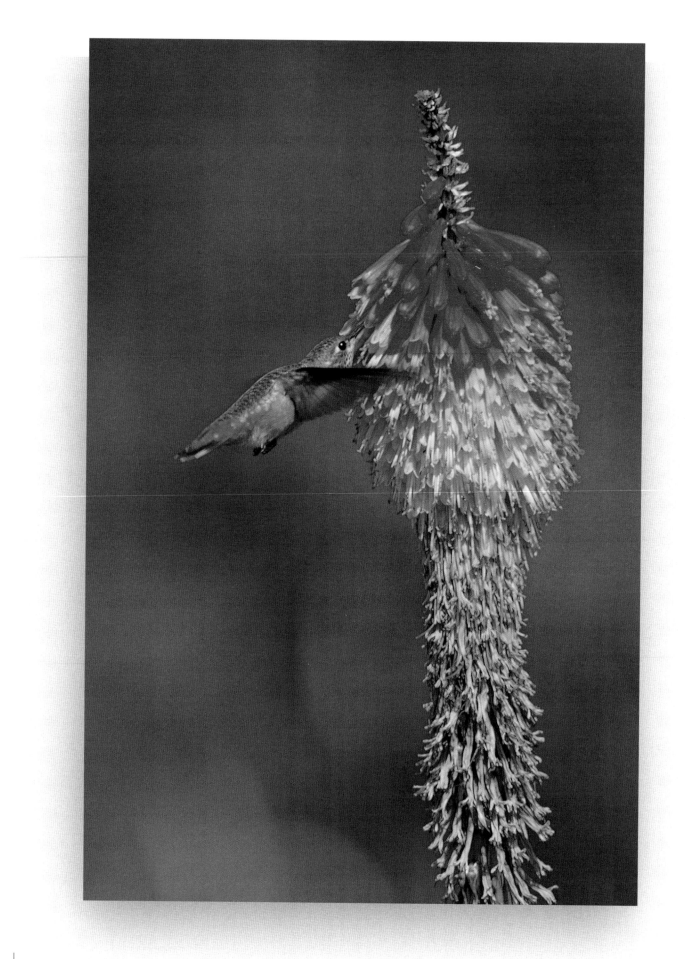

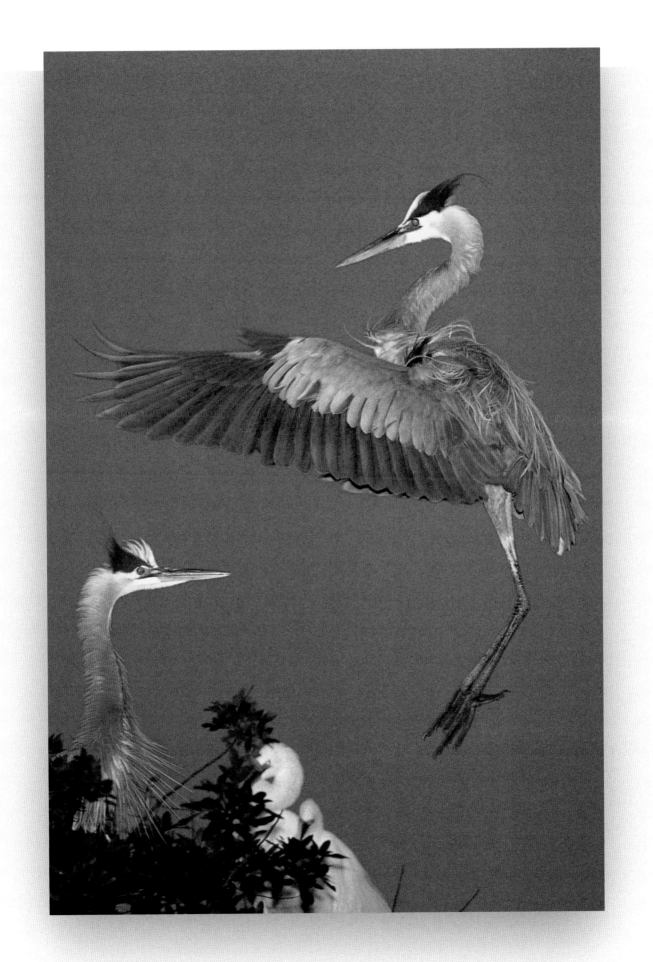

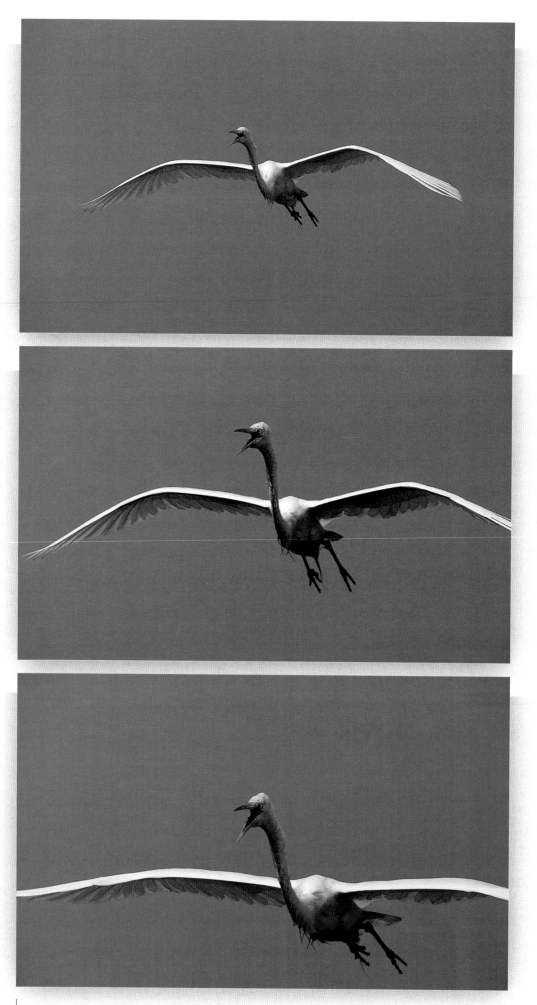

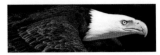

Bald Eagle. Southeast Alaska. In a quick jet boat piloted by an experienced guide, I was able to parallel bald eagles cruising the Stikine River. Traveling at the same speed as the eagle gave the opportunity for this unique vision that suggests motion with the background blurred and the eagle perfectly sharp. To eliminate the vibrations from the fast-moving boat, a gyro-stabilizer was attached to the 300mm lens with 1.4X teleconverter (420mm).

Sandhill Cranes. Denali National Park, Alaska. The fall migration of thousands of sandhill cranes sent wave after wave of the birds over the park for several days. To gain the altitude necessary to cross the Alaskan range, the cranes execute a complex spiraling flight pattern. Lying on a cushion of soft tundra, I pointed the camera straight up to record the swirling designs of the birds circling above.

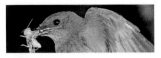

Bluebird in Mid-flight. Mono Lake, California. This bluebird was captured during one of its many flights to its nestlings in a tree cavity. Because of the predictability of the bird's approach, it was possible to focus multiple high-speed flashes in the flight path. The camera's rapid exposure rate enabled a series of photographs to be taken each time the bird flew in front of the flashes.

Hummingbird Nectaring at Aloe Vera (Red Hot Poker). Central California Coast. Hummingbirds are consistently drawn to this cluster of blooming plants, so it's easy to set up a long lens on a tripod. Exposing many frames will render a few with hummer, flower, and light in harmonious composition. The bright light and improved 100 ISO films enable fast shutter speeds to partially stop the hummingbird's wings.

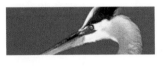

Great Blue Heron Entering a Nest. Venice, Florida. Caught at the end of the day, these herons are lit almost entirely by projected flash. The flash's very fast speed stops their action; but some eye-shine is an unfortunate by-product.

Incoming Great Egret. Southwest Louisiana. This bird is approaching a stationary blind. Predictive autofocus allows the photographer to track and sharply photograph even a bird coming directly at the camera. Canon EOS-1 with EF 600mm f/4L on 100 ISO film.

\mathcal{F}LYING BIRDS

A bird in flight reveals the essence of the animal. The sight evokes in us ground-bound humans both wonder and envy. We dream of flying, bouncing up on takeoff, swimming our heavy bodies through air thick as water, only sometimes reaching those high, swift currents that carry us into flight as effortless as that of . . . birds. Human fascination with avian flight has not diminished since we figured out how to transport whole flocks of humans across oceans in one silver bird. Still we turn to watch them soar and dive; we fall into respectful silence as they migrate thousand-fold across our horizons; we squint to still a hummer's wings long enough to see them. How do they *do* that?

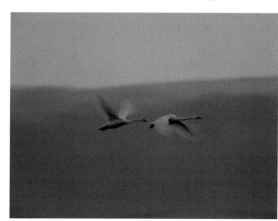

In the low light after sunset, two tundra swans fly past the photographer. A slow shutter speed and panning with the birds yielded an image that emphasized the feeling of movement. 600mm f/4 lens at 1/15 second.

Indeed, the mechanics of flight are highly complex, and the action of a bird's wings is incredibly beautiful. Photographing this phenomenon presents several challenges. The movement occurs on several planes: wings one way, feathers another, the bird's body in yet a different direction. You have to get close enough, your camera has to work fast enough, and you have to anticipate split-second moves. So you need to know something about the habitats and habits of the birds you want to photograph and how to use camera gear that is equal to the task.

New technologies in photography directly address the challenges of capturing birds in flight. The mysteries of flight previously revealed only in slow-motion media now can be translated onto the film of the still photographer. For bird photography, predictive autofocus is the most significant advancement in cameras in the last eight years. Other important developments include the increased power and automated exposure capabilities of electronic flashes, the increased speed and color fidelity of telephoto lenses, and the improved speed, color, and resolution of color films. New, readily available tools have given photographers opportunities for unique portrayals of previously hidden aspects of bird behavior.

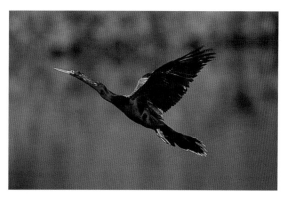

A fast shutter speed and the focusing accuracy of predictive autofocus stop an anhinga in mid-flight. A 300mm f/2.8 with 2X tele-extender (600mm, f/5.6) set at 1/500 second was used with 100 ISO slide film.

Locations for Photographing Birds in Flight

Photographing flying birds requires planning and preparation. You need to be in a place that has lots of room for birds to fly around in close proximity to your camera. One of the best locations is on cliffs where birds soar on wind currents. A wonderful perspective akin to flying in formation with the birds can be achieved. Particular attention must be paid to the lighting, however, as your ability to change position stops at the edge of the cliff. Choose the time of day that offers the best currents and light. A west-facing cliff on the Pacific Ocean may be best used to photograph soaring pelicans early in the morning when the sun is behind you, or late in the afternoon when the sun backlights the subject.

Observing a bird's predictable flight patterns is very useful in determining when and where to photograph. Birds will repeat flights as they come and go from their nesting sites. Cavity nesters are unquestionably the easiest to anticipate, because they fly to and from an exact location. Cup-nesters tend to approach and leave from the same direction, but their options typically include a full 360-degree range. Food sources, artificial or natural, provide another predictable location for photography. Feeders, even those set up in the back yard, can be used to influence the direction of flight, and you can position yourself for optimal use of natural light and background. If possible, you want to catch the birds leaving or landing at the feeder, so observation and anticipation are required; electronic triggering mechanisms can be used under these circumstances.

The splashing and spray involved in waterbird landings and takeoffs make them particularly attractive subjects. Watch carefully for clues that a bird is about to make a move. Certain wading waterbirds gather themselves into a little crouch just before they leap into the air. Waterfowl that need a "takeoff" prior to becoming airborne, like ducks, offer several seconds of water and wing action before liftoff. Other birds that nest around water, such as grebes, skim the surface in a choreographed mating ritual of runs and flights. Feeding habits of skimmers and terns position them somewhat predictably as they repeatedly harvest a school of fish.

Photographing with a long lens, autofocus, and a sturdy tripod equipped with a panning ball head helps to capture images like these brown pelicans flying by and a skimmer cutting the water in search of fish. Both were taken on 100 ISO slide film.

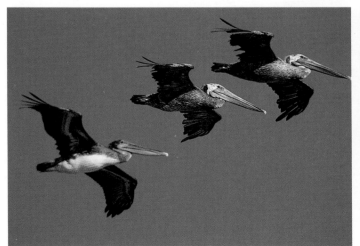

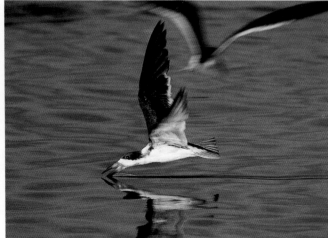

Some birds, especially scavengers like gulls and pigeons, can be enticed to fly around the photographer who offers them leftovers from lunch. Position yourself to optimize the wind and light direction. Aggressive members of seabird species such as pelicans, albatross, and frigate birds can be found following fishing and tour boats as well, affording many interesting opportunities for photographing hovering, diving, and landing behavior.

A great place to photograph flying birds is at nature parks and zoos that have demonstration programs involving controlled flights of large birds such as raptors, ravens, and vultures. You may need to attend a show several times in order to position yourself in an optimum area for photography. Some falconers might be amenable to flying their birds for you in a private show. The birds may wear jesses, so the photographs won't look as natural as you would like; however, they still are worthwhile photographic subjects.

Walk-through aviaries allow you to enter a bird's controlled habitat. The birds typically engage in predictable, repetitive flight patterns to and from nests, perches, and feeding stations. Aviaries allow you to photograph unusual species never available to you in the wild. They also are good locations to try new equipment and master techniques before you invest time and money in travel to exotic field sites.

Capturing the action with all the detail perfectly rendered requires fast shutter speeds. This great egret was photographed at 1/500 second. Photographing smaller birds, like wrens and hummingbirds, may require shutter speeds of 1/8000 second or less to freeze the movement of their wings.

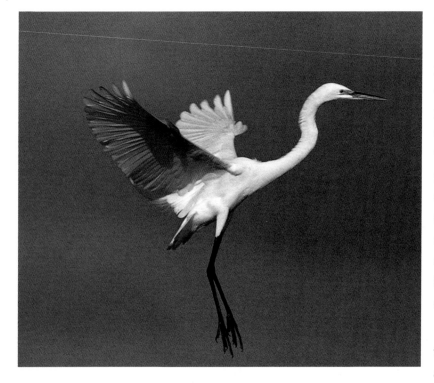

Catching the Flying Bird

Most flying-bird photography involves stopping the action. Whether the bird is taking off, landing, hovering, or flying toward or past you, the goal is to take a picture that suspends, yet suggests, motion. The shutter will be open for only a very short time, presenting a host of related problems. Some of the newer cameras boast shutter speeds as fast as 1/8,000 second. Seldom is there enough ambient light or a usable f/stop with adequate depth of field for these to be implemented using films with a modicum of quality.

The shutter speed you select depends upon the size of the bird, the direction of its approach, the distance to its location, and the degree of suspended animation you seek. You can stop the action of a slow-flying, large bird such as a great egret with a relatively slow shutter speed of

1/250 second, but it will take 1/20,000 second to freeze the fast-moving wings of a small, frame-filling hummingbird.

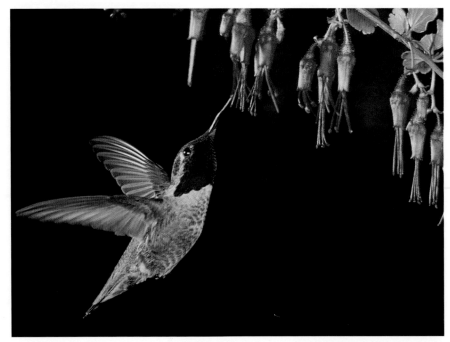

The faster the shutter speed, of course, the more light-gathering capability is required of the lens and film. Slower films with greater resolution and color capabilities unfortunately will directly limit the allowable shutter speed. Fortunately, recent advancements in film technology give us films in the 100 and 100-pushed-to-200 ISO categories that rival the performance of yesterday's 25-to-50 ISO film emulsions. If the faster films still don't allow the necessary shutter speeds, look to faster lenses. A wider lens opening will let in more light, allowing faster shutter speeds but costing us the depth of field which may be necessary to portray sharply the entire bird.

When fast lenses and film don't do the trick, bring your own light in the form of electronic flash, either as a single concentrated flash source attached to the camera, or a multiple-flash arrangement focused upon a target point. The light sources can be set to augment the ambient light, or to provide the dominant light for a fixed duration, thus determining the speed at which the photograph is taken. The flash synchronization speed of the camera, generally maximized at 1/250 second, is not quick enough to be of use as an action-stopper. Rather, the electronic flash's overpowering burst of light within that 1/250 second will define the photograph's duration of exposure. Most flashes at full power have a starting duration of approximately 1/1,000 second, and as the flash is squelched at less than maximum power, the duration is reduced to a minimum of approximately 1/30,000 second. This shorter duration is available to us when the flashes are moved closer to the subject, and faster films and wider lens openings are used.

Be aware that any time shutter speeds or flash durations are less than 1/1,000 second there will be some loss in the ability of the film to record the light, causing slight underexposure. With electronic flash in such short spans as 1/10,000 to 1/20,000 second, as much as one full stop of light could be lost. Test the equipment and film combinations you anticipate using before you take them to the field.

Positioning flying birds in the frame follows the compositional convention of putting room in front of a moving subject. Autofocus has until recently hampered

Hummingbirds are flying jewels, and capturing all the facets requires electronic flash. The light brings out the colors in the gorget feathers around the neck, and the quick flash duration acts like a fast shutter speed to freeze the bird's movements. The ideal lighting system uses two or more flashes to increase the light output for more depth of field and shorter flash durations.

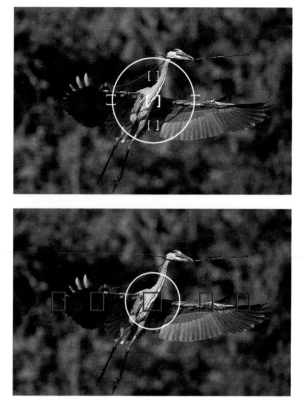

Camera manufacturers are continuously improving the placement of the autofocus sensors in the viewfinder to offer more versatility in composition. With the Nikon (top) and Canon (bottom) AF sensor placement, the subject doesn't have to be centered in the frame.

Using a tall tripod and a tripod head with smooth panning action better utilizes long lenses and autofocus capabilities.

our abilities to place properly such a subject because the focusing sensors are located in the center of the frame. The manufacturers of recent camera models have addressed this problem by spreading the sensors across the frame, or by enlarging the sensor to cover more of the frame.

When the action is fast, such as when panning with a bird flying quickly past you, it may be best simply to concentrate on keeping the subject in the frame rather than to worry about critical positioning within it. Cropping the image later may be a solution, albeit not the best way to assure image quality. With time and experience, the positioning should become easier.

Shoulder stocks, monopods, and tripods are especially useful when working with long lenses even though the exposures may be short and the photographer may need mobility. Shoulder stocks offer the most mobility with lenses up to approximately 500mm. The shoulder stock improves steadiness and facilitates the positioning of your hands on the camera and lens. Stocks are the tool of choice from small boats such as kayaks and canoes, where monopods and tripods cannot be used.

Monopods eliminate unwanted vertical movements while serving as a stable horizontal pivot point. This is useful for tracking or panning with predictive autofocus. A simple tilting head will greatly increase a monopod's usefulness by allowing up and down positioning of the camera.

Six hundred millimeter or larger lenses must be supported by a reliable tripod. When used for photographing flying birds, tripods must extend at least to eye level. Equip the tripod with a quality ball head that will handle the weight of the extended lens and still allow a fluid, full range of positioning to follow the complete arc of the bird's flight.

The predictive autofocus offered by some cameras is especially useful with flying bird subjects. The key to success is to anticipate the bird's flight path and lock the autofocus on your subject early, considerably before the point at which you plan to begin firing off frames. When everything comes together just as you want it, start exposing the film.

You and your camera can fly in formation with some birds. Where large predators, such as eagles, fly predictably low along a narrow navigable waterway, the photographer in a boat can parallel the eagle's flight. The resulting images will give the impression of speed because the bird will appear to be stationary against a fast-moving background.

The same effect can be obtained in the air by flying alongside a formation of larger birds such as sandhill cranes and geese. An airplane capable of very low speeds is necessary because sandhills fly at approximately 35 miles per hour. Slow-flying ultra-lights have been used to document the migratory flights of imprinted geese. As in all photography of natural subjects, be sure to move away from flying birds when it becomes apparent that your presence is causing them to alter their normal behavior. Using a telephoto lens with a gyro-stabilizer accessory keeps you and your craft at a respectful distance.

Lighting for Birds in Flight

Maintaining detail in images of flying birds is a challenge. White-colored birds can become washed-out, dark birds can become silhouettes, and both can turn gray with improper exposure compensation. Dealing with these issues involves efficient use of ambient, flash, or combined light sources. In most cases, the lighting should be directed from the front of the bird; that is, it should appear to be flying into the light. However, back-lighting can be very effective in dramatic representations of flying birds.

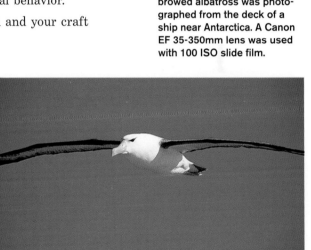

Photographing birds against a bright sky poses an exposure problem. Will the meter base the exposure on the darker, smaller subject or on the brilliant blue background? Or will a white bird be properly exposed against a deep blue sky? Only if you take control of your camera's exposure calculations. Generally the most important area of exposure will be the bird. If the bird is a middle-tone, everything will probably work out fine. Assuming that your camera is set on one of its automatic exposure modes, showing detail in a light-colored bird against a dark sky will require an underexposure of approximately one f/stop. If the bird is darker than the sky, overexpose by one-half to one f/stop. It will take some practice to quickly access the over- and under-exposure control on your camera. If you are shooting groups of both light and dark birds, be prepared to throw out some of your

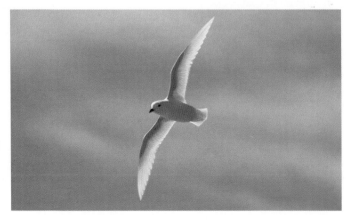

Flying in formation with sandhill cranes is a dream come true. The plane couldn't fly as slowly as the birds, so we moved smoothly past, being careful not to disturb them. A slow-flying ultralight airplane has been used by some photographers to capture amazing in-flight photographs of large birds.

It's important to mind the position of the sun relative to the subject so that the light comes into the face rather than from the tail. This black-browed albatross was photographed from the deck of a ship near Antarctica. A Canon EF 35-350mm lens was used with 100 ISO slide film.

Sometimes it works to have the light come through the bird. The back-lighting on this snow petrel is effective against the deep blue sky of Antarctica. A Canon 35-350 lens was used.

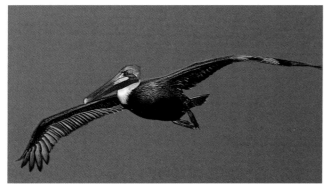

A Project-A-Flash provided an auxiliary light source on this flying brown pelican as it came into a night roost in western Florida. A 300mm f/2.8 auto-focus lens with a 2X tele-extender (600mm, f/5.6) was used to frame the bird at dusk.

Four flashes set at manual 1/8 power were used to achieve a flash duration of 1/6,000 second at f/11. Project-A-Flashes concentrated the light. The exposure was determined with a hand-held flash meter. Multiple flashes can be either connected with sync cords or activated by flash slaves.

exposures. Bracketing is not an option when the action is fast and other variables are abundant. Choose the exposure you think is right, and then concentrate on framing the subject.

Electronic flash as the only light source is most often used to enable a very short exposure in order to stop motion, as discussed above. However, flash also can augment the existing light, giving a fill to provide detail in the shadows. By concentrating the beam of an attached electronic flash through a Fresnel lens, the effective range of the flash is greatly extended, making it power-ful enough to come close to matching full sunlight on a relatively distant flying bird. Because we usually can't control the angle from which birds approach the camera relative to the sun, projected flash fill is very effective in lighting the shadowed portions of the bird to add information and lower the contrast.

Multiple flashes set up to fire simultaneously for very short durations will add up to enough light to cover a predetermined path of the bird. This technique is appropriate when the photography will be performed at a point to which the bird will return repeatedly, such as a nest or feeder. As discussed above, this combina-tion of electronic flash sources will freeze the wing action while giving necessary depth of field. If the flashes are properly powered, they will recycle quickly enough to allow the camera motor drive to capture many successive frames as the bird flies through the focused area in the light path.

The flashes must be able to be set manually to fractional power settings, as in 1/4 or 1/8 power. Each halving of the power setting reduces the flash duration by one-half. For example, if the flash's specifications indicate a full-power duration of 1/1,000 second, at 1/2 power the duration will be 1/2,000 second, at 1/4 power the duration will be 1/4,000 second, and so on. Therefore, if you want to achieve full power at 1/4,000 second, you need four flashes. An exposure of not more than 1/8,000 second is neces-sary to completely freeze the wings of most small birds such as bluebirds, chickadees, and wrens. You can add projected flash attachments to focus and increase the efficiency of each positioned flash.

Coordinating multiple flashes is accomplished in one of two ways. The first is to "hardwire" all the flashes together with either PC or TTL off-camera synchronization cords. Note that since the flashes are set on manual, their TTL function will not be used. The second method is to use electronic

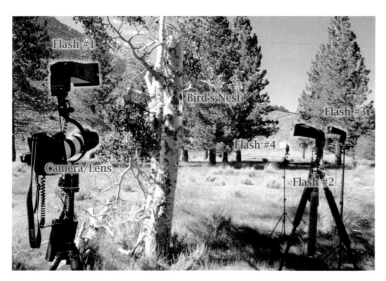

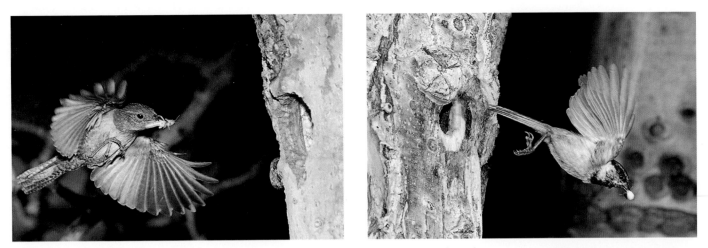

flash slaves to link them cordlessly. Each off-camera flash needs its own slave in order to read and respond to the triggering pulse of light coming from the on-camera flash when the shutter is fired.

Determining the proper camera exposure setting with such a setup is far from routine. Automatic flash exposure of the camera's TTL system is lost with the flashes set manually at fractional settings. A hand-held flash meter will be needed to calculate the light output of your multiple-flash setup. The meter's reading will tell you the f/stop setting for proper exposure. If the f/stop given is minimal (for example f/5.6 with 50 ISO film) and depth of field will be compromised, a faster film is needed. In the example given, 100 speed film would give f/8, or the 100 ISO film pushed to 200 ISO would give f/11. Don't forget the light loss associated with the short flash durations. Starting points are a half-stop loss at approximately 1/2,000 second flash duration and a full stop loss at 1/6,000 second. Shorter flash durations will necessitate even greater compensation.

Auxiliary power to each flash will ensure a very quick recycle time. I extensively use Quantum's Turbo™ power packs. Because the flashes are set at less than full power, they will recycle quickly, but auxiliary power will enable them to keep up with the speed of any currently available motor drive, 10 frames per second.

Knowing the bird's destination or starting point is critical to capturing the in-flight image. This wren (left) and chickadee (right) are nesting in tree cavities. The flash duration was 1/6,000 second for each image. A Canon EF 70-200mm lens set at f/13 and three 430EZ flashes caught the birds on Kodak E100SW film.

A black-chinned hummingbird takes a meal from a hibiscus blossom. A 400mm telephoto lens with an extension tube added for closer focus and two flashes kept the setup simple.

Capturing Hummingbirds

Hummingbirds are a favorite photographic subject. While their petite size, erratic flight, and quick wing movements make them difficult to capture, in fact their behavior is highly predictable and conducive to satisfying photography. They are very territorial, and you can encourage them to stake their claim where you want to photograph them by consistently providing properly prepared

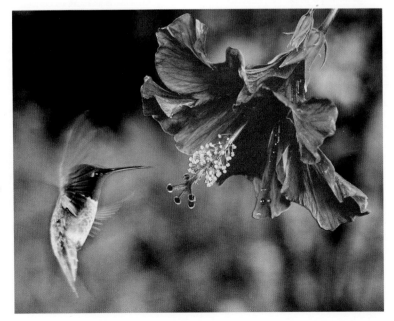

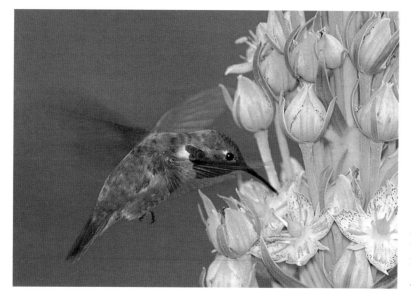

sugar/water solution in clean feeders. Despite their apparent fragility, "your" hummingbirds are surprisingly fearless, and they will easily become accustomed to your presence and freely tolerate the imposing photographic rig necessary to produce stop-action portraits.

Once you've established a friendly rapport with visitors to your feeding station, prepare it for photography. Most feeders are not particularly photogenic, so camouflage yours with material that is more natural in appearance. A tubular flower encasing the feeding tube will entice the hummers; be sure to choose a flower that the birds would normally frequent. Or capture on film the birds as they hover before the feeding station, but don't include the feeder in the frame.

Hummingbird wings beat at an incredible rate of 50 to 75 times per second. To completely stop this whirring action, a minimal shutter speed equivalent to 1/20,000 second is needed. Such a speed can be obtained only with electronic flash set to give a squelched flash duration. Custom flash units designed for extremely short light bursts are costly and cumbersome. The multiple-flash technique discussed in the previous section will better suit most photographers and give nearly the same results.

Aviaries offer year-round opportunities to photograph both local and exotic species of hummingbirds. Three notable hummingbird aviaries are located at the San Diego Zoo, California, the Sonora Desert Museum near Tucson, Arizona, and Butterfly World near Ft. Lauderdale, Florida. With a portable camera/flash system, you can accomplish good photography of feeding, flying, and nesting hummingbirds in beautiful settings.

A portable photographic setup that works well for hummingbirds includes two TTL flashes on a bracket system with a medium telephoto lens in the

Sometimes being mobile is important. A bracket with two flashes and a 400mm telephoto with an added extension tube for closer focus allowed photography of a rufous hummingbird as it fed at different locations in a Colorado high-mountain meadow.

This is the ultimate portable hummingbird or small bird setup. The three flashes produce enough light at reduced power (1/6000 second) for a reasonable depth of field (f/11). The system can be hand-held or worked from a tripod.

200-300mm range. While this rig will give wonderful portraits, it won't completely stop hummingbird wing action.

Sharing Your Photographs

If you like to share your photographs in the form of slide shows and exhibits, a collection of your best flying bird images is sure to please many viewers. As subjects, flying birds possess many of the qualities necessary for compelling images: they can be portrayed in unusual ways because we usually are not very close to them; when they are flying they sometimes exhibit behavior we rarely see; and we never can stop their flight with the human eye. Flying birds come with attractive backdrops of sky, foliage, or water. The photographic challenges flying birds present offer many opportunities to perfect your photographic techniques and style. To the pleasure of pursuit of the bird in flight, and the thrill of using new skills to capture it on film, you can add the joy of sharing a unique vision of nature with other bird-lovers.

A flock of western sandpipers lands in front of the photographer as he shoots from a kayak on Morro Bay, California. Bird portraits are good, but action is better. A telephoto lens, fast shutter speed, small f/stop for depth of field, and serendipity make for some great flying bird photographs. For this image, a 400mm f/5.6 telephoto lens and 64 ISO film were used.

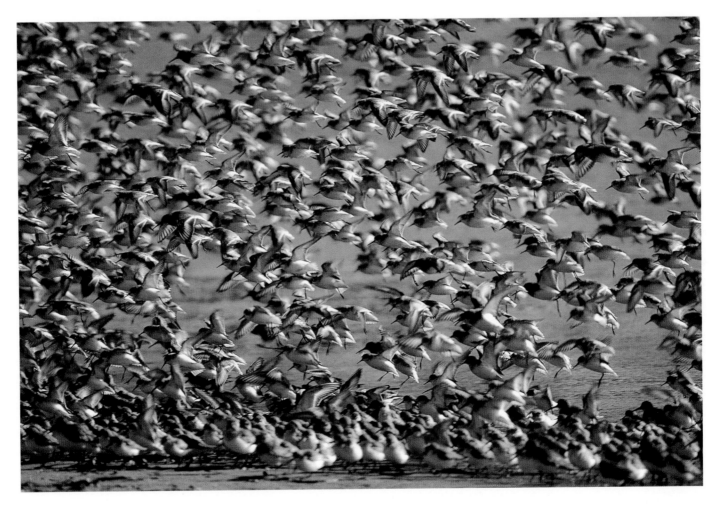

PHOTOGRAPHIC BLINDS

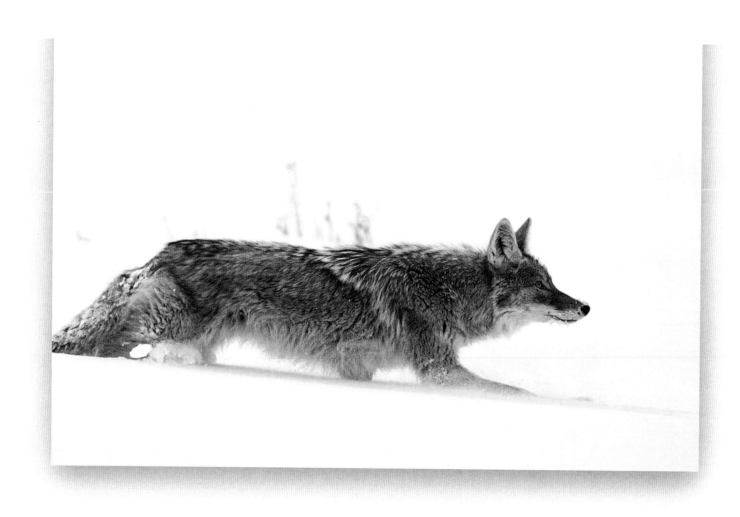

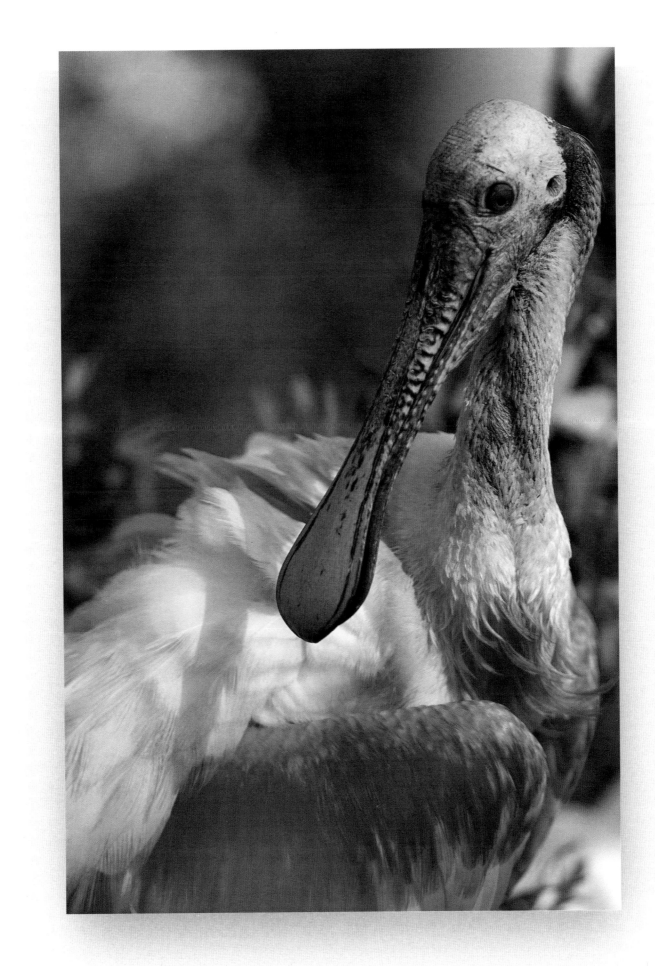

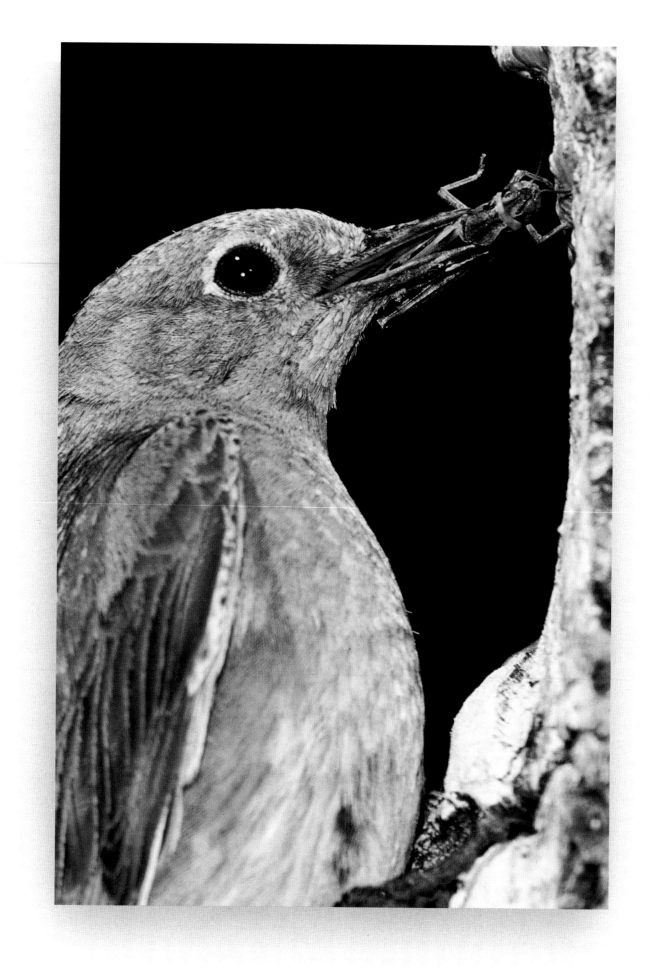

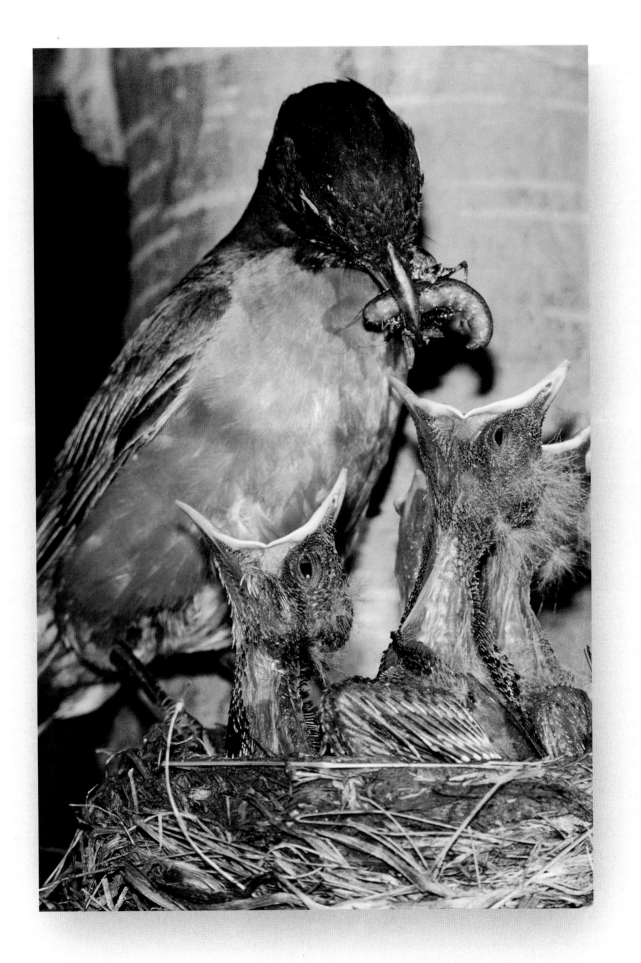

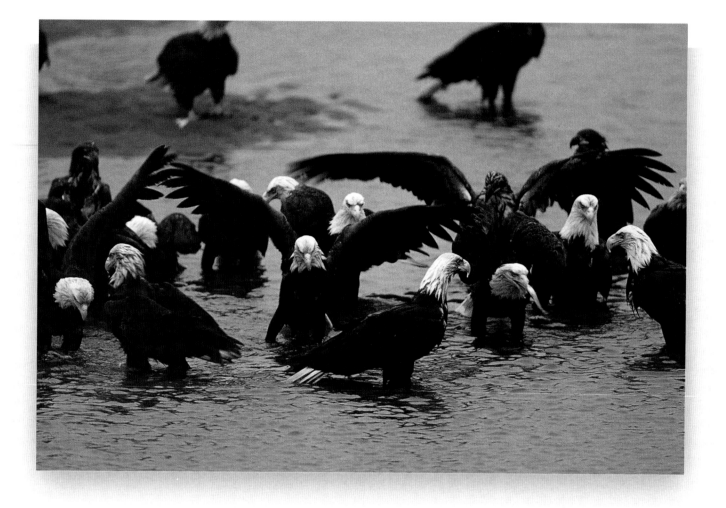

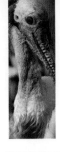

Coyote Tracking. Yellowstone National Park. Coyotes frequent plowed roads in the Yellowstone winter season. As a vehicle approaches, they move alongside the road until it passes. From my van, I photographed this coyote with a 600mm lens. The vehicle in this case is a blind; if a human exits the blind, the animal will take its leave.

Spoonbill on Nest. Southwestern Louisiana. A permanent blind placed at the edge of a rookery offers opportunities for intimate close-ups because the birds have completely accepted the structure over time. This spoonbill portrait was taken with a 600mm lens and a 25mm extension tube to allow a closer focus.

Bluebird with Food in the Hopper. Mono Lake, California. A portable blind with a skirt gave the height necessary to place the camera at the entrance of the bluebird's nest hole. A 300mm lens, a 2X tele-extender, and a 25mm extension tube all combined to give an extreme close-up of a grasshopper's final moment.

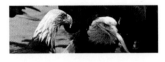

Baby Grub. Mono Lake, California. Once the eggs hatched, the portable blind was placed relatively close to a robin's nest without causing undue alarm to the parents. Two electronic flashes were used to augment the ambient light and a 300mm f/2.8 lens with a 2X tele-extender (600mm) offered the close focus necessary to get this intimate shot.

Bald Eagles Grappling for Hooligan. Southeast Alaska. Sometimes a blind is as big as a barge. From the second story of a logging barge, a 600mm lens with a 2X tele-extender (1200mm) caught these bald eagles in a dispute over fishing rights. The eagles gather annually at this site to feed upon an abundance of spawning smelt called hooligan by the local people. The barge was positioned in close proximity to the feeding grounds.

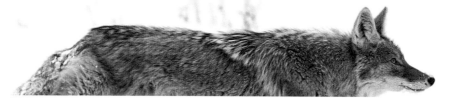

Photographic Blinds

Nature photography is intended to bring the realities of natural environments and behavior into our urban lives, so the very best nature photographs will be completely candid. The subjects will exhibit no awareness of the photographer and/or the photographic equipment necessary to capture the images. Their obliviousness to, or complete acceptance of, the photographic experience allows the photographer to record completely natural activities, posture, and expression.

There are two critical reasons to minimize or eliminate the impact of photography on subjects. First, and most important, responsible nature photography causes neither emotional nor physical distress to natural subjects. Second, photographs of the rear ends of fleeing animals don't look that good on the wall, so why take them? Our goal is to present images that provide important physical and behavioral information, and in order to do this, closer but less intrusive

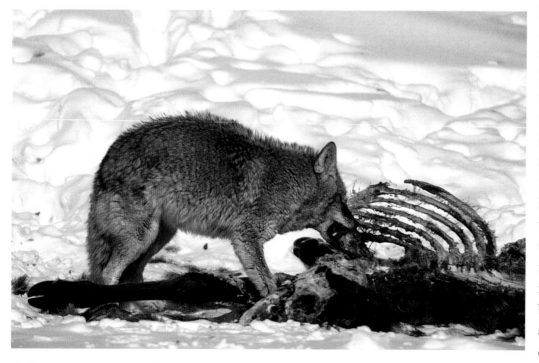

A vehicle can be an effective blind in areas where wildlife has become accustomed to cars and trucks. This coyote feeding on a carcass near a road in Yellowstone National Park paid little attention to the photographer's van at 840mm range.

approaches are necessary. This will require the extra effort, planning, and expense of creating and using appropriate photographic blinds.

Options for photographic blinds range from simple clothing to full-scale structures built on scaffolding. Effective blinds mask the human form, hide movements, and minimize noise. They also may help the photographer to hide from other humans, or provide a safe structure from which to photograph dangerous animals. Each subject, and the importance of the potential photograph, will

As long as the blind hides the photographer's movement and form, it can be as simple as a camouflage-material covering (left). But some conditions call for higher levels of complexity and construction, as with this platform blind on scaffolding (right), needed to photograph a woodpecker nest located high in a tree.

determine the effort necessary to develop essential camouflage. With the use of blinds all the rules of safe approach, minimizing disruption, and protection of habitat are doubly important due to the photographer's closeness to the subject.

Essentials of a Blind

The basic premise behind a photographic blind is that it gives visibility of the subject while concealing the photographer's activity. Therefore, selection of proper blinds should be made from the perspective of the subject. An effective blind will reduce the subject's awareness of potentially alarming visible and audible stimuli. Each species, and each individual within a species, will demonstrate different levels of tolerance for intrusion, thus dictating the type and complexity of the necessary blind.

First, a blind hides the photographer by obscuring the human form and concealing movement. Whether it is as simple as camouflage clothing or as complicated as an elevated platform, the blind must accommodate the photographer's activities. It needs to be large enough, transportable to the field, allow good visibility of the subject and surroundings, provide protection from the elements and insects, and enable the photographer to stay in position for long periods of time in reasonable comfort.

Second, blinds also may hide the photographer's equipment. A simple camouflage sleeve on a lens cuts distracting glare and reflections; larger blinds will obscure the camera, lenses, and tripod. Choose equipment with minimal noise levels whenever possible.

The most sophisticated blinds also hide themselves; that is, they blend into the subject's environment. Natural colors and patterns soften the silhouette and render the blind and its contents less visible and distracting to especially sensitive subjects. This may require the incorporation of some local materials.

Simple Blinds

While mobile and quick to set up, simple blinds don't do a thorough job of minimizing form and movement. They are useful when you must travel light, and for subjects that aren't particularly skittish. For example, consider an expedition to photograph caribou and musk ox in the northwest territories of Canada. You have to fly into the vicinity and then pack in. The animals, when you find them, are especially sensitive to the human form. But the most simple alteration will sometimes help the photographer to gain acceptance.

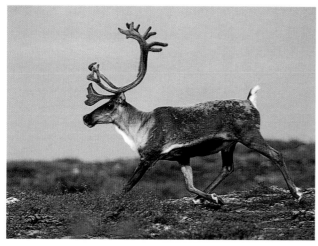

Caribou may pay no attention to you if you have antlers, so raise your arms with hands spread, or hold your tripod on your head as you approach. Individual animals may see you for what you are; they'll let you know by showing you their tails as they leave the area. So be prepared with more than pantomime.

Camouflage clothing is the basic blind. The pattern must repeat the shapes and colors found in your subject's environment. Many options are available in outdoor equipment catalogs, including shirts and pants, camouflage hats with netting to cover the face, and warm winter gloves, or mesh-like summer gloves, to hide the hands and obscure their movements.

Sometimes you just need to assume a familiar form. Our guide, Tundra Tom, places his arms above his head to simulate antlers (upper photo). The Northwest Territory caribou accepted us as long as we had the antlers! The lower photo was taken with a 300mm f/2.8 lens and 2X tele-extender (600mm) on 100 ISO slide film.

Hat and pocket blinds are drapes of camouflage material which do an excellent job of masking the human form but not its movement. The hat blind uses a wide-brimmed hat or pith helmet to keep the material away from the face, while the pocket variety, which folds to fit in a small pouch, is a simple piece of cloth. Each is easy to make, carry, and use while standing or sitting in the field, and

Adding camouflage can make the photographer virtually invisible to the subject. Don't forget to cover your hands; their frequent movement as you work will call attention to your presence.

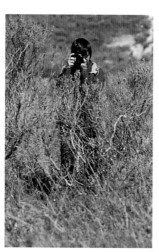
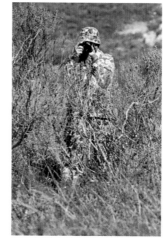
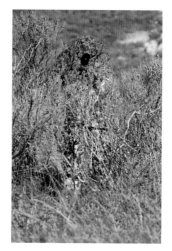

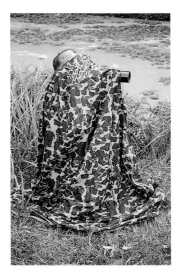

A simple drape blind hides the photographer, who is sitting on a stool and using a tripod. The camouflage doesn't completely mask movement, so stillness is important to successful use of this type of concealment.

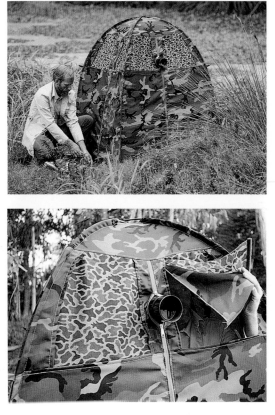

they allow for the photographer's easy adjustment of position and location.

Mobile Frame Blinds

These are the contraptions that everyone thinks about when considering photographic blinds. They have a lightweight, internal or external frame and are similar to a tent. They are available from suppliers of nature photography equipment, or, although more complicated than a drape blind, simple mobile frame blinds can be made at home. As the name implies, these blinds can easily be moved from one photographic situation to another. They usually are assembled from lightweight components, but the covering is made of material thick enough to deter shadows. It is important for them to have windows for visibility and ventilation, and window covers that can be completely opened while using binoculars to survey the area, or completely closed to block light. The design must provide convenient access and appropriate size and height to accommodate the seated photographer. Some have skirts to enable the photographer to remain covered while standing. The ports for lenses should allow for both low and high positioning. The better blinds have a sleeve which hides the barrel of the lens and helps to minimize the appearance of its movement. Some protect from the elements with waterproof materials or a fly to shed rain. It's important that blinds be well secured to the ground to eliminate flapping.

One of the blinds available from Nature's Reflections is supported by bending shock cords, like a pop tent (top). Lots of windows are important in a blind for both ventilation and observation purposes. This blind (bottom) has large openings covered with transparent camouflage material. An opaque covering is available as well to shut out light coming from the back that might silhouette the photographer. The windows also can be opened completely so that the photographer can use binoculars to survey the area.

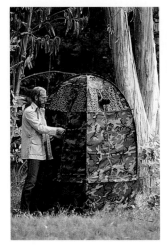

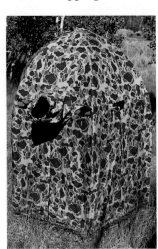

The blind from Nature's Reflections has a skirt that can be used to cover a photographer standing more than six feet tall.

The Rue blind sets up very quickly. It has an excellent sleeve to place around the lens barrel to mask its movement.

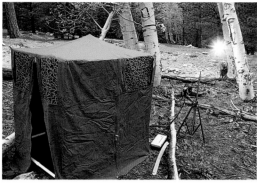

This blind was made at home with PVC pipe and a solid, neutral-colored material. Making your own blind can save money, and you can customize it to your particular needs.

A simple mobile frame blind can be made from PVC pipe and camouflage or neutral-colored material. Some sewing skills will be needed, but these can be procured from your local upholstery shop if necessary. When designing your blind, keep in mind the need for good visibility of the subject, ventilation and breathability in hot weather, and protection from the elements in cold weather. The materials may cost less than a commercial blind, but it might be better to buy one ready-made and invest your time in taking pictures.

A variation upon the mobile frame blind, and one that demonstrates the need to develop particular blinds for special needs, was one I designed to be moved by the photographer within it. I needed to approach bald eagles gathering on flat sandy stretches, with little natural cover except for scattered dead trees. In addition, the eagles would move throughout the day from one area to another, necessitating quick redeployment of the blind. My son, Tory, and I constructed a blind to look somewhat like a dead tree stump. Large wheels helped to roll it across sand, and a comfortable boat seat was added to allow rest during the long hours spent in the blind. A tripod base and ball head were installed in the blind to support up to a 600mm lens. We knew the "Trojan stump" worked when, at one point, the eagles came closer to the camera than the lens could focus.

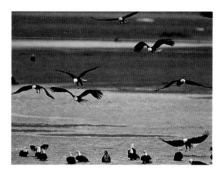

The eagles that accumulate on Southeastern Alaska's tidal flats are very difficult to approach. The "Trojan stump" was constructed to hide the photographer among other logs and branches strewn about the area.

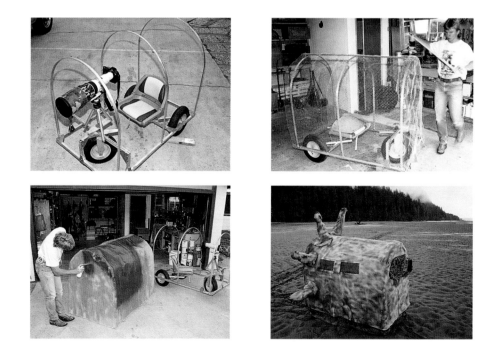

The Trojan stump began with an aluminum frame and three large, air-filled tires for traversing soft sand. A boat seat accommodates the photographer through long hours of waiting for subjects to approach, and a shortened tripod supports the heavy 600mm f/4 lens needed for photography. The outer shell was fabricated from a mold of chicken wire formed over the aluminum hoops. Once covered with fiberglass, the wire was removed to leave a light-weight shell. The exterior was painted to match the color of the sodden trunks on the tidal flats, and roots were added to the back to make the silhouette more realistic.

It worked! On several occasions, the eagles approached closer than the lens could focus. But the exceptionally good fishing Mother Nature offered the birds that season worked against the project. The eagles were widely distributed across a larger area than usual, reducing photographic opportunities at the site of the blind.

Floating Blinds

Animals around water are less frightened by approaches from water than from land. So when photographing wading birds, ducks, geese, or shorebirds, you will have better success with a water-based approach.

Canoes and kayaks are excellent vehicles for work in shore areas. It's easier to work from kayaks because they keep you lower in the water, are more stable, and are more comfortable, especially with their backrests. Canoes ride much higher and tip more easily, but they are frequently more readily available for rent in remote areas. Neither boat will hide the upper half of the human form, so it will be necessary to build some structure to obscure yourself. In addition, paddles, both their movement and the reflection of light flashing from them, can easily startle the birds into flight. For maximum stealth, a quiet electric trolling motor may be the preferred power source. The soft approach is often rewarded with reasonably close photographic perspectives. Still, water-based birds may continue to move gently away from you if your presence makes them uncomfortable.

Float Tubes

There are two kinds of float tubes useful for photography. Commercially available tubes for lake fishing typically consist of an inflatable tube in a canvas housing with pockets, a backrest, and a suspended seat. The fisherman/photographer either uses swim fins or walks along the bottom of the lake to maneuver into position. For use as a photographic blind, a covering will be necessary over the photographer's upper body. This can be in the form of a drape, or a secondary dome supported by a separate, concentric floating ring. The only problem with this configuration is the need for a rigid long-lens support.

A home-designed and constructed float tube, first made and brought to my attention by my friend Bill Sleuter, consists of a large truck inner tube attached beneath a circular plywood platform, which holds a suspension for a seat and acts as a base for a tripod head to steady long lenses. Again, a covering is necessary for the photographer's upper body. This can be made with a chicken-wire support woven with local reeds.

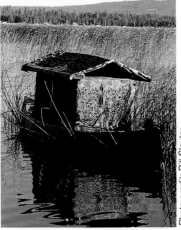

A canoe with a blind attached worked well as a vehicle for photographing grebes on a lake in northern California. The roof on the blind shielded the photographer from the intense heat of the area.

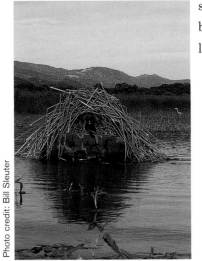

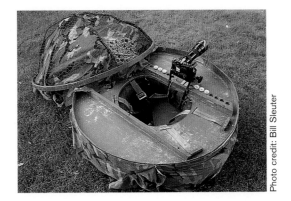

A float tube places the photographer at water level. Covered with reeds from the surrounding area, the blind was accepted by the birds.

The float tube blind consists of a plywood platform mounted on a truck-tire tube. A suspension seat in the center supports the photographer, who moves the blind by walking on the lake bottom. Using flippers to propel the blind in deeper water doesn't work well because it's difficult to control the movement. Walking on the bottom maintains proper orientation and smooth approach.

Float tubes are excellent for the photography of birds such as grebes, ducks, small birds along the shore's edge, and small mammals such as otters and muskrats. The only drawback is that the photographer is limited to certain areas: the water's depth must allow both flotation and touching the bottom.

Vehicular Blinds

Cars and vans are readily accepted by birds and mammals along roadways and make for a comfortable photographic platform. It is important to stay within your automobile; you will be accepted by these subjects only for as long as you are a part of the environment that they have come to accept: a motor vehicle.

Shoot through an open window. Be sure the engine is turned off to minimize vibrations. It may be necessary to use commercially available window mounts, which attach a ball head to the window frame or glass to provide lens support. If you often use your vehicle as a photographic base, be sure to choose one that has windows that open properly for photography. Features such as extended tops can allow higher access and photography from a higher vantage point. Additionally, some professional photographers have made roof openings with platforms above that allow photography from an even higher angle. This particular viewpoint is especially useful for photographing potentially dangerous large mammals such as grizzlies and moose in Denali National Park. Alaska.

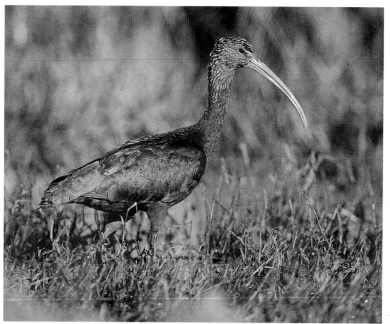

The animals in many refuges are accustomed to vehicles along the roads, but if you leave the "vehicular blind" the subject will move out of your range. This ibis was photographed with a 600mm lens on E100SW film in the Sacramento National Wildlife Refuge, California. The vehicle's window frame provides a steady platform for a long lens.

Stationary Blinds

In situations where the presence of particular mammals or birds is predictable, and your continued access to the area is guaranteed, it may be possible to erect a stationary, permanent blind. In some cases the managers of publicly owned wildlife refuges or sanctuaries can be persuaded to construct such blinds for use by photographers. In other cases, the owners of private property frequented by wildlife can recognize the benefits of providing safe and unthreatening blinds and even feeding stations; these enable the property owner to raise funds necessary to protect the land and wildlife by providing environmentally sound facilities and to control access to the property.

The subjects enjoy an additional advantage with stationary blinds. The structures become a natural and unthreatening part of the environment, to which they

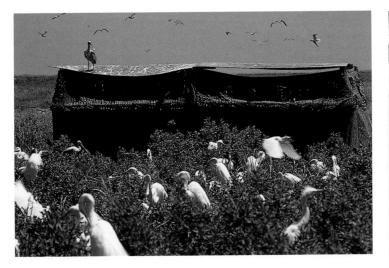

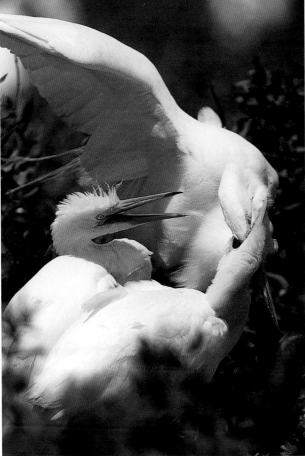

pay no heed. The animals are spared the stress and disruption of repetitive introductions of photographic blinds into their habitats.

Permanent blinds are as varied as the subjects to which they provide access. Their configuration depends also on the environment in which they are constructed. For example, blinds constructed in a Southwestern Louisiana marsh were placed using treated poles inserted by hand into the mire; the base of the blind was then suspended two feet above the ground, keeping the photographer out of the muck and allowing a view into active nests. Another blind in the same region, located at a national wildlife refuge, was built from cinderblock and faces a field of planted grains frequented by migrating waterfowl. Other platforms have been built into trees overlooking raptor nests in anticipation of the birds' annual return to the nesting site.

Placing the Blind

Two considerations will guide your placement of any kind of constructed blind. First, you must determine how closely you can approach the subject without alarming it or damaging its habitat. Position the blind at the perimeter of the habitat whenever possible to minimize the disruption caused by entry and egress from the site. Second, and only within the parameters established by the first consideration, place the blind to achieve optimal photographic conditions, including light, perspective on the subject, and protection from the elements.

Blend into the environment. It will be difficult for the subject to accept any unfamiliar structure, so place the blind alongside shrubs, trees, or ground formations. Use material that repeats the natural shades and shapes of the surroundings. Manufacturers of camouflage materials now have many patterns and colors

A permanent blind—one that is in place before the subjects arrive on the scene and remains throughout their tenure—is a perfect site for photography. The birds are completely at ease with this structure (note the spoonbill standing on top), and the photographer can be much closer than with a mobile blind. This great egret feeding its chicks was photographed in southern Louisiana from the blind shown at left. A 300mm f/2.8 lens was used with 100 ISO slide film.

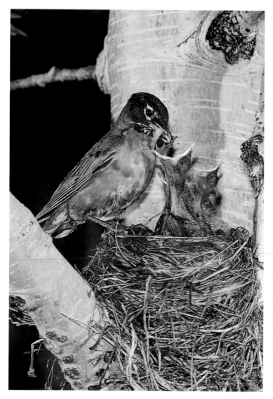

Over a period of days, the blind was moved gradually closer to the nest. Throughout the approach, the subject was watched for any behavioral changes that could be caused by the intrusion. For this photograph on E100SW film, a 300mm f/2.8 lens was used.

Three flashes set for TTL flash exposure were placed around the robin's nest. Be sure that your lighting setup does not block the birds' normal path to the nest.

available to duplicate scenes, from "real-bark" to "desert storm." Remember that it may be even more important to conceal your activities from passing humans than from the subjects! You can protect the site and the subjects by not calling attention to them with your activity.

Introducing the blind into the desirable photographic position is a critical maneuver. First, observe the subject's behavior from a distance so that you will later be able to recognize any behavioral changes caused by your photographic activities. Determine the animal's chosen paths into and out of the area; you must not block those paths with your blind. Note the interval between feedings if a nest is your intended subject; if later your presence changes the schedule you must back off to save the nest. As you move the blind into position, be alert to any changes in the subject's routine so that you can minimize the disturbance you cause.

In some cases, the blind can be positioned swiftly, but in others the animal must be allowed to accept its presence gradually. There is no hard and fast rule for each species, nor for individuals within species; you will need to observe the reactions of your subject and respond accordingly. It is both challenging and enjoyable to learn the unique personalities of your subjects in this way. I have photographed nesting hummingbirds that accepted a blind in a matter of minutes and never gave it a second glance, while others would have nothing to do with their nests and young until I completely removed the blind from the area. I have photographed numerous hummingbirds, but I still remember one anna's hummingbird that would brood and feed her young with me standing by at 200mm macro-lens distance and no blind at all. The babies fledged normally, and she returned to the same area for several seasons, becoming one of my favorite subjects.

The blind itself, and the transportation of the blind into and out of the area, should never cause damage to important habitat. Protect vegetation that may be shielding a nest or giving cover to your subject's domicile, feeding, or breeding grounds. Assemble the blind outside of the photographic area to minimize the amount of time, and subsequent disruption, needed to put it into final position.

Movement of and within the positioned structure must be minimized. Flapping material will usually alarm the subject, so all loose ends of the blind should be tied down or zipped up. Be sure to secure ties and flaps if you leave the blind

unattended, because it alone can cause the subjects undue and prolonged stress, and can even keep parents away from young that need regular feeding. When occupied, the blind should accommodate the photographer's movements without shaking or bulging.

Optimum placement for photography will take into account light sources, prevailing wind directions, and visibility of the intended subject. Backgrounds should be considered; choose a perspective that will exclude undesirable or confusing elements such as structures and power lines or distracting designs or shadows caused by foliage and terrestrial formations.

Observation of the area for the purpose of maximizing the photographic opportunities may take some time. How does light move through the area during the course of the day? From what direction do birds approach and land at the site? Is wind a factor only at certain predictable times? From what position, horizontal and vertical, is the best visibility of the subject obtained? Are there obstructions which can be safely removed or

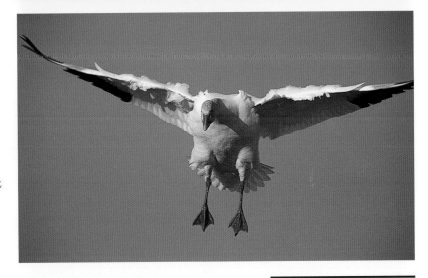

repositioned during photography without adversely affecting the habitat or endangering the subjects? For example, can you temporarily tie back a branch interfering with your view of a nest without exposing the eggs to a potentially damaging change in temperature?

Remember that every blind-placement decision you make requires that you weigh the environmental factors along with the photographic, and you must always err on the side of the subject's welfare. The patience required to get close to many natural subjects without exposing them to stress or danger is an essential virtue for nature photographers, and one that brings rewards in the form of pleasurable photographic sessions and memorable photographs.

A mobile blind is placed next to a grit site where thousands of snow geese land each morning.

If the blind is properly placed, the birds will land facing both it and the sun. The sun's location is predictable, but guessing the wind direction that influences the birds' approach falls more into the category of luck. This snow goose was photographed with a Canon EOS-1, 300mm f/2.8 with 2X tele-extender (600mm), and 100 ISO slide film. Autofocus was an important tool in achieving a high percentage of sharp images on this shoot.

CONTROLLED ANIMALS

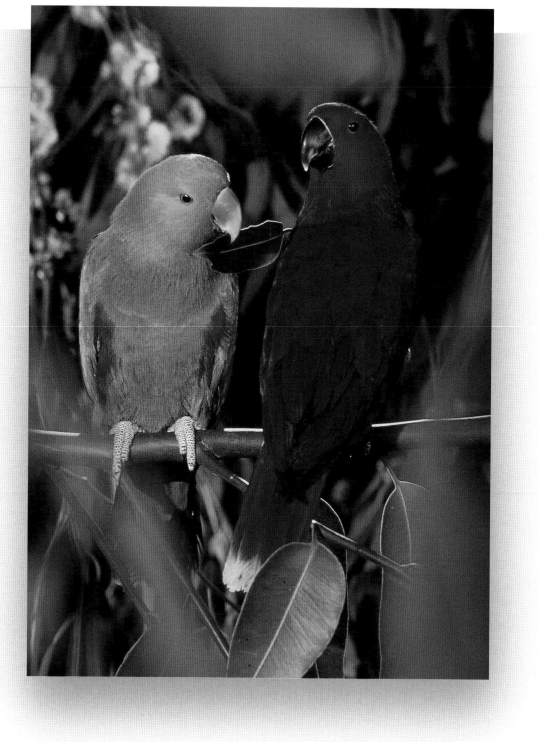

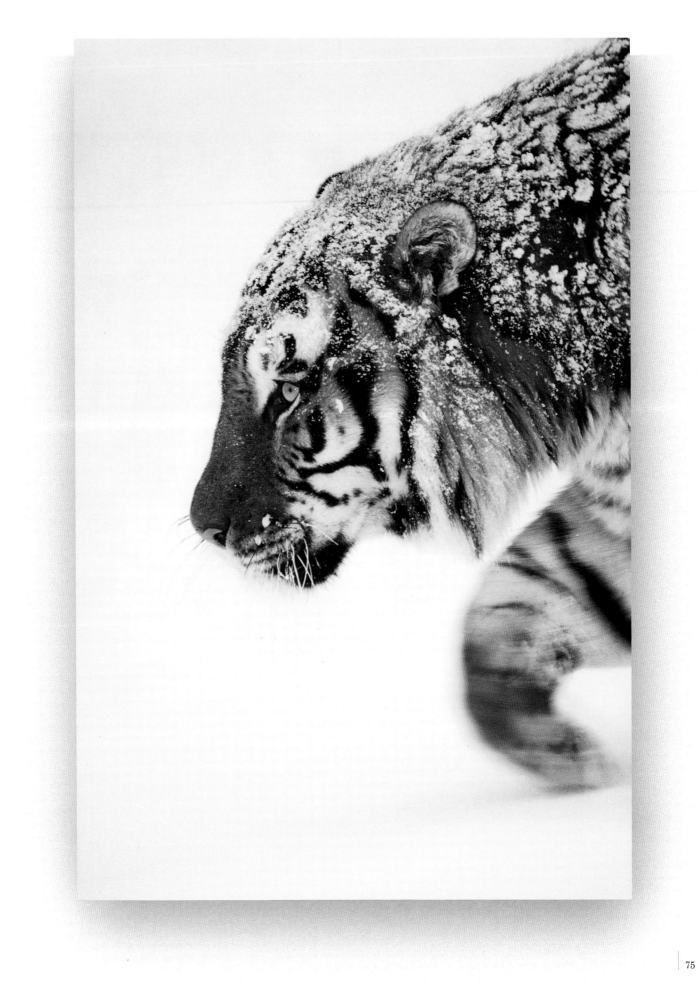

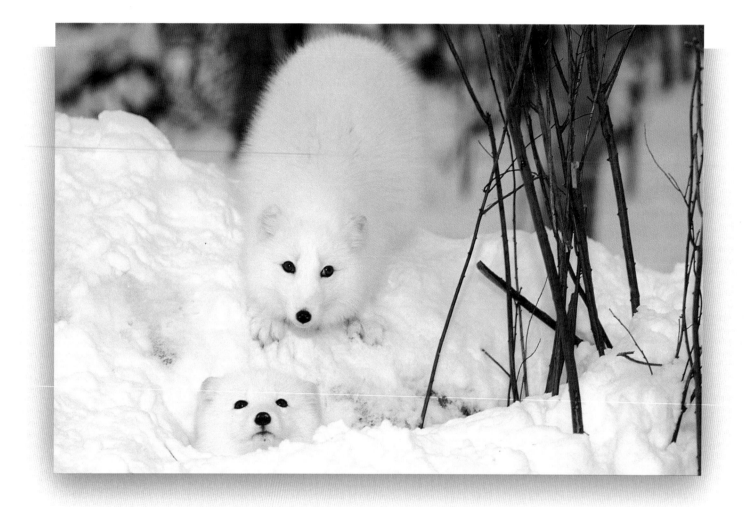

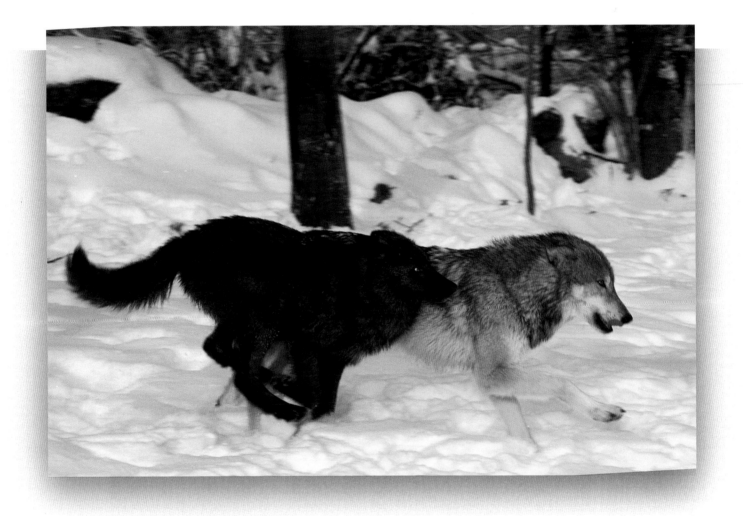

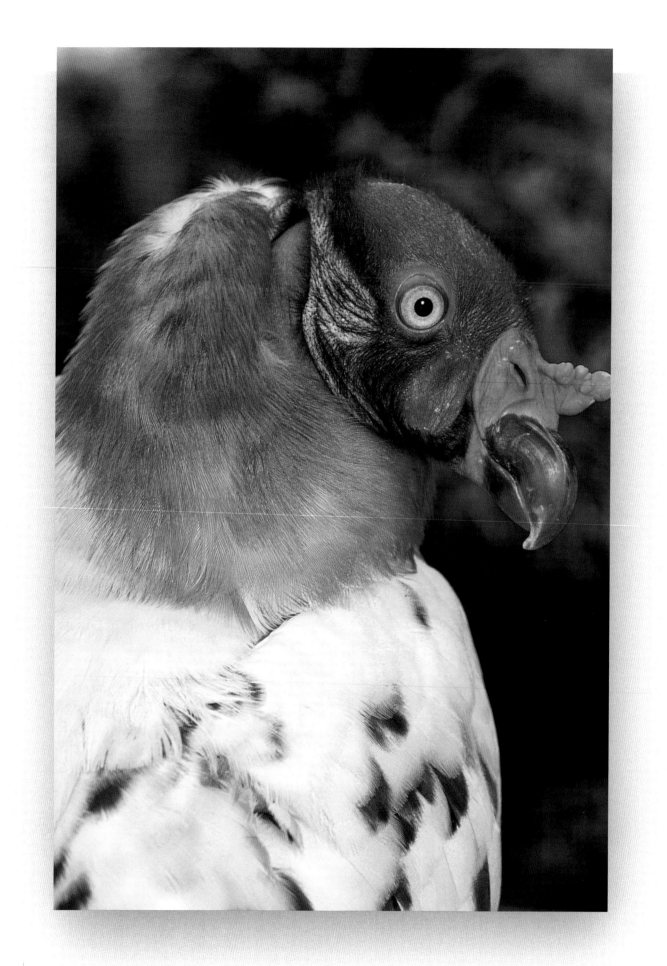

Eclectic Parrots. Los Osos, California. I created an Australian forest in my family room to provide an authentic background for these two exotic pets. With complete control of lighting and placement of the subjects, this nature photography was accomplished in studio conditions.

Siberian Tiger. Vermont. This controlled animal was photographed at a compound in Vermont during a snowstorm. By staying tight on the animal, the background is rendered neutral and compatible with the subject's home range. The element of driving snow adds interest to this action portrait.

Arctic Foxes. Vermont. The natural-looking enclosure provided a great background, and patience yielded photographic rewards. After some scouting around, these foxes found a hole worth exploring. They repeatedly entered and exited the hole and offered many opportunities for excellent group portraits.

Timber Wolves in Full Gallop. Vermont. The close access afforded by game farms lends itself to portraits, but be alert for opportunities to document spontaneous behavior. I caught these timber wolves in a moment of exuberant play.

King Vulture. Portland Zoo. Oregon. Part of the zoo's educational entertainment program, this vulture was photographed prior to a show. The bird was perched and highly accessible, but a medium telephoto lens was used to keep from pressing too close. A hot-shoe-mounted electronic flash filled in the shadows.

CONTROLLED ANIMALS

What avid nature lover does not dream of capturing the perfect moment of contact between the human and the wild thing? You watch the elusive creature; enter the unguarded moment; and see it seeing you. You have so clear a field of vision that every scent and texture can be committed to memory—fur and breath, eyes and emotion. The turning point comes in that miraculous instant when patience is rewarded and the prize is put away, ever to be memorialized, living, and proven on film.

Recognize this fantasy? We call it large, hairy mammal syndrome, the mild-mannered nature photographer's version of safari blood lust. Few of us can afford the financial and physical risk involved in hunting prize photographic prey armed only with the contents of a camera bag. But close encounters are possible in many controlled environments such as game farms, wild animal parks, and private compounds.

To those more thrilled by the chase than the subject, the idea of a day spent photographing enclosed animals may simply not suit. But if you are fascinated by the physical and behavioral traits of exotic or elusive species, a day of relatively safe, close contact in a controlled environment can be the dream come true.

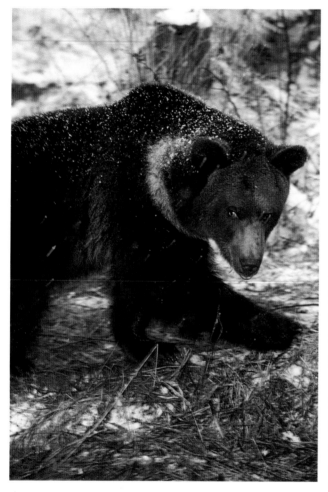

Many nature photographers place big game like cougars and grizzly bears high on their must-photograph list. Close encounters with the likes of BJ, a controlled animal from Triple D Game Farm in Montana, are much safer than close approaches in the wild. A 35-350mm zoom lens and fill flash were used with E100SW film pushed to 200 ISO.

The Controversy of Control

The photography of animals in controlled settings raises several controversial issues now under intense discussion in professional circles. The most important consideration is the animals: their origins, the conditions of their confinement and care, handling, and photographic portrayal.

Many of us would oppose removing an animal from the wild for photographic purposes. We might readily accept the temporary capture and confinement of

insects and small mammals such as mice, which suffer little from such encounters. But capturing and moving a bird or a larger mammal causes tremendous stress. Most controlled "wild" subjects made available to photographers are the offspring of captive-raised animals, several generations away from their wild ancestors. In fact, these animals have become so habituated to humans that they typically would not survive in the wild. Nonetheless, their worth as photographic subjects is responsible for their existence, and our use of facilities that offer controlled subjects perpetuates their breeding.

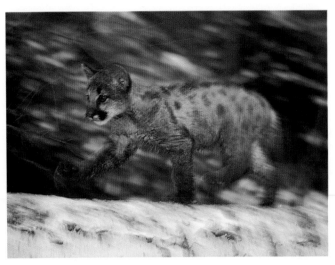

A cougar kitten photographed in a natural enclosure under controlled conditions yields an image that cannot be captured in the wild. A 35-350mm zoom lens, flash fill, and E100SW film pushed to 200 ISO were used.

There are diverse opinions in the professional photography and publishing fields about whether it is ethical to use controlled animals as representatives of wild populations. Under certain conditions, photography of controlled animals has a tremendous potential for increasing appreciation of the photographed species. In controlled settings, it is possible to achieve photography that never could be accomplished in the wild. We rarely become involved with creatures for which we have no affinity, and exposure promotes understanding of and identification with those still in the wild. A greater sense of connection leads us to support efforts to preserve and protect critical habitats and populations. Given this generally positive outcome, one could use controlled animal facilities in good conscience when the physical and emotional needs of the subjects are properly met. The minimum requirements are humane treatment, healthful care, appropriate-sized enclosures, sensitive and informed handling, and responsible breeding. It is beneficial to support those facilities that are opened to wildlife researchers and dedicated to rehabilitation and care of injured or orphaned wild creatures.

What Are Controlled Animal Subjects?

For the purposes of this chapter, controlled subjects are defined as undomesticated animals whose environments are completely delimited and determined by their human caretakers. Such subjects are entirely dependent upon humans for their essential life needs. They are captive, but their enforced habitats may be so capacious as to give the illusion of free range. Controlled animals are found in zoos, animal parks, rehabilitation centers, private homes, and animal farms specifically designed for photography.

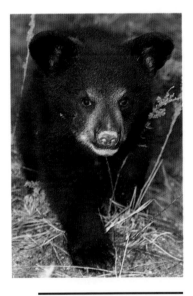

A lively black bear cub at a rehabilitation center makes a great subject. Even under optimum conditions, getting shots of an active cub is not easy. A 35-350mm zoom and flash fill were used with Kodak E100SW slide film.

It is essential that photographs of animals taken in controlled conditions be so identified so that the conditions and behavior are not misrepresented as being produced truly in the wild. However, the validity of such photographs for depicting species-specific behaviors should not be discounted. A controlled running cougar runs exactly the same way a wild running cougar does, and a controlled

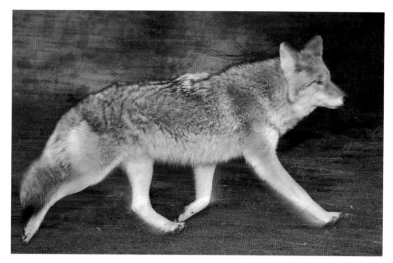

As this coyote checks out a new enclosure, it offers photographs of the animal in motion. Portraits are good, but action is better. A slow shutter speed was used to record a blur that suggests motion, and flash was fired at the end of the exposure to sharply render part of the image. The result suggests the animal's animation. A 35-350mm zoom lens was used to facilitate framing as the animal moved quickly around the enclosure. Autofocus is also an important aid to capturing constantly moving subjects.

drinking wolf drinks exactly as does a wild wolf. The essential difference is that the photographer has greater, safer, access to the animal in a controlled setting, and the animal is more likely to be in prime physical condition and less likely to be stressed by the photographic encounter.

From the foregoing definition we can eliminate those animal subjects that are influenced, but not controlled, by human interaction. Birds coming to a feeder or deer to a salt lick may become somewhat habituated to humans, but they will not be controlled by or dependent upon such treats.

Ethical Use of Controlled Animal Subjects

Controlled animals give many opportunities for inaccurate or careless portrayal of subjects. When photographing animals in controlled settings, the photographer must scrupulously attend to the small details that are usually taken care of by Mother Nature in the wild. If the controlled animal is being photographed in an incorrect setting, neutralize the background by taking only tight portraits that concentrate on the animal rather than the location. If the subject is being photographed in a prepared set, be sure that it is accurately and naturally portrayed.

Be alert to inadvertent or intentional contrived associations. Remember the cute and playful bear cubs and cougar kittens frolicking together in natural history films of the 1950s? They made appealing subjects, but very poor natural documentation. Some Baby Boomers still think that natural enemies play together if they're young enough not to know better.

Staged behavioral studies, particularly those that pit one subject against another, or feed one subject to another, are highly controversial. What are the limits to such depictions? Each photographer must establish his or her own threshold of tolerance and ethical standard. We've all seen the dynamic photographs that result from releasing a snowshoe hare into a compound with a lynx. Hardly serendipitous, they still accurately document an encounter that repeatedly occurs in the wild. Is it right? The rabbit didn't think so. What about offering a grasshopper to entice a bluebird to a photographic position? Or a mouse to a snake?

The final ethical statement about the photograph occurs when it enters the publication, competition, or exhibition arena. It is incumbent upon the photographer to caption accurately all photographs of subjects taken in controlled settings which could otherwise be construed to be wild subjects. This frees the photographer from making a multi-level decision about whether the photograph is

appropriate. The editor makes the decision to use or not to use the photograph based upon accurate information, and the informed viewer may also draw his or her own assessment.

It is essential for the photographer's future credibility that everyone understand which photographs were taken under controlled conditions. Particularly in competitions, images of controlled animals should be judged separately from those taken in the wild. The controlled setting's opportunities for staging behavior, the ease of access to the subjects, and the generally better condition of the animals creates an unfair advantage. Nonetheless, critical standards for photography apply also to controlled subjects, and there is benefit in creating a separate category for them in photography contests.

A fisher is an elusive animal seldom seen in the wild. Portraits of this controlled animal in the setting of a natural-looking enclosure are useful photographic resources for reference works or textbooks.

Photographing in Zoos

The easiest and least expensive location for photographing restrained animal subjects is quality zoological parks. Many offer regularly scheduled performances that showcase birds, mammals, and marine mammals. Before or after the show,

the subjects may be made available, with their trainers, for portrait sessions. Because they are constantly working with trainers and around large numbers of people, zoo performers are usually well-habituated to humans and unbothered by a close approach.

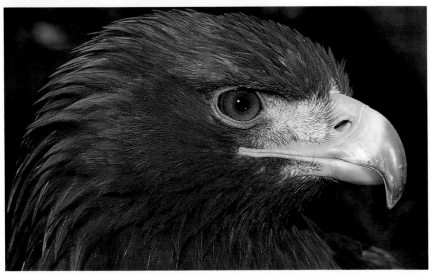

Some zoos offer educational programs that showcase their animals. These subjects become comfortable around people and can be excellent models. This golden eagle was photographed during a workshop at the Portland Zoo in Oregon. A 300mm f/2.8 lens was used to render the background out of focus, and flash supplemented the ambient light.

Some of the more progressive zoos have walk-through displays and aviaries that house mammals and birds in correct natural habitats. Planted with appropriate foliage and flowers, the walk-through displays can provide opportunities for spectacular images of exotic species in nearly ideal photographic settings.

Caged animals offer special opportunities, especially for dramatic portraits of large animals, and many challenges. Techniques for photographing confined subjects are discussed in volume 1 of *Beyond the Basics*.

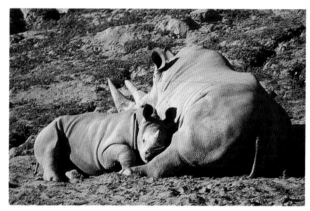

Wait and watch for interesting behavior to add meaning to your zoo photography. These white rhinos were photographed from the back of a Zoo Safari truck at the San Diego Animal Park.

Wild animal parks put the people in the cages and let the animals roam free. Trams, trains, and other vehicles carry people into enclosures so large that they appear to be completely open. For photographers, this offers a variety of backgrounds and perspectives and adds the elements of the landscape.

Zoo photography demands, more than anything, long lenses. That means all of the long-lens accessories must go along too, including tripods and projected flash attachments. All this equipment needs to be mobile, because zoos require a lot of walking. When you have your equipment set up, bring on the patience. You'll need to watch the animal in order to predict its behavior patterns for photography. Wait for the ideal lighting and positioning in relation to fences and other distractions in the enclosure.

Rehabilitation Centers

While some people abhor the concept of captive animals, zoos are in fact the source of most information we have about rehabilitation of injured or abandoned wild creatures. From a photographic standpoint, many of the animals at rehabilitation centers are "flawed" due to their injuries or illnesses. They also may be especially vulnerable to stress. Those who are retained in rehabilitation for a significant time, or who cannot be successfully returned to the wild, may become habituated to people. These are prime subjects for animal portraits.

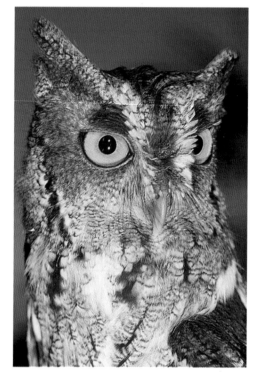

Rehabilitation centers offer opportunities for close-ups of many unusual animals. Be sure that your photography doesn't add stress to an injured or frightened animal. A 100mm macro lens and two flashes were used to photograph this screech owl.

Rehabilitation centers almost always operate on low budgets, and they rely heavily on charitable contributions. Photographers can contribute in the form of volunteer time, financial contributions, or food and other supplies. Photographs of the center's activities and residents are usually welcomed; these are useful in the center's fund-raising and educational campaigns.

Because the enclosures in rehabilitation centers are typically sparse, they don't lend themselves to behavioral or environmental depictions. Some of the resident animals are readily removed from their enclosures for photography in more

natural settings. Portraits are more easily accomplished using medium telephoto macro lenses and zooms that allow you to change your framing without moving unnecessarily around the animal. Electronic fill flash can be employed to great advantage in this situation.

Animals for Hire at Game Farms

Game farms are specifically designed for motion picture and still photography, and many specialize in wildlife native to the location. In addition, they may offer exotic animals that are in demand for photography, such as lions and tigers.

Because photography is their primary objective, game farms typically are situated in areas that offer many appropriate backdrops. They may additionally provide enclosures with appropriate habitat for their animals. Before the animal is brought to the photography site, scout the facility and identify the best locations. This will allow for efficient use of time and reduce the amount of effort required to reposition the animal.

While the animals resident at game farms are usually habituated to humans and many may respond to commands, they are usually not tame "pets." Working with trainers is essential to ensure the safety of animal and photographer. Unless you are willing to pay for private use, expect to work with a group of other photographers. Respect their lines of sight and ideas for positioning of the subject.

A group photographs a cougar handled by Jay Diest of Triple D Game Farm. The cost of this type of shoot may be prohibitive for one individual, but a group shoot makes it worthwhile for photographers and handlers alike.

When working at a game farm, keep the following safety points in mind. They may sound obvious, but they are critical to the success of the session.

• Stay away from vehicles or enclosures used to contain the animals prior to and following photography.

• Don't enter the photographic compound until the trainer indicates that you may do so. Always respond immediately to the handler's requests. Give the animal time to adjust to the photography site.

• If entering or leaving a compound during a photographic session, be sure to secure the gate behind you.

• If a trainer has a problem with an animal and asks you to leave, depart immediately without your gear. You can get it later.

• Make sure that you are carrying no food in your packs or on your person. Most handlers use food to position and reward the animal. Be sure this doesn't show in your photograph.

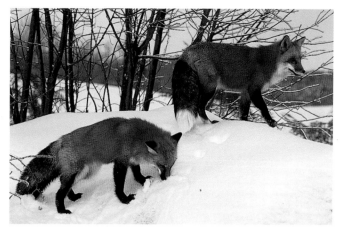

The interaction of two animals adds interest to the image. A 35-350mm lens and flash fill were used with E100SW pushed to 200 ISO.

- Never turn your back on large mammals. Don't assume a crouching position (or bend over to retrieve items from your camera bag) in the presence of large cats; they may react aggressively.
- Avoid sudden movements, especially those directed toward the animal in the compound. Slow, fluid movements will be less disturbing to the subject.
- Don't touch an animal unless the trainer says it's okay to do so.
- To avoid confusing the animal, do not attempt to catch its attention with gestures, calls, or other sounds that will distract it from the trainer's signals.
- When the trainer says the animal is finished, don't push for more. Normal time for working with a single animal is one to two hours, but the animal determines the length of the shoot.
- Remember that animals have bad days and good days, due to seasons, weather, reproductive cycles, health, and attitudes.

You'll want to get as much photography done as is possible in the time allotted, but avoid shots that appear to be set up. Observe the animal and watch for natural behavior. Frame photographs to exclude the handler and any props. Avoid signs of civilization such as fences, cut branches, stumps, telephone poles, wires, and footprints.

It is better to record the animal's interaction with its environment or with another animal than to photograph its reactions to the photographer. Interaction between two subjects in a compound can be a good photographic opportunity if the animals normally would be found together.

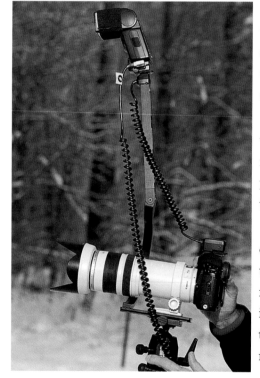

Flash fill used on animals can cause eyeshine, similar to red-eye in photographs of humans. Placing the flash on a bracket (made by Really Right Stuff) above the lens eliminates eyeshine.

Lighting is very important. If it is direct, be sure it falls to the front of the animal. An animal with its head in the shade and hindquarters lit up lacks personality. Fill flash can be a very positive tool if used in a natural way. Setting the flash at two f-stops less than the ambient light is a good way to achieve a natural look. When using flash, be alert to the possibility of eye shine in nocturnal animals. This can be avoided by moving the flash further away from the axis of the lens.

Trained Animal Models

Animal models have been trained to perform one or many actions reliably, which offers the photographer increased opportunities to record action sequences. When, for example, a trained cougar will repeatedly run from one point to another, either directly towards or parallel to the camera, the

photographer can try several variations of film, frame, and light to optimize the predictability of the subject's behavior. However, trained animal subjects most likely will be working for food, and once they are no longer interested in eating, they will stop performing. When they become sated, tired, or sleepy, the action is over, but you may be able to use this time for portraits.

Trained animal models are usually very expensive because they are primarily employed by the entertainment industry. If you have the chance to photograph one, optimize the session by working efficiently. Because you can easily control the animal's range, you can be especially cognizant of the background and lighting. Choose natural and undistracting settings for this work. Early morning sessions allow natural light at low angles to fill in deep-set eyes and give the subject a more lively look. Fill flash can improve the subtle detail in the photograph.

While not often possible, the very best results can be achieved when you photograph the same animal on two separate occasions. After processing the film from the first session, return to make needed improvements in technique and position.

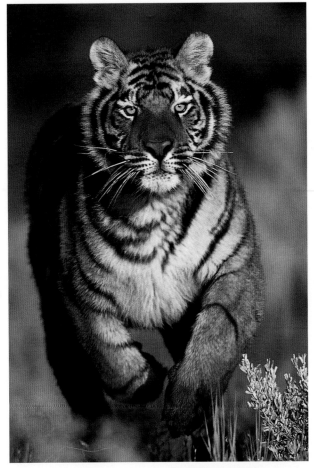

Access to a predictable, trained animal greatly improves the photographic possibilities. This tiger is trained to run from Point A to Point B for food. A Canon EF 600mm f/4L lens used with autofocus yielded many sharp images from the session.

BJ the Bear is a hands-on grizzly. He offers many photographic opportunities not possible with wild bears, or even with game-farm grizzlies that are kept at a distance. The rapport between BJ and his trainer is inspiring, but don't try this at home.

Exotic Pets

Exotic pets such as parrots, reptiles, and some breeds of small cats are commonly and inexpensively available in private homes. They are usually easy to

A photo setup at home using pet birds—such as these rosella parakeets from Australia—can produce excellent results. Make sure that the setting is accurate or neutral. A 70-200mm zoom lens and five flashes were employed for this image.

handle, and the setting is controlled. It is important to work only with legal, well-maintained animals. To do otherwise is to promote the black market trade that decimates such species in their natural habitats.

Ask the owner to help you by handling the animal. Generally the subject is more comfortable and safer with a familiar person. You can make complete sets for photography, or, if the animals travel easily, take them to appropriate locations. Make sure the environment is completely neutral or natural and appropriate to the animal. Parrots, for example, look out of place in pine trees.

Because you have complete control, strive for excellent image quality with careful lighting setups for portraits. Complete flash or flash fill are appropriate. But avoid contraptions such as large reflectors if they appear to disturb or frighten your subject. Since the animal usually will be available again for photography, there is no reason to overtire it. Spread the photography over several sessions, each time improving your technique and results.

The Photographer's Obligations

In your efforts to get the best shots by using controlled animals, be alert to the quality of the facilities and trainers that you encounter. Don't frequent poor ones, but go out of your way to support the good ones. Make sure your photographs are accurate in terms of the behavior and environments they depict; you may not always be able to control how your photographs are used later. Be sure that every photograph you release is properly annotated so that there will be no misunderstanding the circumstances under which it was accomplished. As you are working, think about the ethical questions that revolve around the use of controlled animal subjects. Your own standard should govern your work, but be open to the views of others. In particular, let the criticisms of such photography be heard; this will focus attention on the facilities and trainers that offer controlled animals and improve their quality.

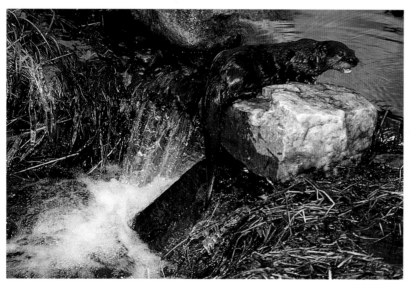

This river otter photograph looks very natural, but still it should be identified as a controlled animal. How the publisher uses the photograph, or whether the published caption conveys the animal's controlled status, are factors usually beyond the photographer's influence.

AMMALS IN THE FIELD

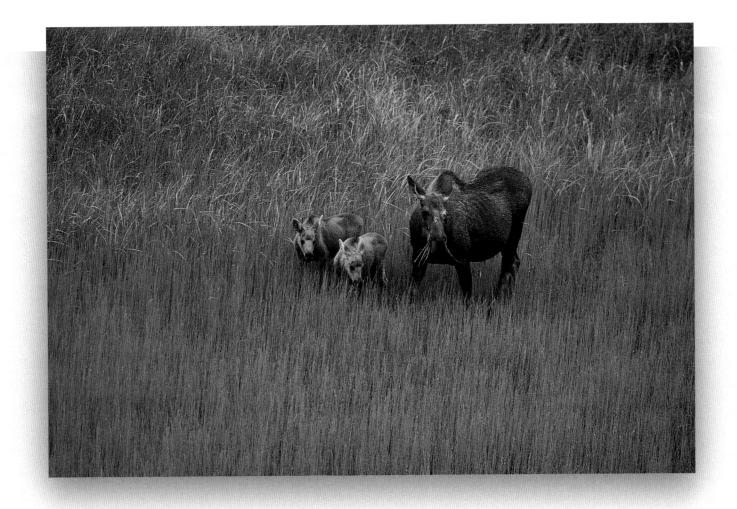

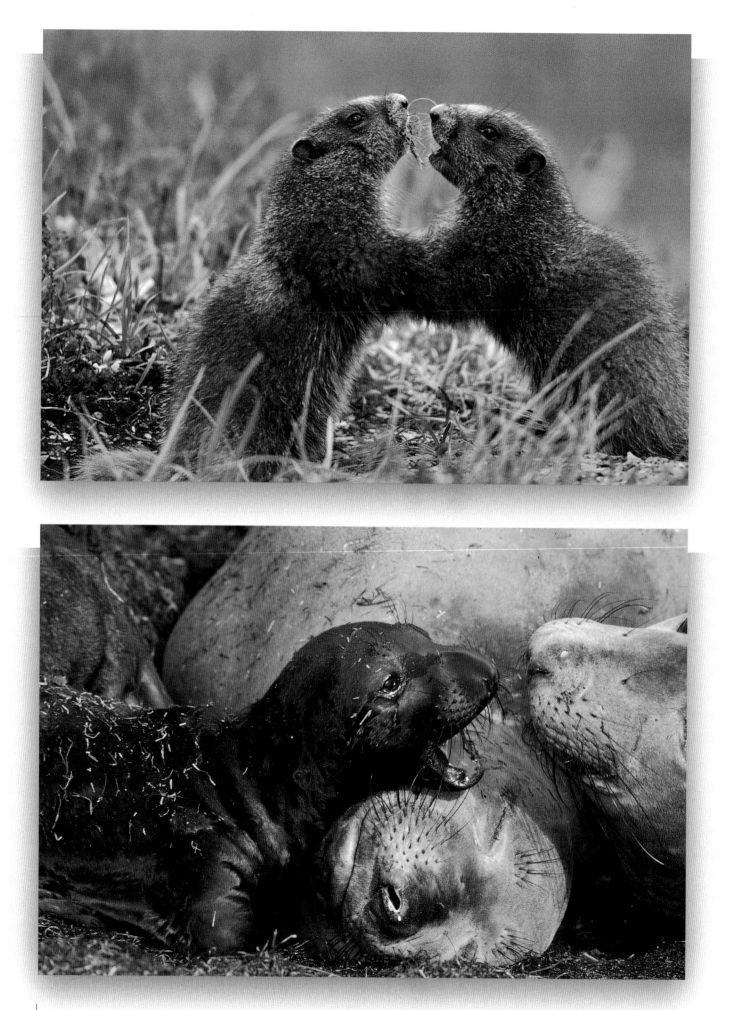

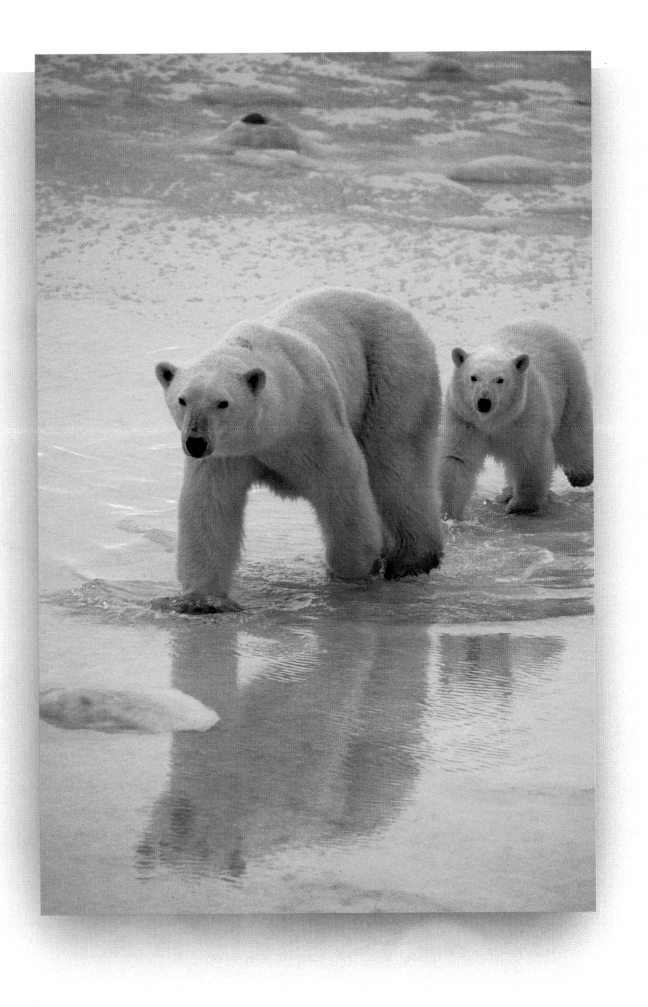

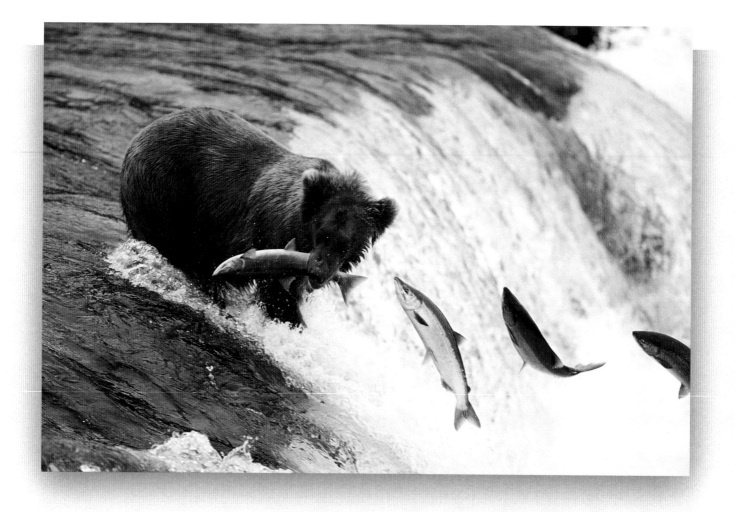

Moose with Twins. A serendipitous encounter below a highway turnout near Denali National Park, Alaska, brought us a long sequence of shots of this moose family. Significant photos are where you find them—sometimes literally around the next bend.

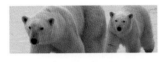

Polar Bear with Cub. Churchill, Manitoba, Canada. An ear tag and neck paint can spoil an otherwise "natural" photograph. If I had eliminated the flaws with my computer programs, would the photograph still be credible?

Black Bear and Red Rose Hips. Yellowstone National Park. From the relative safety of the road, and with a long, long lens (600mm), several others and I photographed this bear as it sauntered through rose thickets. In one rare moment, the bear looked up, the light struck its face, and a big hairy mammal was captured on film. Although I followed this animal for a considerable amount of time, only a few such photographic opportunities presented themselves.

Olympic Marmot Playmates. Olympic National Park, Washington. Small mammals can be interesting subjects, especially when you catch them interacting with one another. Observation with binoculars from a distance showed which burrows were active. I quietly and slowly moved myself toward the burrow, waiting at intervals for the animals to accept my presence.

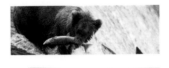

Brown Bear with Salmon and More Salmon. Photographing from a platform at Brook's Falls in Katmai National Park, the photographer tries to anticipate the salmon jumping and the bear catching. Delays in reaction and equipment make the task difficult. The answer is to try again and again. Serendipity may smile as she did here. A Canon EF 600mm f/4L lens was used with Fujichrome 100 film.

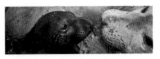

Elephant Seal Females with Pup. San Benitos Island, Baja California, Mexico. It's not hard to get close to these marine mammals as they lounge in the sun. A 300mm f/2.8 lens with a 2X tele-extender (600mm) gave sufficient distance to keep the animals oblivious to the photographer. A photograph with some interest and information requires patience and observation. Projected flash was essential to add detail to the dark pup positioned against the light-colored adults.

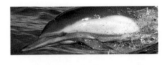

Common Dolphin. Pacific Coast, Baja California, Mexico. Marine mammals, such as dolphins and whales, only show themselves to photographers a small percentage of the time. The need to be constantly at the ready calls for an autofocus zoom lens. This portrait was taken with a Canon EOS-1N and a 35-350mm zoom lens.

\mathcal{M} AMMALS IN THE FIELD

Humans are fascinated by large, dangerous mammals, and photographers are set upon capturing the largest, the strongest, and the most threatening on film. Proof of successful stalking and survival of a face-to-face encounter in the wild now can be brought home in the camera instead of draped over the hood of a car, making photography an improvement over sport hunting. With photography, the thrill of the kill is replaced by temporarily entering the animal's territory and recording its most private behaviors. In this contest, as in sport hunting, the prize—publication—is given for bagging the biggest males, the presumably most worthy adversaries, and the most dangerous opponents.

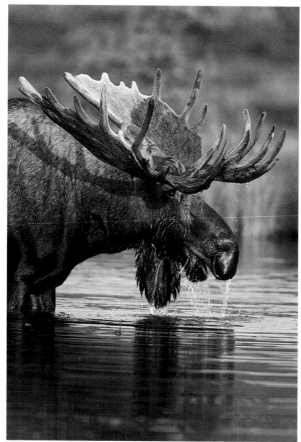

A large-racked bull moose photographed at fall rut is an image trophy many nature photographers would prize. But more photographers should consider the pursuit of mammal subjects other than the usual large mammals. This image was taken in Denali National Park, Alaska, with a Canon EF 600mm f/4L lens and 100 ISO slide film.

Large hairy mammal syndrome, a condition where photographers are interested only in getting images of the biggest and best trophy animals, has reached epidemic proportions. Accompanying symptoms are clogged roads in Yellowstone, bus-loads in Denali, and overcrowded viewing platforms at Katmai. There is little pride in witnessing a horde of professional photographers in hot pursuit of a single bull elk. The bottom line is that there are simply too many people looking for the easy big mammal photo and a perception that there is a large market for such images.

The market isn't really there except for a select few specialists, and that leaves the thrill of the chase as the reason to attempt large-mammal photography. So here I'm going to provide some suggestions for alternative pursuits. Off the beaten path you'll find the photographic challenges to be much more rewarding, the time to observe your subjects to be much more fulfilling and educational, and you may decide that, for yourself, photographs of females and immature large mammals, and all kinds of small mammals can bring you great satisfaction. If you like to be alone, and if you want your photographs to be uniquely yours, choosing the unlikely subject or location will keep rangers off your back and your fellow photographers out of your path.

Large Mammals

You can find opportunities to photograph large mammals in the less-frequented national parks, wildlife refuges, state and county parks, and private preserves. Each of these venues has different rules about approaching wildlife, and it is the visitor's responsibility to be aware of the rules. Most of all, follow the rule of common sense, for your own and the subjects' sake. If the photographer has a risky encounter with an animal due to his or her own carelessness, the animal is more likely to be killed than the photographer. For

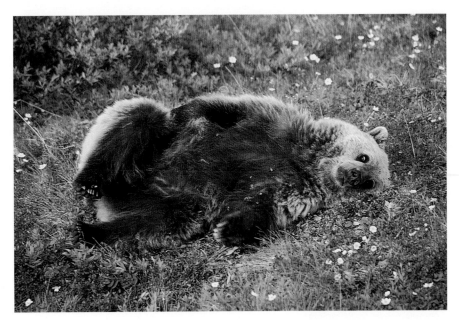

This laid-back grizzly was photographed in Denali National Park, Alaska, from a small bus designed for photography groups. The bear is clearly unconcerned about the observers at close range. A 35-350mm zoom lens with 100 ISO slide film was used.

exercising its normal behavior, protecting its young, territory, or food sources, the animal may be irredeemably spoiled by human contact. This condition sometimes results in the animal's execution by park management.

Each species, and each individual within it, has its zone of tolerance, commonly referred to as the fight-or-flight threshold. A conscientious photographer will be alert to slight modifications in behavior that indicate the animal's level of concern about the photographer's approach. Laid-back ears, or the twitching of a tail, even if the animal is not looking at you, may indicate awareness of your presence. Some predatory animals may give outright warning signals. A standing grizzly bear is trying to get a better look at you or to appear bigger so as to scare you off. If he gives a woof-like grunt, he wants you gone—now. When well-executed nature photography is completed, the animal is still undisturbed and in its original location.

In certain seasons some animals will be more aggressive. Males are more likely to challenge your presence during rutting or breeding season, and females will actively protect their young in the spring. Late winter and early spring can be particularly critical times for large mammals; they may be weak from the food scarcity of the winter months. The sensitive photographer will take great care not to cause additional stress to a threatened animal, further reducing its chances of survival.

The biggest danger to your own welfare may be those shooting with guns, so stay out of posted areas during hunting season. It's not worth it anyway, because the animals during hunting season are so skittish that they will never sit still for a portrait session.

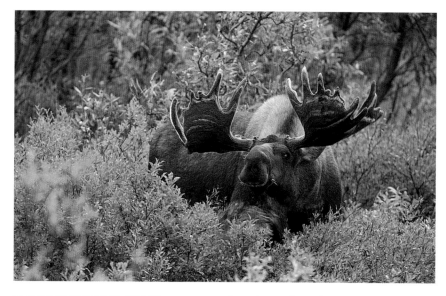

A bull moose acknowledges the photographer's presence. Common sense would dictate the photographer's slow retreat. A bull moose is unpredictable, especially during rut. A 600mm f/4 with 1.4X tele-extender (840mm) is the lens for distance here.

To get close to larger mammals, you need to minimize the human form, movement, noise, and scent.

The human form can be disguised with camouflage clothing; choose a fabric that blends with the colors in the area in which you are working. It's important to cover the hands and the face, because these human shapes and their movements are uniquely recognizable to many animal subjects. Along with the camouflage, use natural cover such as bushes, trees, and rock outcroppings to cover your approach. Camouflage is useful to hide yourself from curious onlookers as well.

Your movement should be slow and fluid, and you should progress when the animal is looking away from you or is preoccupied with its normal activities. It will take considerable patience to approach a large animal, and it is not unusual to require a time-consuming stalk to get in photographic range. Take care that the equipment you carry doesn't give you away with its light color or shiny surfaces. When purchasing tripods, choose dark, matte finishes instead of chrome. Cover light-colored lens housings with camouflage tape.

Reduce the noise of your approach by carefully placing each step. Avoid branches, dry leaves, and other crackling items underfoot. A particularly disturbing sound to most animals is the metallic sound of two pieces of equipment in contact with each other. The mechanical noises of camera functions, such as shutters and motor drives, can be a problem with some sensitive animals. Choose cameras with quiet operations such as the Nikon F4, F5 and Canon EOS. If you're with a colleague, speak in low tones or not at all.

A pair of professional nature photographers working with bison in Yellowstone National Park give the animals plenty of distance and always keep their escape routes open.

The photographer's scent needs to be considered when stalking some animals. In national parks and other places where there is considerable contact with human beings, scent is not an important factor. But in remote areas animals are very sensitive to the scent of predators, and they think you are one. To eliminate the problem, work downwind, which may not put you in the most desirable position for photography. Or purchase commercially available products that cover human scent.

Some techniques that will help to achieve better large-mammal photographs are to use the longest possible lens and to know the animal's habits and position yourself for photography accordingly. For example, if your subject frequents a particular watering hole, you may set up a blind and wait for it to come to you. Animals are more active early and late in the day, so have faster films and lenses available for low-light shooting. If you are working from a vehicle, stay in it.

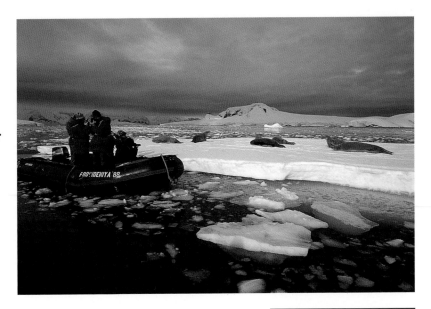

Marine Mammals

Marine mammals present a host of unique problems to the nature photographer. Some spend a great deal of time under water, many species are highly mobile, and photographic locations are typically remote and sometimes require watercraft for access. Photographing from boats can be difficult because the platform is so unstable; special measures need to be taken to control camera movement. Reflections from water and from wet animals make exposure calculations more complex. And care must be taken to observe species conservation measures, as well as to protect yourself from a few marine mammals that can be dangerous.

Working from the shore can be effective with seals, sea lions, walrus, and otters. But it is important not to disturb concentrations of mammals on the shore, because young may be trampled in the exodus you cause. Some males, and even females, may be dangerous on the shoreline, and they can move more quickly than you expect. Calculating exposure of animals on shore can be tricky due to light-colored sand, wet, dark-colored fur, and the light absorption and reflectance of these variables.

Working from boats is necessary with dolphins and whales. Large boats often are able to maneuver close to groups of whales, and on occasion the animals will directly approach the boats. Dolphins are particularly attracted to larger moving boats, where they ride the "pressure wake" off the bow. From large boats, photograph with hand-held cameras for the most part, although in some cases a monopod may be useful. Tripods should not be used from boat decks, since they transfer the vibration and movement of the craft to the camera. The larger the boat, the less vibration and the more stable the platform for photography. Take extra care to protect your gear from banging against railings. Wear the camera strap around your neck, and avoid positions where spray may reach you and your equipment.

Photographing from boats presents the challenges of an ever-moving platform and keeping equipment dry.

Photographing marine mammals such as elephant seals from the shore demands long lenses and a sense of what's happening around you. An animal pushing past from behind or two in heated interaction may cause problems for the unwary photographer. A 300mm f/2.8 with 2X tele-extender (600mm), flash fill, and E100S film were used.

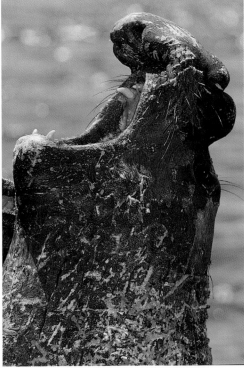

Place the camera in a large, dry-bag when in transit or when water is splashing into the boat.

Small boats exacerbate the problems of moisture on the equipment due to the spray from the moving boat and, if you are very lucky, from whales blowing next to the skiff. To protect your gear, use plastic bags over cameras, commercial wet-bags, and even underwater housings. The quickest method is to wear a waterproof jacket and keep the camera inside it except when you're shooting. A sealable dry-bag offers the most protection because the camera and its accessories can be completely sealed inside when there are suddenly heavy seas or an aggressive whale pushing the boat around.

Autofocus has proven to be a very important advance for photographing whales and dolphins, because while you may have time to frame your subject when it is above water, seldom is there enough time to focus critically. Also needed are fast shutter speeds due to boat movement and subject movement. 100 ISO slide film and 200 ISO print film are the best compromises for speed, color, and sharpness. When photographing whales from small boats, it works best to have two camera bodies. The first, one with a wide-angle lens, is essential when whales such as friendly grays are close at hand and more than fill the frame at 28mm. A second camera fitted with a mid-range (80-200mm or 100-300mm) telephoto zoom is used to capture the spy-hops and breaches, and for close-ups and details such as eyes, blow holes, and attached crustaceans.

Many breaches happen in multiples. Listen to the skipper or resident biologist for information about the whales' behavior that might make you better prepared for the repeatable decisive moment.

When traveling on large boats, you always should have a camera loaded and ready for dolphins. Large groups of dolphins can come from nowhere and be bow-riding and wake-riding the boat within moments. The best lens to photograph bow-riding would be a wide-angle to normal zoom (24-50mm or 28-80mm), because the animals will be directly below you; for wake-riding behind the boat use the mid-range telephoto zoom lens (80-200mm or 100-300mm). Often it is best to pick a single animal from the group and follow it as it swims; be ready for the moment that it breaks the surface and leaps.

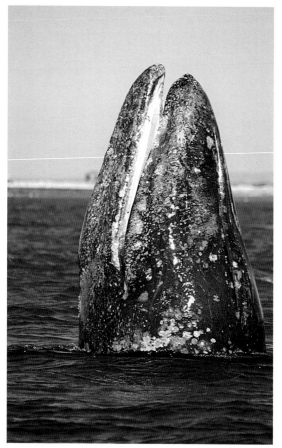

Spy hops and breaches are quick and unpredictable happenings. Autofocus and zoom lenses are critical for images like this one of a spy-hopping gray whale in San Ignacio Lagoon, Baja California, Mexico. A 35-350mm zoom and E100S film were used.

A camera in an underwater housing can be used effectively with a wide-angle lens attached. The photographer holds the camera in the water over the side of the small boat. Lenses as wide as 14mm give the best results due to the closeness and size of the animals. Some of the limitations of the underwater technique are cloudy water and the need for lots of depth of field. 100 ISO film pushed to 200 ISO helps to solve the problems.

Luck, autofocus, and a zoom lens are the necessary elements for capturing breach shots. A 35-350mm gives the photographer a lot of options and can still be hand-held from a small boat.

Many rolls of film are exposed to catch just a few images like this one of common dolphin. A 35-350mm zoom and E100S film were used from a moving boat. A motor drive and autofocus contributed to the successful shoot.

Sometimes the whales are close, so a wide-angle lens is handy. It's good insurance to keep a second camera body with a wide-angle lens in a dry bag nearby.

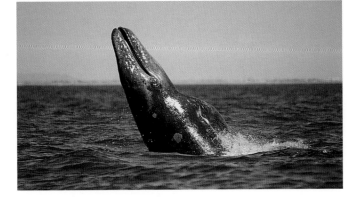

Small Mammals

There are far greater populations of small mammals than large. They're easier to find, less susceptible to disruption, and they are every bit as interesting as the larger mammals. There is a fairly good market for images of some smaller mammals such as wolves, foxes, coyotes, and weasels, especially those with young. Den sites can be very sensitive to disturbance, however; be careful not to force the animals to relocate because of your activity.

When preparing to photograph small mammals, study their behavior, habitats, and patterns that will lead to predictability. You will take better photographs if you understand the meaning of the behavior you are recording. In addition to library research, it can be helpful to consult with a biologist.

Some environmental hazards come with photography of small mammals. Fleas and ticks can cause illnesses such as Lyme disease and Rocky Mountain fever, and

Small mammals are an appealing subject, and they offer as many challenges as the large hairy mammals—but without the danger. These Idaho ground squirrels are representatives of an endangered species that soon will disappear from the planet. A 300mm f/2.8 with a 2X tele-extender (600mm) was chosen for its close-focus capability.

Even the lowly pocket gopher can be an amusing and profitable subject. A slow approach to the burrow and flash fill will produce an image like the one to the right. A Canon EF 180mm macro lens allowed the close focus.

even the dirt in some areas can harbor microbes causing Valley fever. Wear insect repellent around openings in clothing, and know how to identify and to deal with ticks if they attach themselves to you.

Food can be a great motivator to bring small mammals closer, but be sure it will not be harmful to the animals. Salty foods can upset the animals' metabolism, and water may not be available. Soft foods, like chips, can be taken back to the food cache and, because they spoil quickly, can contaminate the entire food supply. Foods that can be used with little danger are natural foods such as unsalted raw nuts. Care must be taken not to cause your subjects to lose fear of humans or to habituate them to feeding, especially near roads where they will encounter frequent danger. It is illegal to feed any animal in a national park!

Another method of photographing small mammals is through the use of trips and beam splitters. This works especially well with nocturnal species that follow standard routes or with subjects lured by bait into an area for photography. Two of the commercial tripping systems available are the Dale Beam and the Shutter Beam.

In some cases, recorded calls can be used to bring small mammals such as foxes and coyotes in close for photography. Effective calls include those of injured small animals or territorial calls of the species you are trying to attract. Be aware that such calls may draw animals into others' territories, or cause them to expend energy protecting their space when no intruder actually exists.

When photographing small mammals, use long lenses that focus fairly close, and blinds set up near dens or burrows at times when young are well-enough developed to emerge. Sophisticated lighting methods such as fill flash and projected flash can add considerable information to photographs of small animals and increase their appeal by sparking their eyes and adding sheen to their fur.

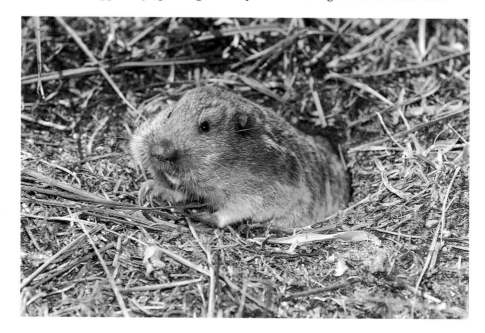

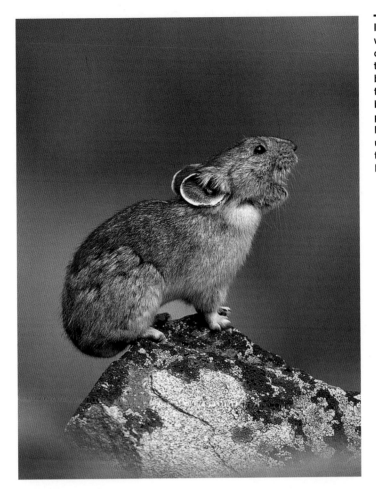

If you wait patiently, a pika will return to its favorite observation post and continue to bark calls. Capturing behavior—other than a reaction to the photographer—should be the goal of all nature photographers. A 300mm f/2.8 lens and 2X tele-extender were used with 100 ISO slide film to catch this pika in Yankee Boy Basin, Colorado.

When photographing mammals in the field, look for healthy specimens doing what comes naturally. This coyote was photographed with a 600mm f/4 lens from a vehicle in Yellowstone National Park .

A photograph of any kind of animal—large or small—is more informative, interesting, and evocative when the subject is depicted in natural settings and exhibiting unfearful behavior. Due to the high profile of large animals and those photographing them, accurate portrayal of large mammals is especially critical. Any suggestion that the photography itself placed the subjects at risk or the photographer in danger can lead to added controls on our future access to these desirable subjects. As an alternative, look towards smaller mammal subjects in less-trodden venues. The end results can be as dramatic and the photography as enjoyable as pursuit and capture of the large hairy mammal.

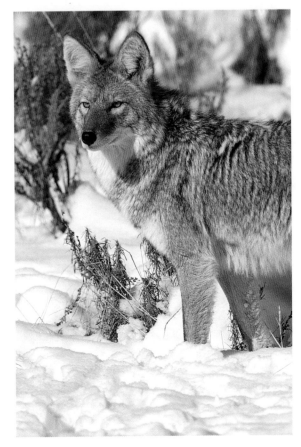

AERIAL LANDSCAPES

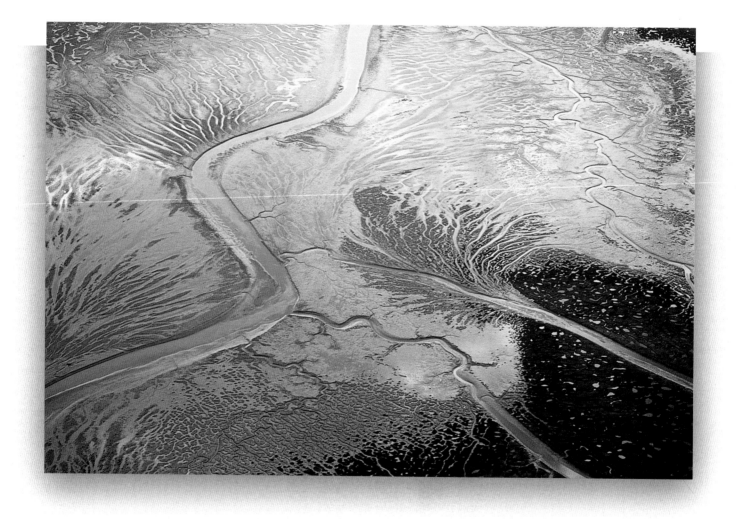

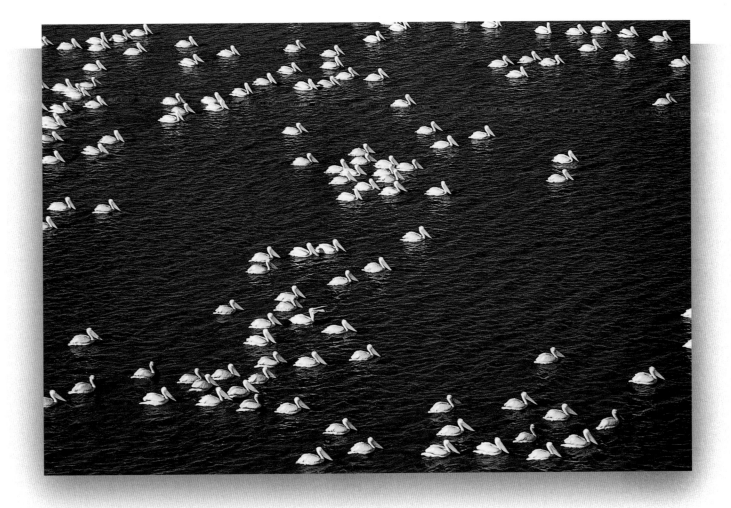

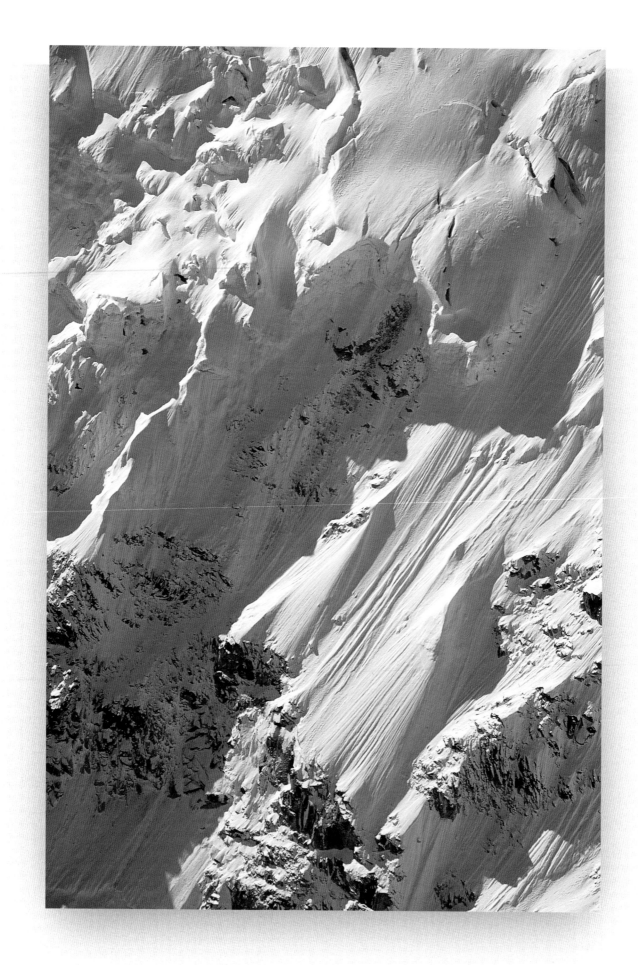

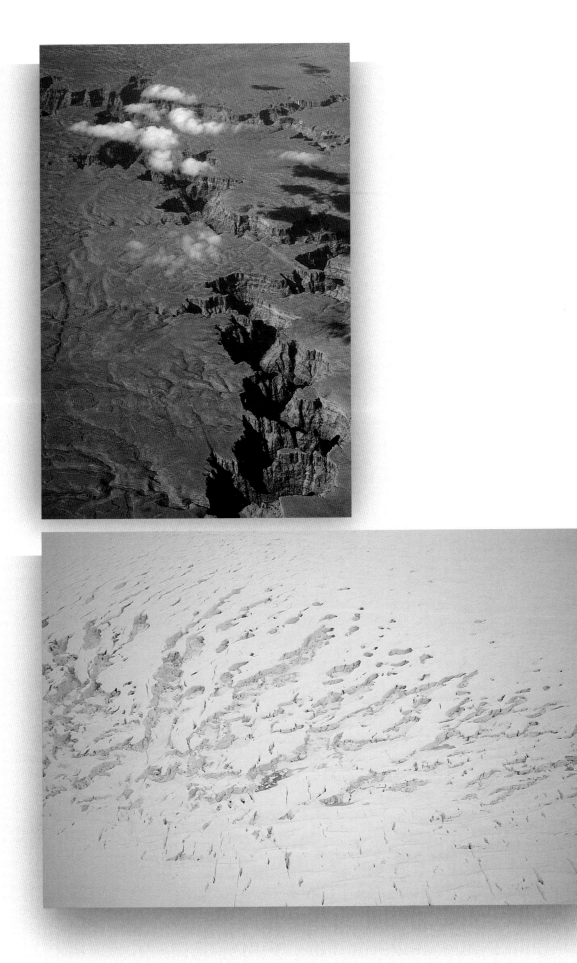

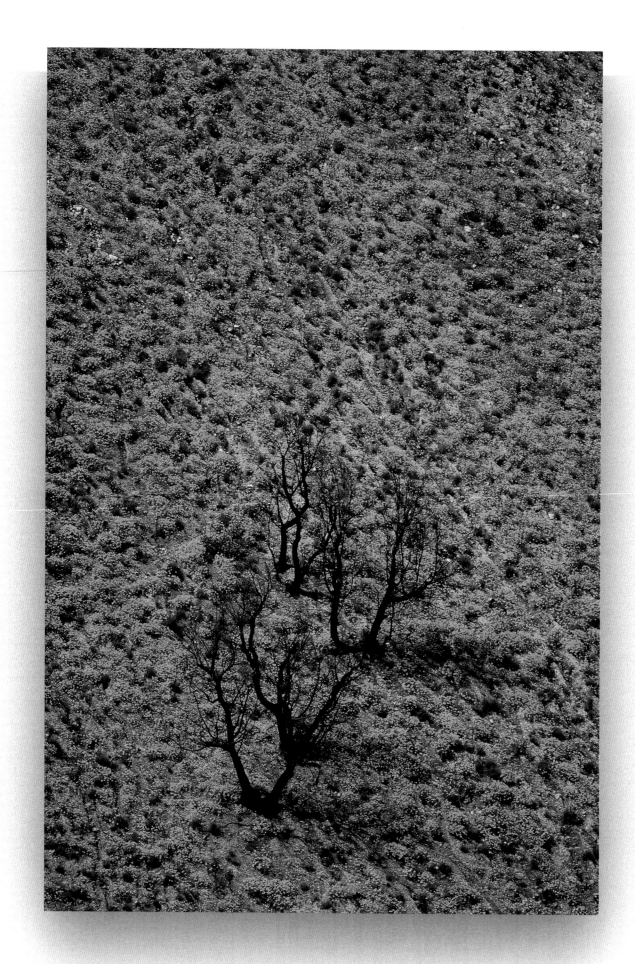

Mud Flats on Morro Bay, Morro Bay, California. From a small, fixed-wing aircraft, I found nice light and design elements close to home. A 28-105mm zoom lens was used.

Canyon. Arizona. This perspective from 30,000 feet is only attainable from an airliner. Necessary for significant photography from an airliner are a window seat on the shady side of the airplane, a clean window, and clear atmospheric conditions. It happens just often enough that I always carry a camera with me when I fly.

White Pelicans at Rest. Southwestern Louisiana. From a fairly low altitude—but not so low as to disturb the resting birds—I photographed these white pelicans with a medium telephoto zoom lens. The zoom lens allows you to change altitude without adjusting the airplane. The lower the altitude, the faster the shutter speed needed to compensate for the speed of the airplane relative to the ground.

Glacier Pools. Southeast Alaska. A float plane and a bush pilot brought me to this position over Shake's Glacier which yielded design images fashioned from a river of ice. In order to achieve the extremely fine detail required for this photograph, the plane's Plexiglas window had to be opened.

The Flanks of Mt. McKinley. Denali National Park, Alaska. A small plane can take you only half-way up this mountain, but dynamic aerial landscapes give a different perspective of McKinley's rugged terrain.

California Poppies. San Luis Obispo County, California. A burn area began rebirth with a fabulous wildflower display. The close detail on this hillside was obtained with a 300mm f/2.8 lens with an attached gyro-stabilizer. An extremely fast shutter speed of 1/4,000 second was necessary to counteract the groundspeed.

\mathscr{A}ERIAL LANDSCAPES

Aerial photography provides an entirely different perspective for landscapes that pique the interest of all non-avian viewers. Most of us have become familiar with the view from airliners at 35,000 feet, and satellite images of the earth are common. But from such spectacular distances, we miss the recognizable details to which the viewer can relate. From elevations of 500 to 2,000 feet, the familiar groundscape can be seen in a most unusual way.

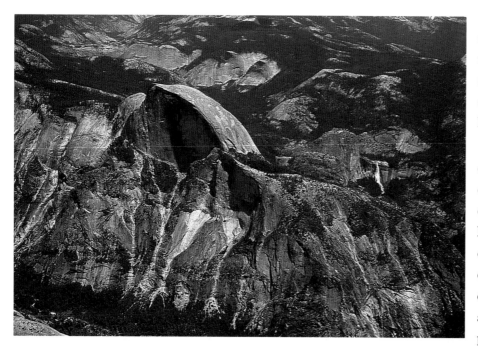

Few have seen Yosemite's famous Half Dome from this perspective. The aerial view is a different way of presenting landscape photography. A 28-105mm zoom lens was used with 50 ISO slide film.

The best way for the average outdoor photographer to get the close-up view is from a small, fixed-wing airplane. Other good platforms, but considerably more expensive, are helicopters and hot-air balloons.

The aerial perspective alone is not enough to support the image, however; lighting and composition are as essential for aerial as for terrestrial landscapes. Magical early morning or late-afternoon light, God rays, a center of interest, or a strong design element will elevate the aerial photograph from a simple new perspective to a significant image.

Equipment and Techniques

Since aerial photography is about details, the camera, lenses, and films used must enable high resolution. Techniques that minimize camera movement are even more important from the airborne platform, because sharpness will be compromised by the motion of the photographer, the plane, and vibrations from the engine and airframe.

Cameras. Critical sharpness for aerial photographs can be achieved with most of the cameras used by serious amateurs, including both 35mm and medium-

format systems. Some photographers prefer medium-format for aerial photography because the larger negative needs less magnification in the final presentation, which can improve clarity. Today's versatile 35mm systems coupled with the newer high-resolution films are also excellent tools for achieving high-definition aerial images.

The metering systems within the camera can be an excellent exposure guide in either matrix-metering or spot-metering modes. Due to contrasts in light or subjects, the ground image is often a mixture of light and dark patterns which must be integrated to give equal importance to all elements of the image. Under such conditions, matrix metering averages the different readings to determine the optimal exposure for the image. When a center of interest in the image is indicated by its own particular lighting or color, spot metering keys the exposure on the most important element.

Every photographic opportunity is critical in the air. The cost of getting up there, the difficulty of getting into position, and the inability to hold the position, call for bracketing exposures. Cameras with autoexposure bracketing will shoot three frames in sequence with either half- or third-stop variances in exposure. Back on the ground, you can look at the set on your light box, choose the best one, and know that you've made the most of the particular situation. Of course this technique uses more film; but the film is cheaper than repeating the flight.

The camera's autofocus capability is not a critical factor because the camera will be focused at infinity for most aerial shots; this allows many older non-autofocus cameras to be excellent instruments for aerial photography. Set the focus while looking through the viewfinder, even though you know the range of the subject is definitely at infinity; on many lenses, the infinity mark is not accurate. This is especially true if you are doing aerials with a medium-to-long telephoto lens.

A camera body that functions quickly and is easily loaded and unloaded is important in aerial photography. The airplane is seldom in ideal position for very long. A winder or motor drive will hasten exposure bracketing and keep you at the ready.

Lenses. A variety of lenses can be used from the air, depending upon the needs of the photographer to interpret the desired groundscape. Quality zoom lenses are extremely useful because they allow immediate reframing of the subject without changing the altitude of the airplane. A disadvantage of single-focal-length lenses is the time lost in mounting and unmounting them while the plane continuously changes its position. One way of improving the situation is to use more than one camera body with different focal length lenses mounted, but often this is difficult in the confined working space offered by a small plane.

A quality lens is usually at its highest resolution capability when stopped down

With a zoom lens and careful technique, design elements can be carved from the aerial landscape. When flying low and using a zoom lens, use the fastest shutter speed possible to minimize the effects of ground movement and vibrations from the plane. These wave patterns were taken with a 100-300mm zoom from about 750 feet.

one to two f/stops. Using this as a starting point, the necessary shutter speed can be quickly determined; the combination will represent the best configuration of shutter speed and f/stop for that lens. For example, a 28 to 80mm zoom lens with a maximum aperture of f/2.8 should be used at f/4 or f/5.6 to extract the highest resolution—even to the edges of the frame—and the best light distribution over the image area. On a sunny day, with 100 ISO film, this would dictate a shutter speed of either 1/1,000 second at f/5.6, or 1/500 second at f/8. The best choice would be the latter (and one-half stop brackets on either side) because the 1/500 second shutter speed is sufficient to minimize movement, and the aperture is slightly sharper than the f/5.6 setting. However, another factor affecting shutter speed is the altitude from which the photograph is being taken. At a lower altitude, such as 500 feet, the 1/1,000 second speed at f/5.6, or even 1/2,000 second at f/4, might be a better choice to compensate for the effect of relatively fast ground movement.

Wide-angle focal lengths in the range of 20 to 35mm (whether zooms or single focal length) are useful for minimizing negative atmospheric conditions such as smog and haze, because they allow you to stay close to the ground while covering a large angle of view. Unfortunately, this angle can sometimes inadvertently include parts of the wing, wing struts, and landing gear of the plane. Be sure to take into consideration the percentage of image area shown by your viewfinder. A 92% viewfinder may present surprises around the edges of the processed image.

Mid-range focal lengths, from moderately wide-angle 28mm to beginning telephoto 105mm, are the most-often used for aerial photography, and the zooms in this range are especially useful for quick reframing without changing altitude. The longer the focal length, the faster the shutter speed required, because telephotos magnify not only the image, but also the problems associated with the plane's movements and vibrations.

Telephotos, from 75 to 400mm, are used in special instances to isolate and emphasize a particular ground feature. The percentage of critically sharp images is greatly reduced with the longer focal lengths because of the magnification of

ground and camera movement. The greatest emphasis must be placed on fast shutter speeds and techniques that protect the camera from vibrations. A gyro-stabilizer is especially helpful in such circumstances. At low altitude, a large image of a small detail can be achieved by using a 300mm f/2.8 lens combined with the gyro-stabilizer. Due to the lens's acute sharpness even wide open and the fast shutter speed at f/2.8, detailed images are possible at altitudes as low as 500 feet.

Canon's Image Stabilization 75-300mm f/4-5.6 zoom lens will work very much the same way as the gyro-stabilizer combination previously mentioned. At 300mm, this lens is a slower f/5.6 which will require slower shutter speeds. At approximately $600, this lens is much less expensive than a gyro-stabilizer, which sells for around $2500. Several additional Image Stabilizer lenses will be available in the near future, and they will most likely be ideal for aerial photography.

Film. For maximum sharpness in aerial photography, we have been restricted in the past to 25 and 50 ISO transparency films because of their superior resolution and high color saturation. Recent developments in 100 ISO transparency films allow us to gain a full stop in either shutter speed or aperture while still maintaining resolution and color enhancements almost identical to the slower ISOs. The finest details of the groundscape can be discerned on such films, even with the diminutive size of a 35mm transparency. Photographers shooting prints can use any of the several excellent high-resolution print films up to 200 ISO. Generally, the best results with prints would be obtained with the 100 ISOs because of their optimum color, resolution, and additional speed. Print films offer another advantage in aerial photography. Exposure bracketing is not required because of the exposure latitude of the film, which can be adjusted for slight variances in the lab. Still, more than one exposure of the same scene will serve as later insurance against lost or damaged negatives.

Adjustments in the processing for transparency films can overcome the problems associated with low-contrast atmospheric conditions, such as light-diffusing overcast or haze. Contrast can be regained if 50 ISO film is exposed and processed at 100 ISO. This method, called "pushing" the film (shooting at an elevated f/stop and processing to accommodate the resulting underexposure)

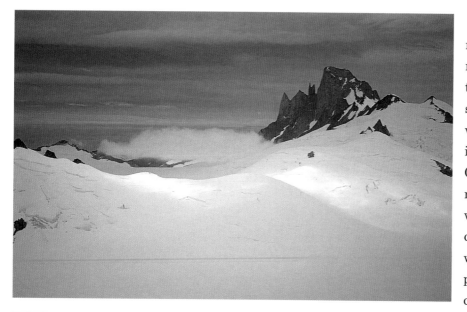

A low-contrast situation can be greatly improved with a high-contrast film, such as Fujichrome Velvia, or by push-processing to further increase contrast. This glacial field was photographed in Southeast Alaska with a 35-350mm zoom, using Velvia push-processed to 80 ISO.

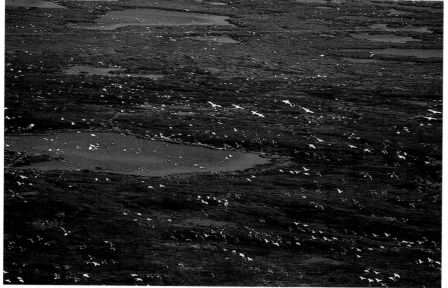

A polarizing filter darkened the water and helped to separate the many snow geese from the land below them. The polarizer loses 1.5 stops of light, so it can't always be used. This scene was photographed in south Louisiana with a 100-300mm zoom lens and 50 ISO film.

maintains nearly all of the film's high-resolution capability and color saturation while considerably elevating the scene's contrast. Pushing the ISO worked exceptionally well, for example, in photographing Alaska's Le Conte Glacier from the air. The weather was marginal for purposes of photography, with just enough openings in the cloud cover to make being in the air worthwhile. When Fujichrome Velvia was pushed by one stop, the increased contrast defined the configuration of the glacier, while the film's great color saturation emphasized the brilliant blue of the pools in the ice.

Filters. Every filter slightly degrades the image taken through it, even if as a single factor the fault is not readily apparent; so use filters only when a particular effect is necessary. In aerial photography, eliminating the degradation caused by a filter becomes more important when combined with the many other variables that erode image quality. With modern lenses' multiple anti-reflectance coatings, along with the excellent color rendition available in films, it is unnecessary to use anything more than an occasional polarizing filter for aerial photography. Under certain conditions and at the correct angle to the sun, the polarizing filter can cut some haze and backscatter from atmospheric moisture while increasing contrast and saturating some colors, especially blue skies. Filter use is a personal choice, of course, and others will extol the use of many kinds of filters for aerial photography.

Gyro-stabilizers. Many great photographs are taken outside of the realm of easy and on the fringes of impossible. In aerial photography, these conditions include extremely low light, low altitudes, and longer-focal-length lenses, all in addition to the hand-held camera and the vibrating platform. For the really serious aerial photographer, a gyro-stabilizer can be the decisive enabling factor in such difficult conditions. Manufactured by Ken Lab in Essex, Connecticut, this important professional tool minimizes the

the effect of the photographer's movements and of much of the airplane's vibration. Attached under the camera or lens collar, the gyro-stabilizer is a small pod encasing two gyroscopes that spin at more than 20,000 rpm to counteract short-term movements of the camera and lens. As a result, acute sharpness can be maintained at slower shutter speeds, allowing aerials to be taken under lower light and/or with higher resolution films. At 1,000 feet, a shutter speed as slow as 1/30

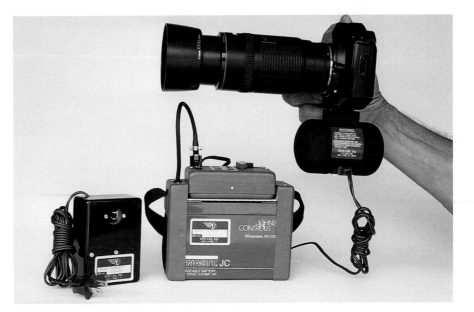

second can be used with a 50mm lens. Longer telephoto lenses and lower altitudes are also possible for aerial photography when using the Ken Lab Gyro-stabilizer; but it is still imperative to increase the shutter speed to minimize the effect of the ground movement. At 500 feet, a 300mm f/2.8 lens coupled with 100 ISO film gives consistent results. Fast shutter speeds take care of the ground speed, and the gyro eliminates the effects of airplane vibration and the photographer's movements.

Techniques

To obtain a sharp image, any optical obstruction that might degrade it must be removed from between the camera and the scene. Whenever possible, avoid photographing through Plexiglas or glass.

Maintaining the stabilization of the camera is the most important photographic technique associated with aerial photography. The photographer must be able to absorb much of the airplane's vibration in his or her lower body, leaving the upper body stable and concentrating on minimizing camera shake, just as one would do on land. The upper body must not touch any part of the airframe in order to prevent the transmission of vibrations that already are being isolated by the lower body. With the window opened or a door removed, the camera should

The serious aerial photographer will use a gyro-stabilizer to minimize camera movement and the effects of airplane vibrations. It works well on smaller zooms and telephotos up to 300mm f/2.8.

Reflections from Plexiglas can mar an otherwise good aerial photograph. Whenever possible, shoot through an open window. It is difficult to photograph through a bubble canopy, such as this one on an experimental Long EZ.

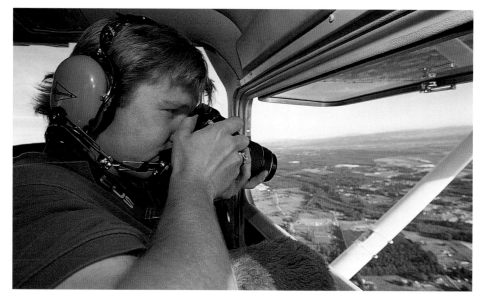

not be placed out into the airstream that, on a fixed-wing aircraft, will be rushing by at 70 to 100 mph. The photographer can keep the camera still by staying just inside the aircraft enclosure, and using the neck strap of the camera will help protect against loss caused by buffeting winds.

Small Plane Aerials

With the airspeed at less than 100 mph the window can be opened in most small planes. Keep the lens out of the airstream and your body away from parts of the plane that are vibrating.

Smaller fixed-wing aircraft and pilots to fly them are available for rental from most airports. The most common types are the Cessna 150, 152, 170, 172, 180, and 182. The "2" designates a tricycle landing gear versus the tail-dragger. The 150/152 is the cheapest to rent, but very cramped for taking photographs. The 170/172 is a four-place with considerably more room; its speed is nearly ideal for aerial work. The 180 and 182 have even more room and additional horse-power, but with this comes a faster flying speed and additional expense for fuel and rental fees.

Most open-window aerial photography is best accomplished at under 100 miles per hour. The slower flying capability of some planes allows positioning over the target area longer and with less wind buffeting. All of the above-mentioned small airplanes have windows that can easily be removed or opened, eliminating the Plexiglas obstruction that will otherwise prevent maximum resolution.

The Cessna 206 and 210 also can be very useful for photography, because their rear doors can be removed to give a large, unobstruct-

High-winged airplanes like this Cessna 172 are good platforms for aerial photography, but the wing strut and the landing gear get in the way. Keep them in mind while framing your aerial landscape.

ed view of your subject area. But, faster speed is needed to keep the plane from stalling; it uses more fuel; and it is considerably more expensive to rent.

The ideal aircraft for aerial photography would be a roomy high-wing with no struts, a very slow stall speed, and a window that folds out of the way for an unobstructed view.

Choosing a Pilot

The person who takes you up for your aerial photography must be a qualified pilot with considerable experience flying in unusual conditions. During the course of an aerial shoot, the plane will be put into nearly aerobatic attitudes. The tight turns, close proximity to the ground, and speeds near the stalling limit of the airplane make this anything but routine weekend flying.

Flight instructors often make the best pilots for aerial photography. They are readily available at the same locations that rent small aircraft, and since they usually use the same aircraft for flight lessons, they have considerable hours of experience in small craft.

Communication with the pilot during the flight is important and headsets will facilitate in-flight directions. Review the flight plan before taking off to let the pilot know what you have planned, what altitude most of the images will be taken from, any hazards, such as mountains, that might be encountered, and any other information that will be helpful to minimize wasted time in the air. Airplanes are usually rented in 1/10 hour increments and time saved is money saved.

Be aware that both the pilot and the photographer need to be watching continuously for other aircraft in the area during the flight. Any help you give the pilot will be appreciated.

The pilot will keep you advised of rules concerning the minimum altitude over structures and people. Don't ask the pilot to violate those rules; not only the pilot's license, but your safety and that of others will be at risk.

If you are photographing animals on the ground or birds in the air, don't approach so close as to stress them unduly. Federal rules establish how closely an airplane can approach whales and some protected bird nesting sites. If you plan to photograph such subjects, do your research before you take off.

Lighting Conditions

The conventions of lighting in ground-based landscape photography also apply from the air, but an additional consideration is atmospheric conditions that can rob the aerial scene of contrast and detail. Moisture and other particulates in the form of haze and smog need to be avoided or minimized.

A good pilot is essential to success in aerial photography. I prefer flight instructors because they have current experience and the skill to put the airplane into the unusual attitudes often needed for aerial photography. My pilot here, Tony Dawson, is not only an instructor but also captains a 747.

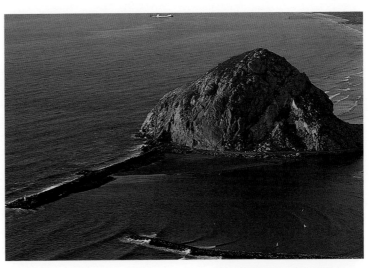

Some areas have closed or restricted airspace. Pilots must maintain particular altitudes around Morro Rock, California, near my home, because it is a sanctuary for peregrine falcons. Your pilot's charts should show local restrictions.

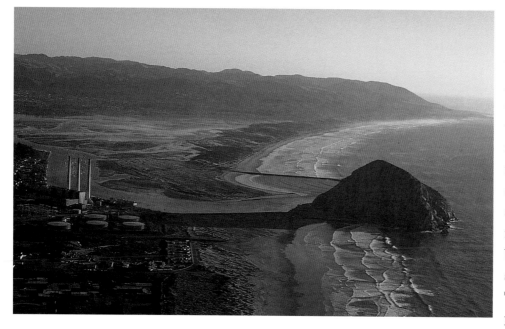

Photographing into the sun causes backscatter. The light bounces off the particulates and moisture in the air, resulting in a low-contrast, hazy image. This photograph and the one below were taken just minutes apart.

Positioning of the plane relative to the sun and the ground target is important. The direction of the light relative to the photographer will determine the shape of the ground features because of the fall of shadows. The backscatter from any particulates either will be minimized by having the sun behind the camera or emphasized if shooting into the sun. The time of day also plays a part in shaping the subject because early and late light cause long shadows and increased contrast, while shooting during the middle of the day with the sun directly overhead will flatten the lighting and minimize the delineation of ground features. For dramatic lighting, consider the unique qualities of dawn and sunset.

To minimize the effects of haze and smog, the distance between the subject area and the photographer must be decreased. Using lower altitudes and wider-angle lenses will help in this endeavor. The best atmospheric conditions usually occur immediately following a storm when the air is seemingly scrubbed of pollutants. But waiting too long after a storm works in the opposite direction; haze will increase from the moisture escaping into the atmosphere. Windy conditions sometimes clear the air, but also can lift dust to obscure the photographic target. Overly windy conditions will make controlling the aircraft more difficult.

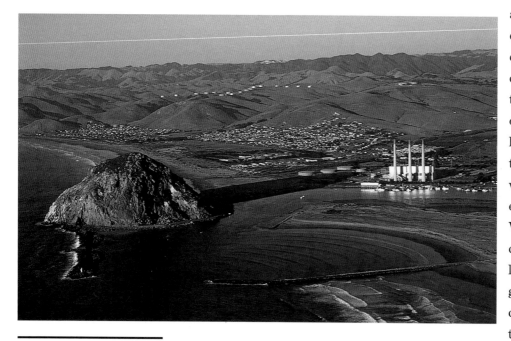

Photographing with the sun behind the plane minimizes backscatter and produces a much clearer image. The scene is Morro Rock and the town of Morro Bay, California.

Clouds can add variety to aerial photographs, but too many shadows on the ground can cause a problem with contrast and take the emphasis away from the ground features that should be the center of interest.

Helicopters

Helicopters offer a number of advantages for aerial landscapes because they can be flown at low speed and can even hover at a set position. Disadvantages to helicopters are their high cost and the engine and rotor vibrations inherent in the platform.

Flightseeing tours are a relatively inexpensive way to use helicopters for photography because the cost is spread among the members of a group. You can expect to pay from $50 to $150 for an hour-long tour. The tour will have a set

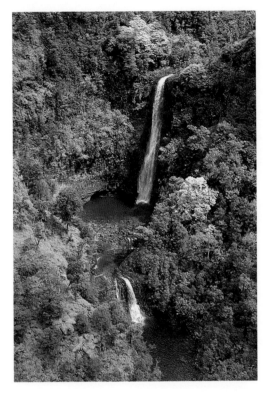

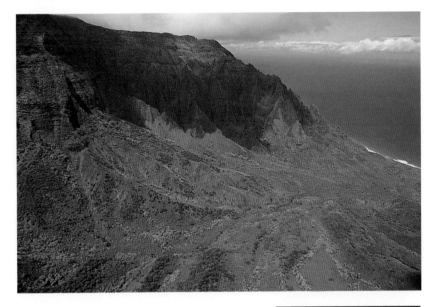

agenda, so you won't have any control over where the helicopter goes; but the best places for flightseeing are often the best places to photograph.

Helicopters offer the great advantage of maneuverability and precise positioning. A fixed-wing aircraft would be unable to bring the photographer close to these water falls in Kauai, Hawaii, (left) or to the head of the valley (above) The higher cost is just about the only disadvantage to helicopters. Both photographs were taken with a Canon EF 35-350mm zoom lens on 50 ISO slide film.

Choose a flight time that will give you the best light on the subject area. Make sure you get an unobstructed window seat or you may find yourself trying to photograph over someone's shoulder.

Wear dark clothing to minimize your own reflections in the Plexiglas window. A white T-shirt is deadly for reflections and will effectively prevent any worthwhile photographs. Dark gloves may be necessary to keep the reflections of light-skinned hands out of the picture.

Privately rented helicopters are available at many airports. It can be useful first to take a group flightseeing tour to check out an area, and then to hire the same company for a subsequent private flight. The private rental may cost as much as ten times the amount for the group flight, but it will be more efficient. The flight can head directly to the desirable locations and the helicopter can be

Hot-air balloons offer a slow-moving, stable platform. Although their paths are unpredictable and the flights are relatively short, depending on wind conditions, ballooning is a great experience.

Other than an occasional burst of gas and flame from the burner, hot-air balloons usually give no evidence of their presence to subjects on the ground. The cattle in this pasture didn't have a clue. A 35-350mm lens and 100SW slide film were used.

The familiar airliner window can be the frame for a great image. You'll have a better chance if the window is clean, unscratched, and without moisture between its layers. Keep the lens as parallel to the plex as possible for increased sharpness.

positioned precisely. If the door can be removed from the helicopter, a 180 degree view—without Plexiglas—can be realized. Sitting in the doorway, you can shoot with lenses as wide as 20mm, but be sure to tape the buckle on the safety belt so that accidental release isn't possible. If you have a gyro-stabilizer, the result will be vibrationless imaging at its best.

Hot-Air Balloons

Imagine suspending yourself above the landscape, barely moving and as stable as a skyhook. Impossible? A hot-air balloon does just that. But, as with other aerial photography platforms, there are both advantages and problems associated with balloons.

Hot-air balloons offer a stable platform that allows the use of a 35-350mm lens at all focal lengths, even at shutter speeds as slow as 1/90 second. You get maximum access to the landscape as the balloon slowly floats along. But you have little control over where the balloon will go and how long the flight will last. Any measurable wind will either cancel or prematurely end the flight. Balloon baskets offer minimal space and care should be taken not to lose lenses or film containers overboard. And then there's the landing: either gentle descent in the hands of the ground crew or a tense crash with little control. Be sure your equipment is stowed before you land.

Don't limit your balloon photography to images taken from the air. The color and design of the balloons and the excitement of the ground procedures at a balloon launch make for great photographs.

Airliners

The views from 20,000 to 35,000 feet can be marvelous, and commercial airliners can be effective platforms for aerial landscapes. Always take a camera with a wide-angle to normal zoom and several rolls of film along on your cross-country jaunts. In addition to the camera, you'll need a window seat, preferably in front of the wing and on the shady side of the plane. The window seats behind the wing can be good vantage points on those airliners with the engines positioned at the rear and up under the tail, but wing-mounted engines leave an image-degrading heat trail.

If you're lucky, you'll have a clean and undamaged window, without finger writing from the last three-year-old who occupied your seat. The newer the plane, the better the chance of a clear window. Most airlines don't give a high priority to washing external windows, and older planes have Plexiglas windows that are scratched and aged from years in the sun.

To maximize the chances of clear images from an airliner, use a lens from about 24mm to 50mm. A zoom lens in this range works well, but longer lenses won't give a sharp image due to the several layers of Plexiglas in the window. Filters don't work because of the properties of the Plexiglas. Polarizing three or more layers of Plexiglas will give some interesting colors to your image, but probably not the ones you intended.

Use one of the slower films, such as 100 ISO, be it print or slides. You'll be looking for maximum definition of the details below. Be sure not to press the lens against the Plexiglas window. The plane's vibration will cause unsharpness and you'll scratch the plex. Do keep the lens close to the window, however, and at an angle that brings the lens plane and the window in parallel.

Leave exposure on automatic, and bracket in 1/2 stops to both sides of the indicated correct exposure. The multi-layers of the Plexiglas and shading in the windows make guessing the exposure relative to basic daylight impossible. Here's where automatic saves the day.

Unique Aerial Photography

It can be a great challenge to offer your viewers unique visions of landscapes, because most stunning vistas have been rendered commonplace through frequent photographic portrayal. Aerial photography offers the opportunity for a different view from a perspective that many people can only imagine, and others glimpse fleetingly from a mountaintop or an airliner. This special view can influence your work even when you're back on the ground. If you have the time to spend in aerial photography, be sure not to get so caught up in the technique that you don't spend time studying the groundscape. Thoughtful time in the air will increase your overall understanding of an area and improve your earth-bound photography as well.

The Stikine River flows from Canada, through Southeast Alaska, and into the Pacific Ocean near Wrangell Island. The upper photograph of the Stikine Delta was taken from a small plane at less than 1,000 feet; the lower image is from an airliner at 20,000 feet. Both were taken with a Canon EF 28-105mm zoom lens on ISO 50 slide film. Each image offers a different perspective and information, and both are useful.

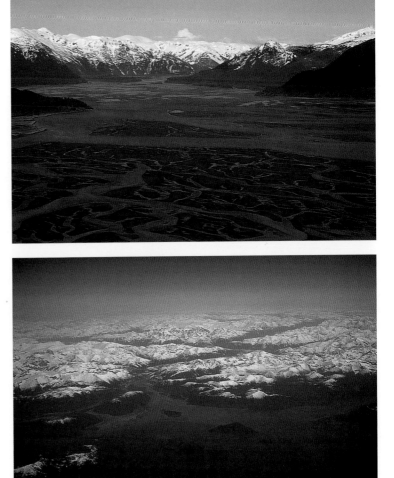

FALL COLORS

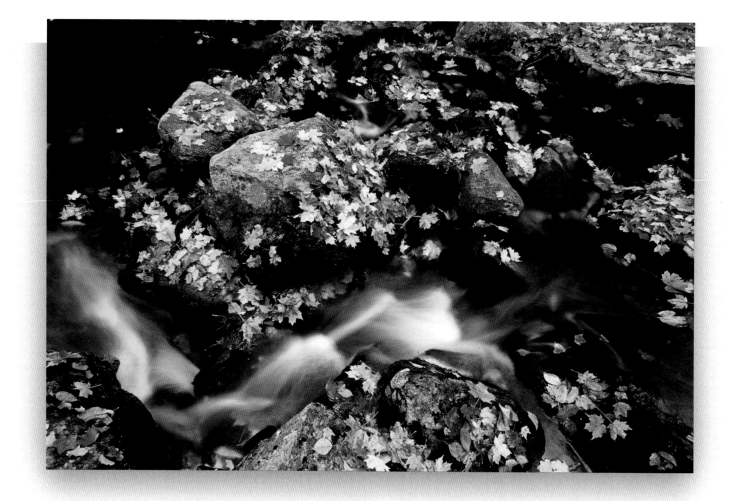

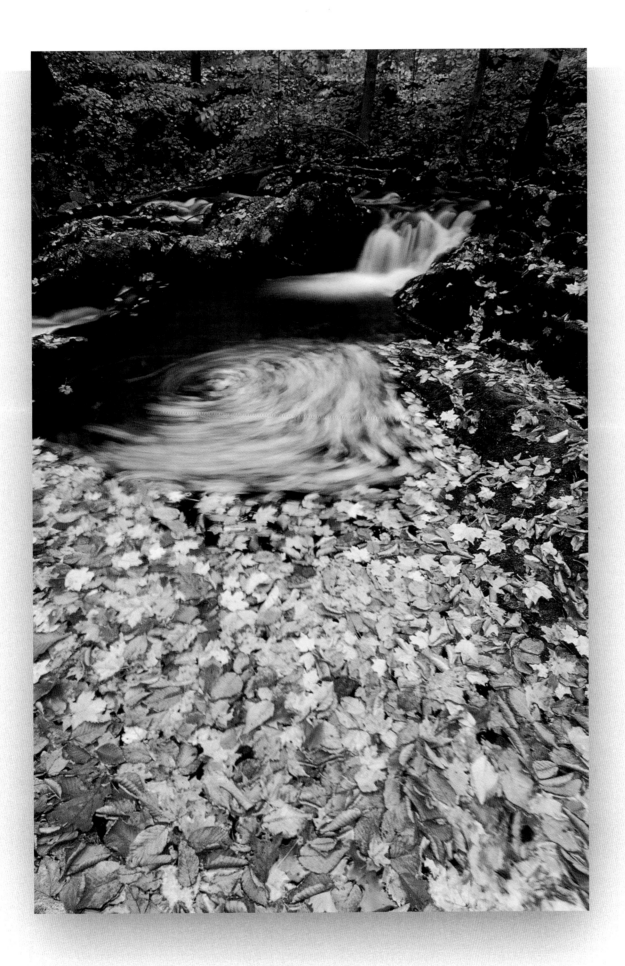

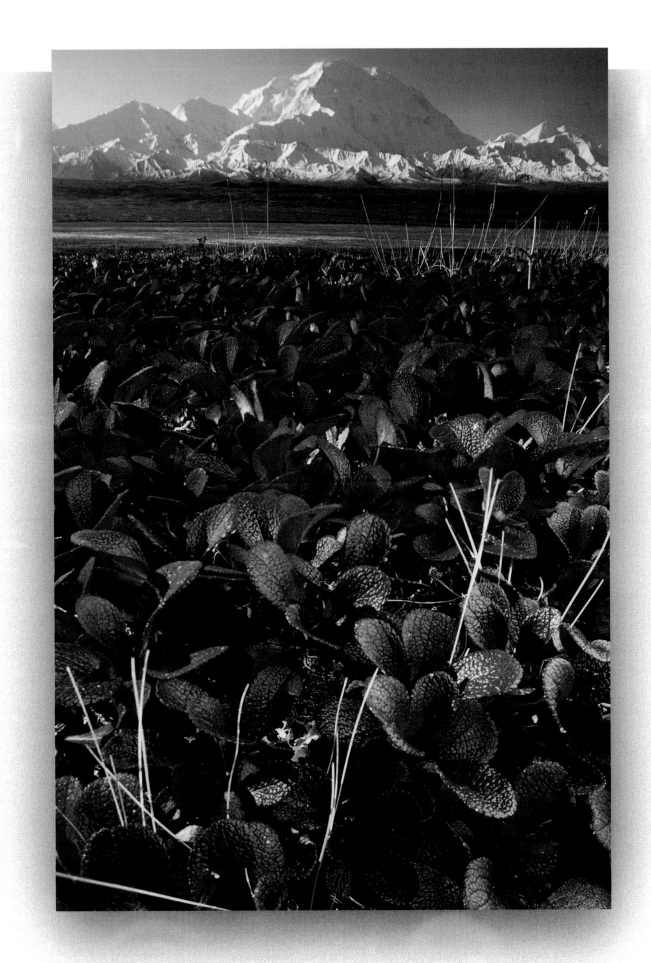

Creek through Fallen Leaves. Harriman State Park, New York. A simple extraction from a waterfall scene yielded this complete image. A longer exposure of one second renders the crisp, splashing water as a silky stream. The exposure also yields the smaller f/stop needed to give the expanded depth of field required to carry the scene.

Waterfalls with Swirling Leaves. Harriman State Park, New York. In an attempt to capture the complex activity before me, I calculated the overall exposure into nine separate ones, during which I fired an electronic flash toward the rotating mass of leaves. The completed image shows the swirling movement of the leaves while maintaining the natural light. On the original slide, each leaf can be tracked in nine different positions. A Canon 24mm tilt/shift lens was used with Kodak E100SW film.

Bed of Leaves. Harriman State Park, New York. To give this bed of leaves a slightly different appearance, I used a double exposure. One half of the exposure was rendered tack sharp, while the other half was completely out of focus. The two combined on one frame added up to the correct exposure. The end result is a sharp image with a slight halo effect around each detail.

Mt. McKinley with Fall Foreground. Denali National Park, Alaska. Fall doesn't last very long in Alaska, and this pristine fall day was a rare pleasure. The entire image was rendered sharp, from the vast expanse of bear berry ground cover in the foreground to the massive peak at the horizon—some thirty miles away—by using a 24mm tilt/shift lens to maximize the depth of field.

Fall Show above Lake Sabrina. Eastern Sierra Nevada Mountains, California. Brilliant gold aspens add glitter to this jewel of a lake located above the Owens Valley. A 35-350mm zoom lens was used to fine-tune the optical extractive composition.

Aspens and Granite. Below Sabrina Lake, Eastern Sierra Nevada Mountains, California. Fall color is more than the grand vista. Colors, lights, and shadows create a design image in this unusual perspective of aspens.

\mathcal{F}ALL COLORS

An elusive spirit heralds autumn—one that creeps up on us, arousing our senses in the yellow-lit early morning of the first crisp day of September. The tender pale greens of spring and the vibrant greens of early summer have turned to mundane, dusty, endless, monochromatic landscapes. Mother Nature, sensing our disinterest, begins the overture to the autumnal concert. First, a little solo—a suddenly golden maple revealed. Low notes follow—poison oak flushed from its hiding place, deep red on the forest floor. The color literally falls upon us, from high to low points, moving from tips of trees to centers, from hilltops to valleys, from north to south. At the crescendo, the full range of color is played in a symphony of reds and oranges and golds and burgundies. We revel in the sound, the scent, and the sight of fall at its scurrying, greatest glory because we know, without warning, one grayish early morning following a storm, we will wake up to winter.

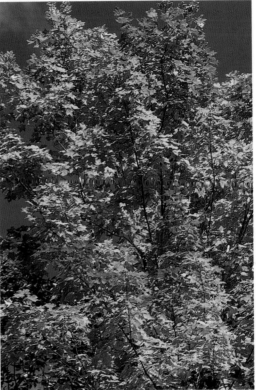

Foliage doesn't turn color overnight. Many trees display a range of color, from bright greens to brilliant reds and yellows. The maples of Vermont offer some of the most spectacular fall color examples. Photographed on Fujichrome Velvia slide film.

Fall color is the landscape photographer's holy grail. Fall can be called a moving display because (a) it moves, (b) it moves us, and (c) we move around a lot to catch it at its peak. Indeed, calculating the best place and time to capture superior fall-color images occupies a great deal of the nature photographer's summer, just as in winter and early spring we try to anticipate the best wildflower displays. Knowing when and where the best fall color photo opportunities are likely to present themselves and mastering techniques that translate the color and spirit of autumn onto film can lead you to one of the most satisfying photography seasons.

The Science of Fall

Everybody knows that it's the chlorophyll in plants that makes them look green. But what makes them look yellow, or orange, or red? It's the absence of chlorophyll that enables us to see the carotinoids that give plants their rich fall hues. As autumn approaches, changes in the duration of daylight and lower temperatures break down the food-producing chlorophyll in the leaves of trees,

Only thirty miles from New York City, Harriman State Park offered a fabulous fall color display in 1996. A running stream and cascades to complement the colors combine to make the best of all worlds, a situation guaranteed to eat into your film budget. A Canon EF 17-35mm lens at 17mm and Kodak E100SW film were used.

shrubs, and vines. The death of leaves occurs when their remaining nutrients are pulled back into the host tree in preparation for winter's dormancy. In the spring, the release of nutrients begins the new growth cycle.

There are great variations in the geographic and species-specific range and intensity of fall color. At higher elevations and northern latitudes, the changes may occur as early as August, while the U.S. Southwest typically sees the greatest displays in October or as late as November. The famous large spans of single-color aspen groves are uniquely based in the shared root system, and thus identical genetics, of thousands of trees which may cover several acres of land. In contrast, a single East Coast sugar maple begins the season entirely green, then demonstrates a multi-colored confetti effect until all the leaves catch up with each other to render the tree in a single splash of rich color.

Some Fine Fall Color Locations

A great diversity of fall color is available in North America. Aspens and willows in the western United States, the famous Eastern hardwood forests, and the Alaskan tundra all offer very different settings and hues. All over the continent, the broad range of botanical species and their geological surroundings present abundant opportunities and challenges for the creative nature photographer. Beyond considerations of ease of access, expense of travel and accommodations, and the photographer's personal wanderlust, choosing your fall color location requires some understanding of the likely types and timing of displays.

The dry, eastern slopes of the Sierra Nevada in California, hosts a combination of willow and aspen at 6,000 to 9,000 feet. The aspen concentrations, typically found in the canyons, are not as large as those found in the Rockies. Willow, colorful brush, and abundant evergreens often provide interesting supporting tones in fall photography accomplished in this region. Some huge individual cottonwood specimens can be photographed dramatically posed before a backdrop of spectacular mountains. Cottonwoods are located in the rural Bishop, California area, among pastures and farmlands at the base of the steepest escarpments of the range. Nearby is Mt. Whitney, the highest point in the lower 48 states.

The cottonwoods, at 4,000 to 5,000 feet, turn later in the season, so plan a second trip to capture these brilliant yellow torches in the northern part of the Owens Valley.

The previous season's moisture is decisive in determining the quality of the Eastern Sierra's fall color. Winter snows and spring rains contribute to abundant growth and healthy trees; drought-stressed plants are vulnerable to unattractive and unphotogenic diseases. Drought-prone California produces a highly variable show from year to year. Early fall storms and frosts can abruptly and prematurely end a beautiful display, so once you've identified peak color in the Sierra, don't hesitate.

Dogwood is found in the coastal California mountains below 6,000 feet and on the western slopes of the Sierra Nevada, where Yosemite National Park has a particularly fine representation. Well-known for its abundant, large white blossoms in the spring, the dogwood provides an equally beautiful fall show of red-to-pink leaves.

The Rockies' strongest fall color is in the rugged San Juan Mountains along the backbone of the range in Southwestern Colorado. Fourteen thousand-foot, snow-tipped peaks provide a striking backdrop to the vast aspen groves that cover their lower slopes. The San Juan Skyway, a road circling the peaks, gives many scenic views from such lofty points as Durango, Silverton, Ouray, Telluride, and Dolores. Along the Continental Divide from Canada through Idaho, Wyoming, Colorado and spreading out even as far as Utah, there are many promising locations for aspens which can rival those in the San Juans.

The east side of the Sierra Nevada Mountains in California displays yellow aspen and multi-colored brush during September and October. This view of Lundy Canyon was taken with a 35-350mm zoom on Kodak E100SW film.

The aspens and high rugged peaks of Colorado's San Juan Mountains are legendary sites for landscape photographers. This scene was recorded near the town of Telluride, Colorado. A polarizer and Fujichrome Velvia were used to heighten the color.

A few scrubby trees and a mat of low foliage produce fall displays that rival the best colors of New England. Denali National Park, Alaska, can be spectacular in late August and September. It helps to have a 20,000-foot, snow-covered mountain as a backdrop. A Canon 20-35mm lens with a polarizer and graduated neutral density filter were used on Velvia film.

You might not think of Alaska as the place to find fall color, especially when you consider that there are few deciduous trees. Aspen groves can be found in the lower stretches between Fairbanks and Anchorage along the Alaska Railroad corridor, and in some areas south of the Alaska Range. But the taiga and tundra of Central Alaska, which includes Denali National Park, offer the more unique and spectacular fall displays. The problem is that fall is a very short season in Alaska, sometimes limited to a few weeks in late August and early September; the peak may last only a few days. If you can catch it, you'll find a thick carpet of bright red color in ground-hugging plants, berries, and grasses, punctuated by occasional yellow ribbons of willows. All this makes a dramatic foreground to glaciers and icy peaks—Mt. McKinley, of course, chief among them. Alaskan tundra on a crisp, blue fall day is a really pleasant place to be. The insects are gone, and the large mammals are showcased in their prime. You can compete with the bears for the many varieties of edible berries. And if you are really lucky, you'll photograph the exodus of many thousands of thermal-gliding sandhill cranes.

The Northwest Territories of North Central Canada offer displays similar to those of the Alaskan tundra, but it is far more expansive and situated among a multitude of lakes, slow-flowing rivers, and eskers—serpentine-like drifts of gravel and sand. Located north of the treeline, the region is a flat expanse stretching to the horizon. It is the domain of caribou, musk oxen, wolves, bears, and little else.

Fall comes in August to Canada's remote Northwest Territories. Bearberry and mosses combine with smooth glaciated rocks to paint the landscape. A Canon 20-35mm lens and Fujichrome Velvia were used.

Hardwood forests of the eastern United States are famous for their fabulous fall show which lends itself to more traditional landscape photography. Sugar maples, birch, poplar, and oaks all add to the quiltwork of leaf-induced hues.

The beauty of the trees combines with local color, such as farmhouses, churches, covered bridges, and historical sites, to make New England a popular destination for fall photographers. The action begins around the first of October. Progress reports for this national treasure are readily available in the popular press.

The Blue Ridge Parkway, running more than 450 miles along the crests of the Southern Appalachians, offers a great show from late September. The

highway connects two national parks, Shenandoah and the Great Smoky Mountains. In the northern portion, look for tremendous deep-red displays of dogwood, blackgum, and sourwood; multi-colored red maples; gold hickory and tulip trees; and neon-orange sassafras. In the Smokys, find chestnut and white oaks, maples, yellow poplar, and magnolia in the low-to-middle elevations.

Keeping track of fall color is practically a national pastime. *U.S.A. Today* publishes a chart almost daily during "leaf peeper" season. Photography newsletters such as Carol Leigh's *Picture This*, travel guides for photographers such as *Photo Traveler*, and magazines such as *Sunset* and *Outdoor Photographer* are good sources for specific locations. If you are serious about dedicating your vacation to photography, consider a photo tour with a professional photographer who leads groups to prime sites and gives hands-on instruction in photographic techniques specific to fall color. Various hotlines for fall color are set up each year; their numbers are subject to frequent change so I won't list them here. And, of course, if you want to spend some time surfing on the Internet, you'll find both photographic and fall color guides.

Photographic Considerations

Don't let the fabulous colors blind you to the need for scrupulous composition and good photographic technique. Be sure to look beyond the grand scenic; fall color photography includes many opportunities for patterns and textures isolated from the larger view. Fall color can be a backdrop to another subject, such as a deer, a mountain range, or a cloud formation. Keeping the color in the background can be the key to a great image. Water and fall colors go together. Flowing streams with masses of leaves or reflections of colorful trees in a still lake tell a more complex photographic story. Techniques with moving water, such as waterfalls and rapids, are especially effective in fall environments.

Vermont, with its forests of hardwoods, plays host to many "leaf peepers" every fall. Call ahead to estimate the time of the peak show, and hope that lodging is available. A Canon 35-350mm lens was used to extract this hillside view. Polarizing filters can help to saturate the colors by eliminating reflections from the leaves. A high-color film—such as Fujichrome Velvia and Kodak E100SW—is the best choice for slides. A slower print film (100 to 200 ISO) will brighten the colors and give a sharp image.

Using the Light

Fall colors can be photographed in all aspects of light. The colors will be most vivid in bright sun, and the contrast against a bright blue sky is a strong image. But midday light is not the best choice. Early morning and late evening light will add a directional quality that increases the three-dimensional aspect, something that is completely lost in over-cast or midday light. It's wise to use a polarizing filter if it enhances the scene by removing reflections from the leaves and darkening the sky.

Bright sun and overcast give entirely different renderings of the same scene. Use a circular polarizing filter in both conditions. A warming filter will brighten up overcast subjects.

Overcast softens the landscape and gives a completely different mood to the scene. Use a film that has high color saturation and increased contrast. Including gray skies in these pictures will deaden the image. A light rain or mist will saturate the colors and give you new subjects in close-up. With serendipity you may catch an early snowfall, which gives a rare combination of bright colors against a pure white backdrop.

Close-ups generally are better accomplished under soft, overcast lighting. Fall color lends itself to many unique medium close-up opportunities. These can be of individual leaves, of leaves with raindrops, groups of leaves in streams or puddles, or in clumps of ferns or moss beds. Macro opportunities abound, such as designs within a single leaf or combined with the elements of dew, rain, or snow. Look for other subjects, such as berries, seedpods, dried flowers, and even a few remaining fall wildflowers.

An area of water in the shade, with sunlit leaves on an opposite bank

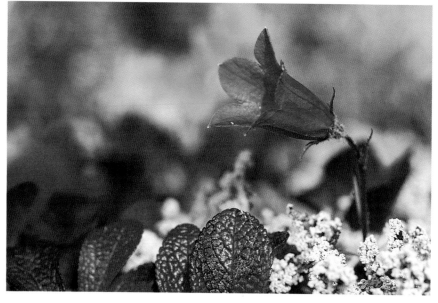

The summer season is so short in the northern reaches like Denali National Park, Alaska, that you might find bluebells next to fall-colored red bearberry. A 100mm macro lens and Velvia were used.

reflecting into the shadowed area, can create images with a feel of liquid light. Add a polarizing filter to see if it enhances or diminishes the image, and look for a rock or other subject to anchor the swirling water and color.

The transparency of colored leaves may lend them to backlighting, which will heighten the color, give the effect of a glow that comes from within the trees, and offer the possibility of a sunburst effect among the leaves. Exposure bracketing is essential here; you never know until you see the finished image which exposure will give you back the vision you had when you took the picture. A darker exposure will emphasize the dark sky and a sunburst, whereas a lighter exposure might be best to show details within the mass of leaves.

A 100-300mm telephoto zoom can be used to advantage in extracting brilliant trees reflected in streams.

Filters

Polarizing filters are effective in removing unwanted reflections that hide the colors in the leaves. Don't forget that the filter causes a light loss of about 1 1/2 stops. Even in overcast conditions, check to see if a polarizing filter increases color saturation by removing gray sky reflections from the leaf surfaces. Polarizing filters tend to "cool" an image, and a photographer may want to add a warming filter, or use a combination polarizing/warming filter, when photographing fall colors.

Any time that photographs are being taken in full shade, there is a need to compensate for the reflected blue light of the open sky. An 81A, 81B, or 81C warming filter adds warmth to the scene, minimizing the unwanted blue tones. With today's warm films, the 81B is a good, all-purpose filter.

Enhancement, or color-intensifier, filters, available from manufacturers such as Tiffen and Singh-Ray, will strengthen certain colors without affecting others—in theory. Neutral colors in the scene are likely to pick up the magenta quality of these filters. The filter will heighten reds, yellows, and oranges in the image, and if those are the predominant colors, the result will be especially vibrant.

The lower image of this beaver pond and tundra is an example of the effects of a polarizing filter. The upper image is not polarized. A 35-350mm lens and Fujichrome Velvia were used.

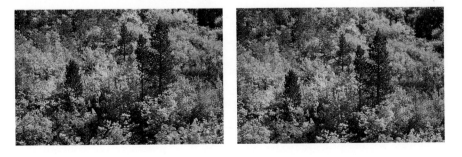

Using color-intensifying or enhancing filters can bring up the yellows and reds in a scene. The aspens on the left were photographed without filters; on the right the same scene was photographed with a Singh-Ray Color Intensifier. Both images were taken with a 35-350mm lens on Kodak E100SW film.

Graduated split neutral density filters are especially useful when a dark area of fall color serves as the foreground to a larger, brighter subject, such as a

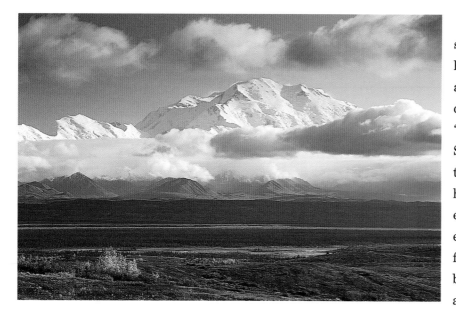

Two filters combined recorded the scene to full advantage. A polarizer darkened the sky and helped separate the mountain, while a three-stop graduated neutral density filter held back the brighter upper half of the scene to better match the lower half.

snow-covered mountain range. The filter holds back the light on the brighter area, allowing greater exposure of the darker foreground, and providing a "graduated" transition between the two. Some manufacturers offer varied graduations for different applications, from a hard, abrupt transition to a soft, blended effect. They come in different densities, enabling the photographer to hold back from one to three f/stops of light in the brighter area. Practice is essential since a photograph with an obvious transition will look contrived. Different manufacturers have different definitions of "neutral." Less-expensive filters may add unwanted color tones to your image.

Tripods

As in any other landscape photography, fall color scenics demand a quality tripod. Longer exposures are often necessary due to light-robbing filters, small apertures needed for fine detail and depth of field, and slower ISO films that give greater color saturation and exceptional resolution. For close-ups, choose a tripod that can be lowered close to the ground either by splaying the legs (like the Bogen and Gitzo models), or with a boom head design (the Benbo). Another great tool for close-ups from a tripod is the Bogen Magic Arm, which clamps on a tripod leg and holds the camera as low as ground level.

Close-up details of colorful aspen leaves round out a slide show or print exhibition on fall colors. Bracket the composition as well as the exposure. These photographs were taken with a 100mm macro lens; the left with E100SW and the right photo on Velvia.

Fall's Reward

Fall is a fleeting time of transition, and capturing the autumn landscape is high on most photographers' "must-do" lists. Indeed, the only photographic season that rivals fall is the spring/summer interval that gives us riots of wildflower subjects. Even these can't offer the expanse and diverse locations of fall colors, so let your creativity and all your technology run rampant in autumn. Try every lens, every filter, and all the techniques you can muster in your efforts to do justice to nature. Fall will reward you with a harvest of vivid memories, magnificent landscapes, and unique close-ups.

DESIGN ELEMENTS

140

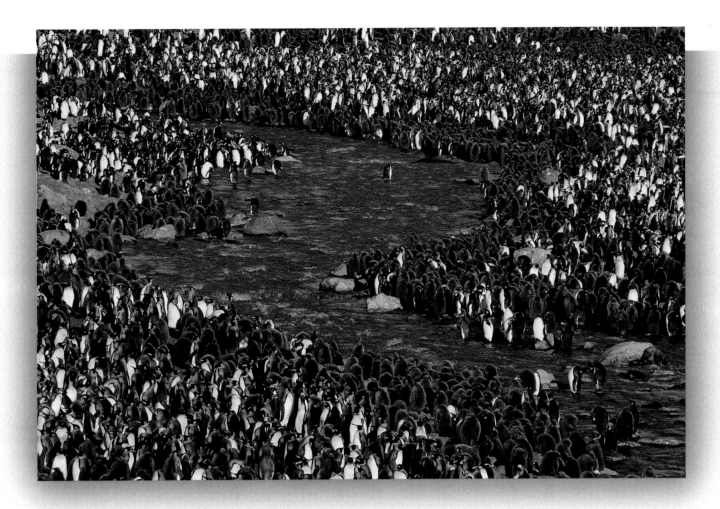

Turban Shell in Surf. Baja California, Mexico. Along a deserted beach, I found many beautiful shells. Some were high and dry above the surf, but those awash in waves were more interesting. A slow shutter speed (1/15 second) was used to allow the water to blur while the shell sat firm; a back-lit position added highlights from the reflecting sunshine. A reflector was held to fill in the shadow side of the shell. A Canon 35-350mm zoom, with a 25mm extension tube for closer focusing, was positioned on a tripod; Kodak E100SW film.

Whimbrels on Golden Sand. Central California Coast. Shore-lines offer many opportunities for design images. These feeding shorebirds were photographed at sunset from an overhanging cliff. The main feature of this design com-position is the contrast of the subject and the shadows against the pattern of golden sand.

Wild Barley. Mono Lake, California. These grasses, with their tender shades of green to red, invite photography through-out the summer along Mono Lake. In the fall, their dried seed heads offer another perspective. In this image, the subtle changes of color and repetitive forms are captured with a macro lens.

King Penguins along a Glacial Stream. South Georgia Island, South Atlantic Ocean. This densely populated penguin colony follows the S-curve of a glacial melt stream. The concen-tration of brown at the edges of the stream belongs to the "okie boys," the juvenile birds.

Icicles on an Iceberg. Antarctica. The shapes and monochromatic hues of blue give an eerie quality to the small details of a large iceberg. The melting, freshwater icicles add intricate shapes and highlights.

Rabbit Bush in Ice. Loa, Utah. Weeds alongside the road became a unique design image when a farmer's irrigation sprinkler misted the area along this fence row. Temperatures in the 20s froze each particle of moisture as it landed on the plants. The result was a truly spectacular combination of man's and nature's handiwork that offered hours of satisfying photography.

Limber Pine. White Mountains, California. The twisted limbs of these extraordinary trees are shaped by the harsh winds and storms at timberline. This tree, at 10,000 feet elevation, offered both swirling forms and contrast-ing golden colors.

Bromeliad. Miami, Florida. The repetitive red curls are the back-drop for two purple blossoms— the center of interest. The colors, as much as the shapes and contrasts, are integral to the design in this image.

DESIGN ELEMENTS

If it is to surpass simple documentation, a photograph must possess at least one of the elements of art: a center of interest, color, or design. It is in design that many people associate photography most closely with artistic expression. In fact, design elements are neither more nor less creative than other photographic subjects. In the same way that macro or wide-angle lenses give us different perspectives on nature, extracting design elements from a larger scene gives the viewer a unique way of seeing sometimes familiar subjects.

In breaking a scene down to its most essential parts, the photographer reveals structure, repetition, or formations that, separated from the whole, become a complete image in themselves. Rendered as a design element, a subject may no longer be recognizable or identifiable. A single azalea petal, for example, could contain plenty of color and pattern to carry a photograph, while even a botanist might be unable to name its source.

Art or not, the most important criterion for good photography is whether people have an interest in viewing it. Design elements will appeal to those with

There's always more than one photograph before you. Here are three views: the poppy field, the close-up design within a blossom, and a composition of only form and color. All on Kodak E100SW.

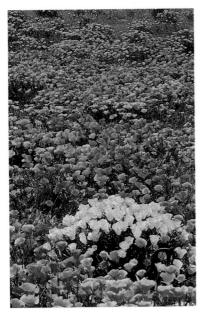

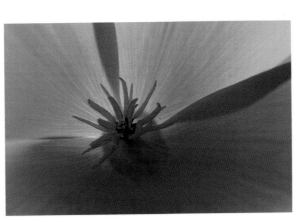

a penchant for mystery, for detail, for discovery. Because they are highly personal expressions, photographs of details and patterns are more often suitable for exhibition than publication. Some people are uncomfortable with deconstructing a subject into its most basic elements, while others love design elements so much that they look for them in everything. Indeed, there is design in virtually every natural subject. An adequate design photograph asks to be viewed in the context of its larger source, an image that is one of, and defined by, a set of photographs. But a really good design photograph stands by itself; it captures the viewer's interest without concern for its identity.

Concepts of Composition in Design Photographs

Composition counts. Even though you may be completely filling the frame with a single photographic component, the basic rules of composition still apply. Pay attention to balance within the photograph and placement of the most important elements. Approach the design from different magnifications, angles, and with varied lighting effects, while you look for many photographs in a single subject. Study design photographs that you admire to identify the following critical elements:

The two groupings of grass balance each other in the frame. Photographed with a Canon 90mm Tilt/Shift lens on Kodak E100SW film.

- **Balance.** Look for a sense of dynamic equilibrium among the opposing elements in the composition. Position the fulcrum of the image just under its center. The distribution of the weight of the compositional elements should achieve overall balance.

As the water is followed from the top to the bottom of the image, the waves of ice establish rhythm. A 90mm T/S lens with EF 2X tele-extender (180mm) and Fujichrome Velvia film were used.

- **Rhythm.** A flow with a recognizable, rhythmic pattern will create relationships between forms that give life, vitality, and energy to the work.

• **Contrasts.** Strong contrasts in color or light enliven a composition by giving it vibrancy, emphasis, and rhythm.

The contrast between the palms and the dark background and the varying directions of the patterns add impact to this image.

• **Mood.** The viewer should have a spontaneous, expressive response when viewing the image. The mood can be set by colors; textures; levels of contrast; strong vertical, horizontal, or diagonal lines; and the selection of media or tools. Certain films create a vibrant, up-beat color palette, while others offer muted, quiet tones. Long lenses compress and tighten an image, while wide-angle lenses give an airy feel.

• **Unity.** When all the elements of the design are working together, a theme emerges that demonstrates unity. A design image without cohesion probably will not maintain a viewer's interest.

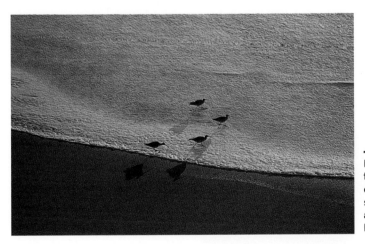

Many facets can combine to unify an image. This combination of the bird silhouettes, wave patterns, and warm sunset colors brings this image together.

The deep blue of an Antarctic iceberg sets the tone and mood of the shapes and forms in the cavern. A 35-350mm zoom was used with Fujichrome Velvia film.

Finding Design Elements

Identifying design elements suitable for photography involves developing a critical eye. Yes, there is design in everything, but not every design deserves to be photographed. The weathered fence with blooming rabbit brush along it might suggest an image, but covered with ice the scene demands to be photographed from many angles and exposures. Bracketing the composition is as important as bracketing the exposure in design photography. The design aspect that first drew

your attention may not be the one you take away with you on film. As you explore a subject, it will reveal many photographic options to you.

A simple exercise can help to develop skill in finding worthy patterns and formations for photography. Using your own or others' images and simple cropping tools, such as four strips of white paper, you can find pictures within pictures. In everyday activities, even when you're not taking photographs, you can continue the challenge of looking more completely at your surroundings and extracting new compositions from them. Don't limit yourself to the outdoor subjects typically associated with nature photography. Some of the most famous design photographs depict uncommon aspects of common household subjects, such as Edward Weston's beautiful work on vegetables.

It's very helpful to take classes from a photographer whose design photographs you admire. In a field workshop you can concentrate on developing your ability to discern and select worthwhile design subjects and learn how to photograph them to best effect.

Photographic Considerations

Design elements are accomplished through the use of extreme measures. Using macro techniques, the photographer can move into the scene to focus closely on and magnify a small portion. The same result can be accomplished by moving back from the scene to extract and enlarge your design with a long telephoto lens.

Be sure to document the overall scene, and keep it in mind as you work. Bracket the composition between the larger and extracted elements; often they work very well in conjunction with one another.

Design elements are all around us everday, and with practice you'll find them even when you're not looking. While photographing caribou in the Northwest Territories of Canada, I found these grasses in kettle ponds. A Canon EF 35-350mm zoom lens stopped down for maximum depth of field allowed many different renderings of these unique design elements.

Discovering Design

Design images, whether simple or complex, must powerfully suggest emotion or content if they are to hold the viewer's attention. But the act of capturing design on film can be a source of immense, private satisfaction for the careful photographer. There are many new discoveries to be made in the course of breaking down nature photography to the most basic elements of composition. Extreme techniques will distill a composition to its strongest elements. Macros bring us in tight, while telephotos hone the image and eliminate

Design elements abound in mineral specimens. This amethyst sample (left) has interesting repetitive colors and shapes. Cross-polarization (see *Beyond the Basics I* for a complete discussion of this close-up technique) was used to eliminate specular highlights. Both images photographed using a Canon EF100mm macro lens, two 430EZ electronic flashes, and E100SW film.

the chaff. After such refinement, can you see a strong design element that stands alone as a complete image? If so, you'll come to recognize and effectively use all the more subtle aspects of design that come together to create your larger compositions.

Exercise in Finding Design Elements

1. Find a stream with a waterfall.

2. Thoroughly and carefully photograph the waterfall in its entirety from many perspectives using wide-angle lenses.

3. From a position with a good vantage point of the entire waterfall, and where lighting is advantageous, use a zoom telephoto (80-200mm or 100-300mm) or several different focal-length telephotos (100mm, 200mm, 300mm, 400mm) to isolate individual elements of the waterfall. Choose interesting rock shapes, or water flowing around some rocks, the froth of the falls hitting the stream bed, or growth of moss on rocks alongside the stream.

4. Add other photographic techniques to alter your compositions, such as long exposures, short exposures, and filters.

5. Move closer to the water at the base of the falls; be mindful of your safety and that of your equipment. Using macro techniques, or even medium telephotos with extension tubes, look for closer design elements such as bubbles at the bottom of small falls, leaves caught in currents or along the edge, algae and moss, and mist on vegetation. Experiment again with different techniques, such as long and short exposures with electronic flash and multiple exposures on one frame.

Now you have an intimate view of the waterfall on your film, and in your memory. The search for design elements can lead you to much more intimate knowledge of your natural surroundings and innovative and satisfying photographic expeditions.

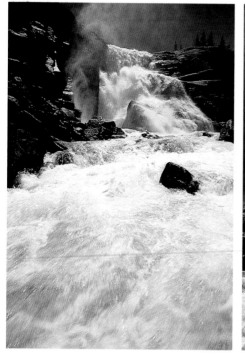

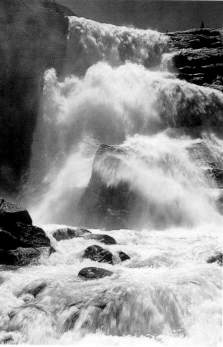

A 35-350mm zoom lens more closely defines the falls, with the emphasis now almost equally balanced between the cascades and the river.

A waterfall on the Tuolumne River, Yosemite National Park, photographed with a 20-35mm lens. The wide-angle lens emphasizes the rushing water of the river.

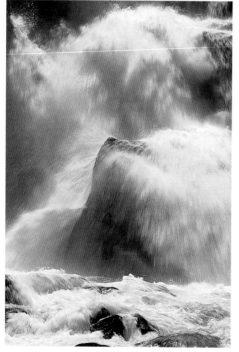

The overall composition yields many vignettes that can stand alone or as part of a series. Rarely does one photograph truly convey the full emotional range of a place. A 35-350mm zoom was used from a different vantage point to extract the rock and water.

Zooming in, the extraction of the water bouncing off the rocks becomes the focus of the image. The size of the waterfall or river is no longer important. The 1/15 second exposure continues to emphasize the dynamics of the moving water.

At a shutter speed of 1/500 second, the same framing portrays a different spirit. Experiment with shutter speeds and framing to find the one or many images that convey the feeling of the place as you experienced it.

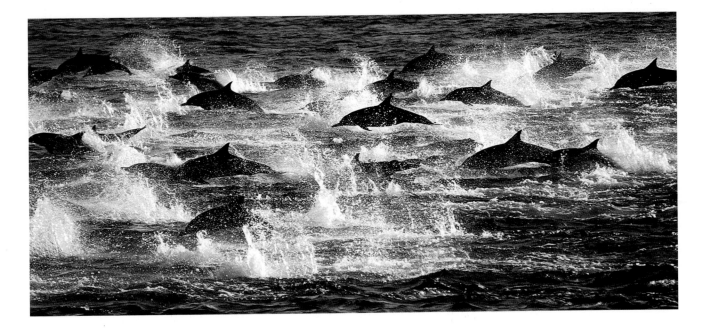

\mathcal{A}fterword

As nature photographers, we dedicate a lot of our time to observing and understanding the natural world. We spend long hours waiting for the decisive moment and travel far to seek out unique and exciting photographic opportunities. With the knowledge gained from our photographic pursuits, we have the opportunity to inform and influence others; and with our photographs, we can share the bounty of natural beauty we have experienced.

While it may never make us rich, nature photography—as hobby or profession—is the most enriching and personally fulfilling occupation I can imagine. So, with the completion of this book, it's time to shut down the computer and hang that old sign on the door:

Gone ~~Fishing~~ Photographing

Image quality is not the product of a machine, but the person who directs the machine, and there are no limits to imagination and expression.

Ansel Adams from his autobiography, 1984

ℛESOURCES

A & I Color Lab
933 N. Highland Ave.
Los Angeles, CA 90038
213 464-8361
Film Processing, Dupes, Photo CD

Bogen Photo Group
P.O. Box 506
565 E. Crescent Ave.
Ramsey, NJ 07446
201 818-9500
Tripods, Flashes, Power Packs

Canon USA
One Canon Plaza
Lake Success, NY 11042
516 488-6700
www.canon.com
Cameras, Accessories

D-Max Hollywood
740 N. Cahuenga Blvd.,
Los Angeles, CA 90038
213 464-2727
Film Processing, Dupes, Prints

Edmund Scientific
101 East Gloucester Pike
Barrington, NJ 08007
609 573-6260
Polarizing Material, Catalog

EverColor
70 Webster
Worcester, MA 01603
800 533-5050
Pigment Color Prints, Digital Prints

Gitzo
P.O. Box 506
565 E. Crescent Ave.
Ramsey, NJ 07446
201 818-9500
Tripods and Accessories

Ken-Lab, Inc.
29 Plains Rd.
Essex, CT 06426
860 767-3235
Gyros

Kirk Enterprises
107 Lange Lane
Angola, IN 46703
800 626-5074
www.kirkphoto.com
Tripod Accessories, Quick Clamps,
Ball Heads, Photo Books, Catalog

Kodak Corporation
434 State Street
Rochester, NY 14650
800 242-2424 Ext. 19
www.kodak.com
Film, Photo Products

Laird Photo
P.O. Box 1250
Red Lodge, MT 59068
406 446-2168
Tripod Leg Covers, Camera Covers

Lepp and Associates
P.O. Box 6240
Los Osos, CA 93412
805 528-7385
www.lepphoto.com
Books, Journal, Photographs,
Seminars, Workshops

Light Impressions
439 Monroe Ave.
Rochester, NY 14607
800 828-6216
Archiving Supplies, Filing, Mounting,
Books, Catalog

Minolta Corporation
101 Williams Dr.
Ramsey, NJ 07446-1293
201 825-4000
www.minoltausa.com
Cameras, Accessories

NANPA - North American Nature
Photographer's Association
10200 W. 44th Ave. #304
Wheat Ridge, CO 80033
303 422-8527
Information, Communication,
Annual Meeting

Nature's Reflections
P.O. Box 9
Rescue, CA 95672
916 989-4765
Nature Photography Accessories, Blinds

Nikon Inc.
1300 Walt Whitman Rd.
Melville, NY 11747
800 645-6687
www.nikonusa.com
Cameras, Accessories

Pentax Camera
35 Inverness Dr. E
Englewood, CO 80112
800 877-0155
www.pentax.com
Cameras, Accessories

Really Right Stuff
P.O. Box 6531
Los Osos, CA 93412
805 528-6321
Tripod Accessories, Quick Clamps,
Catalog

Rue, L.L.
138 Millbrook Rd.
Blairstown, NJ 07825
908 362-6616
Nature Photo Accessories,
Books,
Blinds, Catalog

Saunders Group
21 Jet View Dr.
Rochester, NY 14624
716 328-7800
Backpacks, Macro Bracket,
Photo Books

Sedona Digital Print Service
6746 S. Revere Pkwy., Suite 110
Englewood, CO 80112
303 706-9109
www.dl-c.com
Digital Prints, Photo CD, Software

Singh-Ray
153 Progress Circle
Venice, FL 34292
941 484-6086
Filters

Tory Lepp Productions
P.O. Box 6224
Los Osos, CA 93412
805 528-0701
www.lepphoto.com
Project-A-Flash

Werner Publishing Co.
12121 Wilshire Blvd.
Suite 1220
Los Angeles, CA 90025
310 820-1500
Publications for Nature and Digital
Photographers,
Outdoor Photographer and *PCPhoto*

\mathcal{I}NDEX

C

D

Page 151. Afterword
A pod of common dolphin race through the Gulf of California, Mexico. Captured by a Canon EF 35-350mm zoom lens with Fujichrome 100 film.

Page 152
A male polar bear wanders through lemon grass at Hudson Bay. Photographed near Churchill, Manitoba, Canada, with a Canon EF 300mm f/2.8L and EF 2X tele-extender (600mm f/5.6) on Kodachrome 200 film.

Notes